OBJECTS OF KNOWLEDGE

New Research in Museum Studies: An International Series

Series Editor Dr Susan Pearce (Director, Department of Museum Studies, University of Leicester)
Review Editor Dr Eilean Hooper-Greenhill

This important new series is designed to act as a forum for the dissemination and discussion of new research currently being undertaken in the field of museum studies. It will cover the whole museum field and will, broadly, address the history and operation of the museum as a cultural phenomenon. The papers published will be of a high academic standard, but they are also intended to relate directly to matters of immediate museum concern. The publication will fill a major gap in the present scope of museum-based literature.

Members of the editorial advisory board

Members of the editorial committee

NEW RESEARCH IN MUSEUM STUDIES
An International Series

1

Objects of Knowledge

Edited by Susan Pearce

THE ATHLONE PRESS
London & Atlantic Highlands

First published 1990 by The Athlone Press Ltd
1 Park Drive, London NW11 7SG and
171 First Avenue, Atlantic Highlands, NJ 07716

© The Athlone Press 1990

British Library Cataloguing in Publication Data
Objects of knowledge. – (New research in museum studies; 1).
1. Museology
I. Pearce, Susan M. (Susan Mary) 1942– II. Series 069
ISBN 0–485–90001–7

Library of Congress Cataloging in Publication Data
Objects of knowledge / [edited by] Susan Pearce.
 p. cm. — (New research in museum studies; v. 1)
Includes bibliographical references and index.
ISBN 0–485–90001–7
1. Museums—Philosophy. 2. Museum techniques.
I. Pearce, Susan M. II. Series.
AM7.025 1990
069'.5—dc20

Typeset by J&L Composition Ltd, Filey, North Yorkshire
Printed in Great Britain by Billings & Sons Ltd, Worcester

Contents

Part Two

List of Figures

List of Plates

Notes on contributors

Susan M. Pearce

Susan Pearce read history at Somerville College, Oxford, and remained at Oxford for postgraduate work in archaeology. She gained her PhD from Southampton University in 1981. She had curatorial posts at the National Museums on Merseyside and Exeter City Museum, was appointed Senior Lecturer in Museum Studies in the Department of Museum Studies, University of Leicester in 1984, and took over as Director of the Department in 1989. She is interested in the interpretation of material culture and the meanings of objects, and the history and nature of museum collections. This has drawn her to Bronze Age studies (the subject of her doctorial thesis and Somerville College Fellowship Grant, 1984) and Inuit material (research work in Arctic, Churchill Fellowship, 1974). She has published a wide range of papers and eight books, including *The Bronze Age Metalwork of South Western Britain*, *Museum Studies in Material Culture* (edited) and *Archaeological Curatorship*. She edits the book series *Leicester Museum Studies*. She was a visiting lecturer at Berkeley University, California in 1982, and lectures widely.

Eilean Hooper-Greenhill

Eilean Hooper-Greenhill trained as a sculptor at the University of Reading followed by several years teaching in a large London comprehensive school. A five-year period of varied freelance art teaching projects in museums, galleries, schools, colleges and art centres in London and the South East, preceded an appointment in the Education Department at the National Portrait Gallery. Since 1980, Dr Hooper-Greenhill has been lecturing in the Department of Museum Studies, University of Leicester. Dr Hooper-Greenhill's MA thesis researched the National Portrait Gallery as an agent of cultural reproduction, using some of the educational and cultural theories of Basil Bernstein. Her PhD was awarded from the University of London in 1988, and used the theories of Michel Foucault to re-read museum histories. Dr Hooper-Greenhill has published extensively on

museums and their social role. She is the author of *Museum and Gallery Education* (Leicester University Press. Forthcoming). Dr Hooper-Greenhill is a Trustee of the Horniman Public Museum and Public Park Trust and the mother of two children.

Mark Goodwin

Since completing his degree in English literature at Aberystwyth in 1981, Mark Goodwin has led a nomadic career: he has undertaken freelance work for museums, including the Dove Cottage Trust and the Victoria and Albert Museum, and other organizations such as Arts for Nature and the World Wide Fund for Nature. In 1988 he completed the MA in Museum and Gallery Administration, for which he gained a distinction, at the City University. During this period he became increasingly intrigued with the activities of Sir Henry Cole and the political culture in which Cole operated. He now writes and gives lectures on nineteenth- and twentieth-century political culture and the visual arts and is contemplating doing a PhD. In his spare time he writes quizzical short stories.

Edwina Taborsky

Edwina Taborsky, PhD, University of Toronto, teaches in the Sociology Department at Carleton University, Ottawa. Her research deals with the cognitive structure of groups and the relation between the individual and the group. Previous papers have analysed the group as a biplanary structure made up of a long-term pattern of cognition and an interpretative level. Her book *Society and the Individual* will be published in 1990 by the University of Ottawa Press. Current research is focused around the concept of society as a textual structure. A recent article 'Society as Text' dealt with the analysis of society as a structure of metaphors which operate within a discursive interaction to produce actual meaning. A forthcoming article 'The action of textuality' analyses the spatio-temporal discursive frame created by the 'Agent' and the 'other', within which the 'sign' as an action of meaning can exist.

Anthony Alan Shelton

Anthony Alan Shelton studied sociology and social anthropology at the Universities of Hull and Oxford. He has been director of a primary school in Mexico and lecturer in Pre-Columbian Art and Anthropology at the University of East Anglia. At present he is a curator of American collections in the Department of Ethnography of the British Museum (Museum of Mankind) and the visiting fellow (1989–1990) Department of Anthropology, Smithsonian Institution, Washington DC. Between 1978 and 1984 has conducted fieldwork among the Huichol and on Nahua and Tlapanaca communities in the State of Guerrero, Mexico. He has published on the Huichol, and on comparative Uto-Aztecan system of thought as well as written on various aspects of Aztec religion and symbolism. Since 1986 he has been interested in the history of the definition and institutionalization of Western concepts of the 'Other'.

Ghislaine Lawrence

Ghislaine Lawrence has been Assistant Keeper at the Wellcome Museum of the History of Medicine, Science Museum, London since 1979. Before this she qualified in medicine and spent some years working in hospitals and general practice. Her publications and ongoing research interests lie in the history of medicine and science and in cognitive issues associated with contemporary and past museum practice in these areas, particularly relating to exhibition.

Peter van Mensch

Peter van Mensch was born in 1947 at Gouda, Netherlands and graduated from the University of Amsterdam in zoology and archaeology. He worked since 1967 in different museums, among them the National Museum of Natural History, Leiden, as Head of the Department of Education and Exhibition. He is currently Senior Lecturer of Theoretical Museology at the Reinwardt Academie, Leiden, and the University of Leiden where he exercises various honorary functions within the museum field, including Chairman of the ICOM International

Committee for Museology (ICOFOM) and Chairman of the Working Group on Terminology of the ICOM International Committee on Documentation (CIDOC).

Michael M. Ames

Michael Ames gained his BA from the University of British Colombia in 1954; and his PhD in Social Anthropology from Harvard University in 1961. He has researched in India, Sri Lanka and British Columbia. He was Professor of Anthropology at the University of British Columbia and since 1974 was Director of the Museum of Anthropology. He was elected Fellow of the Royal Society of Canada in 1979. Research and teaching interests include museum studies, cultural policy, changes in artistic and intellectual traditions, social and religious organizations, and the anthropology of anthropology. He acts as a consultant for universities, museums, and museum training programmes. Recent publications include papers on contemporary Native Indian art, museum policies, and *Museums, the Public and Anthropology* (University of British Columbia Press, 1986). He is editor of *Museum Anthropology Museum Note* series.

Margriet Maton-Howarth

Margriet Maton-Howarth qualified as a teacher in 1976 and went on to read educational theory at the University of East Anglia. She has taught in primary and secondary schools in both the public and private sectors, her last post being Head of Art in a London secondary school. In 1980 she began researching into the concept of children's creative inhibition at London University Institute of Education; this initiated her current work on 'learning outside the classroom'. In 1986 she was accepted to gain a masters degree in graphic design at the Central School of Art and Design developing a learning system for use in museums and heritage institutions. She has since been working as an educational and design consultant.

Editorial introduction

Susan M. Pearce

The appearance of this volume sees the beginning of a new venture in museum studies, the publication of a periodical series entitled *New Research in Museum Studies*. The appearance of a new journal in any field is a major event, and not one to be undertaken lightly, or without a careful review of editorial policy.

New Research in Museum Studies has been designed to meet two clear contemporary needs: to add to the broad debate now underway in museum circles, and to provide an appropriate forum for discussion. It is a truism, but nevertheless true, that museums are changing in Britain and elsewhere, as new public needs, new management styles and new philosophical perceptions about society, knowledge, and the nature of objects and collections are explored, and as the impact of these changes are absorbed in the day-to-day life of working museums. All this has stimulated a public discussion on the nature and role of museums, conducted with a conceptual breadth and depth which would have been unlikely only a few years ago.

Nobody now in museums remains untouched by contemporary movements, or supposes that it is sufficient simply to have permanent exhibitions that are indeed permanent, and immaculate store rooms which shine like good deeds in a naughty world. There is, however, still an unwillingness, particularly in Britain, to allow that contemporary needs and their satisfactions are rooted in contemporary thought, and that both must be canvassed and understood before they can be translated into new museum practice.

This is another way of saying that the new thinking in

museum studies has (like most of us) two parents. On the one side is the pragmatic British tradition, respectful of rational science and scholarship, interested in effective action and workable policies, uneasy with strange gods and foreign philosophies, and temperamentally at one with the Great Duke whose exploits are touched upon later in this volume, and whose response to change and need was to tie a knot and go on. On the other side, we have the continental and related North American critical tradition, speculative, unashamedly intellectual, and self-conscious. This frequently takes a post-modernist, or broadly structuralist and post-structuralist, tone, a central tenet of which is the conviction that all knowledge, and all value – aesthetic or social – have no external reality but are socially constructed. The political and social implications of this are obvious, since it is undeniable that value and knowledge, and the social systems they underwrite, are held in place by power-play of all kinds, in which, inevitably, large groups are excluded or dispossessed. The political dimension ensures that this is not mere verbal flourishing and sparring but has a real effect in real lives and day-to-day decision making in museums and elsewhere. In terms of traditional curatorship, this is uncomfortable, disheartening and undermining, because it eats away at the accumulated body of knowledge and expertise which we have acquired painfully since childhood, and challenges the authority of scholarship and judgement which, in our hearts, we probably value and respect.

The effects of the critical tradition, especially as it has developed since the Second World War, are with us everywhere and in Britain as powerfully as anywhere else. Its consequences are felt at the most basic level of, for example, local government administration and finance, which now reflect the new nature of leisure, the sharp revision of values accorded to ethnic and women's culture, and the changing nature of social class. All these aspects of our daily working lives in museums reflect the impact of new ideas, and it is necessary for us all to come to grips with their nature and flavour if we are to grapple successfully with their implications.

As a result, there is emerging a body of published work which reflects current preoccupations, and which is helping to bring

about a climate of discussion, disagreement (often sharp), and debate at conferences, museum gatherings and informal meetings, and which stimulates creative experiments in museum operation. Most of this work is very recent. We may pick out the volume of papers edited by Lumley, *The Museum Time Machine* (1988); the symposium *Making Exhibitions of Ourselves* held at the British Museum in 1986; the conference *Museum Studies in Material Culture* held at Leicester University in 1987 and its published volume (Pearce, 1989); the volumes of papers produced by the ICOM Committee International Committee for Museology (ICOFOM), and the volume *The New Museology* edited by Peter Virgo (1989). All this writing is characterized by a desire to grasp the critical issues at a conceptual level, and to work out their implications on the ground by relating them to museum practice.

Ongoing debates need regular publications which can express them. The museum scene in Britain has the *Museums Journal*, issued by the Museums Association, which now appears monthly and which serves admirably as a news and information magazine. It also has the *International Journal of Museum Management and Curatorship* which appears quarterly. This broad pattern of monthly and three-monthly periodicals is repeated throughout the museum world, in Europe, North America and beyond. It is generally not a form suited to the publication of papers long enough to explore and develop a point of view, or substantial enough to express the content of a specific piece of research or body of work.

New Research in Museum Studies is designed to fill this gap. It will publish solidly based papers written according to normal academic conventions, and, in broad terms, is intended to give museum studies the kind of periodical which is taken for granted in discipline-related fields like history and archaeology. *New Research in Museum Studies* is designed as a series, with one volume appearing yearly. Each volume will carry a range of papers on a particular topic, which will also give a title to the volume, together with other contributions. It is intended to complement existing journals, volumes of papers, and book series like *Leicester Museum Studies* being published by Leicester University Press. It is also intended to bridge the divide between traditionalists and modernists, and to stimulate controversy, but

3

always to engage significant issues in present museum thinking and practical operation.

In the light of this broad background to the current state of museum studies, it was thought appropriate to devote the first volume of *New Research in Museum Studies* to an examination of the problems surrounding the nature of knowledge and meaning in museum objects, and the ways in which these qualities can be created. These issues are of fundamental importance to every museum worker, because they underlie the classification of every specimen, the writing of every label and the framing of every gallery talk. The topic has been interpreted deliberately very broadly, and so the papers gathered here approach it from a wide range of angles, each of which has its own particular contribution to make. Goodwin takes an historical perspective and, in analysing the origins and early history of the Victoria and Albert Museum, demonstrates how museum objects and collections contributed to the development of Victorian certainties about the moral values of objects and how this influenced the workings of government in relation to museums and the arts. The papers by Taborsky, Shelton, Lawrence and Pearce, from their different approaches, consider questions like the ways in which objects generate interpretation, the nature of the conventions which govern the museum exposition of objects on display, the impact of some particular post-modernist thinkers on collections and display and the ways in which historical objects transmit significance. The contributions of van Mensch, Ames and Maton-Howarth speak from the same broad standpoints, but address a range of particular museum interpretative projects: conservation, the relationship of 'first nations' to their cultural material which museums hold, and an interactive learning system.

The issues which these papers draw out can only be ignored at the price of dishonesty. Equally, paralysis in the face of conceptual and operational difficulties will not serve either our museums or our public, and we must search for ways in which to act. This is a central paradox of our times, and we hope that, in the segment of contemporary endeavour which museums occupy, *New Research in Museum Studies* will take its place in a fruitful debate.

Bibliography

Lumley, R. (ed.), *The Museum Time Machine* (Commedia Press: London, 1988).

Pearce, S. M., *Museum Studies in Material Culture* (Leicester University Press: Leicester, 1989).

Virgo, P., *The New Museology* (Reaktion Books: London, 1989).

PART ONE

1

Objects, belief and power in mid-Victorian England – the origins of the Victoria and Albert Museum

MARK GOODWIN

Introduction

In an essay entitled 'USA Museums in Context', Jane R. Glaser makes some assertions as to present-day thinking about education and the role of museums in the United States: 'Today most museums in the US endeavour to narrate a coherent story through their collections, to stimulate the visitor toward exploration, discovery, wonder, and learning to "see" by experiences; and to provide other enrichment and educational activities' (1986: 20). It is just these kinds of sentiments that were held by some of the nineteenth-century administrators and curators at the South Kensington Museum (Victoria and Albert Museum); particularly Sir Henry Cole who played a major part in the formation of the Museum.

The struggle to 'narrate a coherent story' can be seen to have been centred upon the objects that were held by the Museum and those collected for it, and the implicit cultural assumptions associated with them. Objects were, at first, collected, catalogued and displayed to reflect contemporary manufacturing concern over the appeal of an object allied to its function: they were displayed as materials intended to offer didactic instruction rather than to show the stylistic and aesthetic parameters that some Victorian curators, like Sir John Charles Robinson, favoured. Gradually, however, this was to change as the South Kensington Museum developed, and the principles of historic design enshrined in Owen Jones' *Grammar of Ornament* were to give way to aesthetic considerations and to the worship of a canon of excellence with high art orientations.

This drift towards 'high art' or 'fine art' came to have an outward

manifestation in the names given to the Museum and the administrative arrangements made for it. Very briefly, when the Museum was first established at Marlborough House in 1852, it was named as the Museum of Manufactures and administered by the Department of Practical Art under the jurisdiction of the Board of Trade. In 1853, the Museum was renamed the Museum of Ornamental Art. In the same year science/scientific education was added to the responsibilities of the Department of Practical Art, which already administered the Schools of Design. The department was subsequently renamed the Department of Science and Art. In 1856, overall responsibility for the Department of Science and Art was transferred to the Privy Council's Committee for Education by an Order in Council of February 1856. This finally came into effect in 1857 when the Museum moved to its permanent site at South Kensington. It then became known as the South Kensington Museum. By this time the Museum was aspiring to become a fine art museum of international renown, along the European model. Greater emphasis was placed upon collecting artefacts of European culture and British art; even contemporary art or manufactured design took second place as far as the interests of the Museum were concerned.

Recently, there has been an attempt to harmonize the differences of approach to the Museum's collections, heralded by the Museum's change of name to the National Museum of Art and Design. The problem of reconciling the various approaches to interpretation has been neatly expressed by Charles Saumarez Smith in an article for the *V&A Album* entitled 'The Philosophy of museum display — the continuing debate':

What is the most important consistent property in determining the form of an object? Is it the intrinsic physical properties of the object, the material from which it is made, the way the body is manipulated and structured according to inherent skills of craftsmanship and technique? Or is it rather the extrinsic circumstances of the surrounding culture, the demands of the client and the ruling aesthetic of a particular period? (1986: 37).

It is this dichotomy which infected the political, cultural and ideological debates surrounding the formation of the Museum

and the acquisition of its collections. These debates encompassed, at one level, the social and historical factors that contributed to the formation of the Museum at South Kensington and, at another level, the relationship between the artists and artisans, the objects the Museum retained, the audience/visitors to the Museum, the other institutions that affected its development, and the role and function of the arts administrators, particularly Sir Henry Cole, in the bureaucratic structure arranged by Government to manage this example of nineteenth-century arts subvention. To these considerations may be added, as Wolff has argued, 'the study of aesthetic conventions' since it both informed and promoted decisions taken regarding the administration of the Museum. Embedded in such considerations were economic criteria which also affected the thinking of those involved in setting up the Museum (Wolff, 1987: 139).

This paper sets out to outline some of these variables, and to demonstrate how they affected both the fortunes of the South Kensington Museum in its early stages of development and the values attached to the Museum's collections, which determined, to a large extent, its ability to 'narrate a coherent story'. Since the Museum's origins are so firmly tied to the career and inspirational leadership of Sir Henry Cole, part of his career will be examined in conjunction with an outline of the Museum's early history.

The discussion of all these variables has largely been confined to the political arena and to political culture. Harrison provides a useful definition of what is meant by political culture:

The notion of political culture is used in political analysis as a shorthand term for the emotional and attitudinal environment within which the government operates. Broadly speaking, any attitudes which may be partial determinants of governmental style and substance are part of political culture, but there are levels of increasing relevance. Political traditions, the accepted version of society's history, common values, social structure and norms, and commonly recognised symbols, are all factors which may be linked with predispositions in a society towards various kinds of political beliefs. They may affect, for example, the citizen's perception of his political role (including the proper, desired, and the efficacious limits of participation), his acceptance of the roles of others, especially constitutional roles,

concepts of political obligation, and the proper limits of governmental action (1980:16).

The Museum's early history and Sir Henry Cole

It is within this framework that Sir Henry Cole, along with Prince Albert, had to operate as they strove to establish the Museum, secure its funding and establish its cultural value.

The significance of Henry Cole's contribution to the formation of the Victoria and Albert Museum has been much obscured, due in part to contemporary envy at his close working relationship with Prince Albert, to his energetic response to problems, and to the persistence of his ambition, which was to make him many enemies (see pl. 1, p. 13). His reputation has also suffered from the compartmentalization of intellectual pursuit which saw the ascendancy of the professional specialist, scholar, scientist and aesthete. According to T. W. Heyck, this began to occur towards the end of the Victorian era. This certainly seems to account for the muffled and ambivalent praise to be found in Sir Henry Trueman Wood's letter to *The Times* of 28 June 1909, two days after the opening of the Victoria and Albert Museum by Edward VII. In it he asserts that Cole:

did more than any other man to bring about the modern change in sentiment in the appreciation of industrial art, and this though he had no aesthetic judgement and no artistic power. Within his limits he was a great man, and his work deserves, especially at this moment, at least the tribute of recognition (Physick, 1982: 249).

One is prompted to speculate how Cole managed to achieve so much without some aesthetic judgement, even if this judgement were borrowed from some other source.

Cole was a superb administrator, a man who could apply his mind to a wide variety of interests: a utilitarian man of letters. In a set of family photographs at the Victoria and Albert Museum, there is one photograph which portrays Cole studiously perusing a book. This image of him serves to evoke a sense of

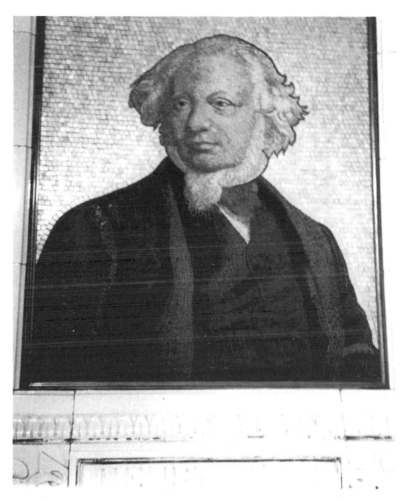

Plate 1. Detail of Memorial to Sir Henry Cole, designed by
F W Moody. Mosaic portrait executed by Florence Cole. Completed in
1877. To be found on the West (Ceramic) Staircase, Victoria and
Albert Museum.

erudition and breadth of learning. Another image of Henry Cole is provided by the touching vignette Elizabeth Bonython gives of this most energetic of men:

Cole was a smiling man, short athletic and bespectacled. It is a great pity that portraits and photographs usually show him looking serious. His spectacles were always omitted, which could be owing to his own vanity. He was one of those people who always looked crumpled however carefully they dress themselves; he invariably had a coloured handkerchief dangling from his coat tail pocket. By the time he was forty-five his hair had gone white, and he wore it and his whiskers unfashionably long, so the effect was of a quick-striding man, clothes and mane flying. A little dog was his constant companion, yapping and scampering along the museum galleries, its toes clicking on the mosaic floors (1982: 2).

Cole was born on 15 July 1808 to Laetitia Dormer and Captain Henry Cole of the First Dragoon Guards. At the age of eleven, Cole was sent to Christ's Hospital in the City of London. Here he gained a thorough grounding in mathematics, Latin and Greek. He won a silver medal for writing and with this distinction he was able to enter the Record Commission in 1823, under the supervision of the Sub-Commissioner, Sir Francis Palgrave. With his neat and precise handwriting and his cursory knowledge of Latin, which was probably greater than he admitted to, he set to work on the editing and transcribing of the large collection of parliamentary writs that the commission held. By a process of osmosis, Cole came to have a useful knowledge of parliamentary procedure and practice.

During this time, Cole's interest in painting and the arts began to flourish. David Cox gave him lessons in watercolour painting and he exhibited sketches at the Royal Academy. The Victorian preoccupation with medieval art infected him too. His friendship with Francis Douce, an antiquary and, at one time, Keeper of Manuscripts at the British Museum with the responsibility of cataloguing the Landsdown and Harleian manuscripts, did much to stimulate his curiosity. It was through these kinds of activities that Cole began to build up a useful number of contacts within the Victorian intellectual and art worlds which were to prove invaluable in his later work. He was fortunate also

in that the house he was living in belonged to Thomas Love Peacock, satirist of the Romantic Movement. Peacock lived in two of the rooms of the house and the others were used by the Cole family. Peacock and Cole soon became friends, each collaborating in the other's endeavours, according to the *Dictionary of National Biography*. Cole drew for him, helped in writing critiques of musical performances and was introduced by him to J. S. Mill, Charles Buller, and George Grote (*DNB*, iv: 724–6). Charles Buller, MP for a rotten borough in Cornwall, along with William Molesworth, MP and Baronet, were to prove invaluable parliamentary contacts in Cole's later adventures. His friendship with J. S. Mill, and the principles of utilitarianism he absorbed at this time at meetings at George Grote's house, were to influence his thinking for the rest of his life.

After nine years at the Record Commission, Cole was promoted to Secretary of the Commission under Charles Purton Cooper. It was at this point that Cole first experienced internal governmental wranglings and disputes which were to affect him personally. Essentially, the row centred on the gross mismanagement of the Record Commission's collections. Spurred on by Purton Cooper's decision to demote him, Cole was galvanized into one of his bouts of reforming zeal. In 1836 a select committee was set up, prompted by the request of Charles Buller, which looked into the mismanagement that Cole had exposed. Throughout its deliberations, Cole covertly intervened to the extent that many of his recommendations were adopted. Pressure for change was maintained by the publication of *The Guide* which, like the *Journal of Design* later on, served as a public manifestation of many of Cole's views and visions. In 1838, five years after his marriage to his first cousin Marian Bond, the commission was finally reconstituted and Cole, under the affectionate and paternal eye of Longdale was appointed as one of the four senior assistant keepers with responsibility for the records of the Exchequer of Pleas in the Carlton House Riding School.

Cole worked for the Record Commission until 1852, when he was transferred to the Board of Trade. He had, by this time, become deeply engaged with questions relating to industrial design – art applied to manufacture. His areas of activity had markedly increased and some of the work he had undertaken

introduced him to design and its associated problems. In 1838 he had worked with Rowland Hill on postal reform and had arranged for designs to be made for the first pre-paid postal envelope. This had introduced Cole to a number of artists such as William Mulready who made the designs for the envelope, Thomas Webster, H. J. Townsend, John Callcot Horsely and Richard Redgrave, who was to become one of Cole's closest working companions.

Under the pseudonym of Felix Summerly, Cole began to publish pamphlets and letters on various topics including guides to historic buildings, catalogues of picture galleries and childrens' books. As Felix Summerly, Cole produced *Text Books for Workmen*. These treatises attempted to make a connection between the work of the artist and artisan, and as such built upon ideas that had been expressed in the 1835–6 Select Committee Report on Arts and Manufacture. Henry Cole described his books as 'Being short Treatises on the amount of Elementary Knowledge of Art, which every Workman who has to produce Art-Manufactures ought to possess'.

From the 1840s onwards, Cole took up the cause of improving artistic standards in industrial production with vigour and enthusiasm, using, as a forum to propound his ideas, the Royal Society of Arts and Manufacture. His activities were to contribute to the growing acceptance of government involvement in the funding of such an endeavour. Three events proved to be particularly important for the future of the Museum: the setting up of Cole's Felix Summerly Manufactures; the Great Exhibition of 1851; and the reform of the Schools of Design by Cole in the same year. These events provided the necessary 'attitudinal change' required for Government involvement, and precedents which augured the establishment of the Museum. They contributed also to the development of administrative structures which would carry that burden of Government involvement with the museum deemed acceptable to politicians and government officials alike.

Henry Cole's ability to harness the activities of a number of manufacturers like Herbert Minton to make for him 'objects of everyday use' and the success and popularity of these objects, had the effect of making matters of design a national issue. To ensure maximum publicity, Cole made sure that in the contracts

he had with various manufacturers, they paid for the cost of designing the items while he paid for the catalogues and newspaper advertisements. More particularly, when this was linked to the activities of the Royal Society of Arts and Manufacture, which, through Cole's suggestion together with John Scott Russell, put on exhibitions of art manufacture that included many of the items which his firm produced, Cole had in effect, heightened the Society's role as a lobbying organization. When Prince Albert became the Society's President in 1843, this bestowed the authority of the Crown upon the activities of the society: the co-operation of the Crown in the personage of Prince Albert also had the effect of both legitimizing and reinforcing the appropriateness of public sector funding. By 1850 Cole had become the Society's Chairman, and it could be considered that by this time the Society had taken up the role of a visual arts quasi-autonomous non-governmental organization (quango). Although there was no direct link between the activities of the Society and the Schools of Design, set up after the 1835–6 Select Committee Report on Arts and Manufacture to promote and foster art manufacture and industrial design – when Cole first suggested that the Society should run a competition to find good designs of everyday objects and promptly won it with his own design for a tea set in 1846 – the activities of the two organizations can be seen to have merged at certain points. The regular exhibitions that were begun by the society in 1846 resembled temporary museum exhibitions, and the principles that were being promulgated by the Society were similar to those that Dyce had tried to implement at the Schools of Design.

The ambitions of Cole and those within the Society grew ever larger and out of the series of exhibitions held by the Society germinated the idea of the Great Exhibition. The scale of the enterprise soon outstripped the resources of the Society, and it was taken over by the public sector in a way which meant that it kept its quango format:

While the initial impetus for the Great Exhibition came through the Society of Arts, it was felt desirable, given the scale of the venture, to ask the Government to appoint a Royal Commission to organise and manage the Exhibition. This was duly established

in 1850, first via a Commission of Management established by Royal Warrant on 3 January, this being subsequently incorporated by Royal Charter on 15 August, 1850. The group directly responsible for organising the exhibition was a small committee of five headed by Prince Albert, and included Henry Cole (Pearson, 1982: 3).

In effect, the way in which the Society of Arts operated had been incorporated and legitimized by government through the award of a Royal Charter, although the government was not involved in its activities, leaving its authority at one remove in the authority of the Crown save over where the Exhibition was to be sited:

Parliament was involved in the exhibition at the level of the debates over whether or not the exhibition should be sited in Hyde Park: this, in a sense negative, power was important. But once the Hyde Park site had been granted that was the end of direct Parliamentary involvement. The Exhibition was of the State, but not of Parliament or Government (Pearson, 1982: 32).

However, because the Royal Charter had been passed, it is to be presumed that this was part of Government policy. The distinction between Parliament and Government merges. What is important is that the quango model had a new legitimacy. It was used by Cole to resolve the crisis in the Schools of Design and, because it was so successful in administering the Exhibition, was accepted.

Two further developments which occurred as a result of the Great Exhibition's success had a tremendous impact on the Museum's destiny. First, the Commission was retained to administer a £5,000 grant made to enable the Museum at Marlborough House to acquire items from the Exhibition. This firmly established the Museum as a museum of arts and manufacture and fulfilled one of Cole's ambitions. Secondly, the Commission was given the responsibility to dispose of the surplus funds of £186,000 derived from the Exhibition:

It was decided that the Royal Commission that had been established to supervise the preparation and administration of the Exhibition should remain in being to dispose of the surplus money. Queen Victoria confirmed a Supplemental Charter on

2 December 1851; the money, invested for educational purposes, is still in use; and the Royal Commission for the Exhibition of 1851 remains an active organization today (Physick, 1982: 19).

It was these funds which were used to establish the Museum's permanent site at South Kensington. Another effect of the Great Exhibition's success was that it served to encourage confidence in public participation in the funding of institutions such as the Art schools and the Museum. Public opinion had endorsed the event and the issue of arts manufacture had assumed national importance. Despite these developments however, it was the crisis of management at the Schools of Design which allowed Henry Cole to interpose a plan for a publicly funded museum within the re-organization of structure for the administration of the Design Schools, whose headquarters was the school at Somerset House. The collection of casts and decorative motifs at Somerset House, which students had to copy to attain the desired facility when it came to applying art to manufacture, had always opened up the possibility of having a museum.

In 1848, the officials at the Board of Trade, under whose jurisdiction the Schools of Design came, had been struggling to find a form of administration that would resolve the crisis of confidence and administrative confusion that had once more arisen. The organizational structure of the Schools of Design had been too weak to contain the ideological splits that had plagued their history. In his opening chapter on the Schools of Design, Bell catalogues the disasters:

The Schools of Design were the first State supported art schools in England; their history is one of scandal, confusion and disaster; they were distracted by feuds, encumbered by debts and convulsed by mutinies. This unhappy state of affairs was in part due to the circumstances of the age, to the condition of the bureaucratic machine and our economy in the second quarter of the last century (Bell, 1963: 1).

Government officials like Shaw Lefevre were now determined to provide the Schools with sound administrative machinery. In pursuance of this objective, Shaw Lefevre had already discussed

their problems with Henry Cole on a Chelsea Steamer in 1847 before formally inviting him to submit plans for their reform in 1848. Bell notes this change in policy objective:

During the years 1849, 1850, and 1851 the debate concerning the schools ceased to be argued on a question of principle, but dealt rather with the personalities and administration. The Board of Trade, still pursuing its difficult course of trial and error, abolished the Committee of Management in November 1849 and a new committee, consisting only of 'laymen': Labouchere, Granville, Northcote, Porter and Booth, undertook the business, Redgrave, Poynter and Deverell usually being in attendance at its meetings (1963: 243).

The invitation for Cole to submit plans for the reform of the Schools presented him with an opportunity to introduce his own form of administrative quango within the structure of the Schools, akin to that of the tightly knit organization that had planned the Great Exhibition:

The remedy was to be found in a small but well paid executive: one Department Head, a Deputy who would deal with finance, establishment, administration and industrial relations, a Secretary, an Accountant, a Curator and Masters who would have charge of specific branches of manufacture (Bell, 1963: 233).

In his evidence to the 1849 Select Committee which was set up to examine his proposals for reform, Cole had drawn a direct comparison between the administrative problems of the Schools with those that had beset the old Public Record Office. Both had had similar administrative structures:

He began by saying that the Schools of Design were very similar in their administrative structure to the Old Record Office, an office which he himself had reformed so well that now there was no department in which responsibility was more tight, in which there was more work done or a better account given to the public (Bell, 1963: 108).

Now, according to Cole's plans, the clumsy structure, whereby the leadership of the School and its administration was headed

by the academics and teachers that taught at the School of Design, was to be removed. Removed also were the Committees of Management, with their unclear lines of authority, where the appeals of the masters could interrupt the smooth running of the Schools when embroiled in ideological disputes about design.

The administrative structure envisaged by Cole was very much the structure of administration set up to run the Museum. Administrative and curatorial functions were clearly defined, with Cole being the final arbiter in the decision-making process. This administrative structure was to be operated by a different department within the Board of Trade, and yet its operations were quite separate from it; for instance, Cole could appeal to Prince Albert, if this were required, in the furtherance of his ambitions.

However, Cole had to fight for this reform, not on the ground of administrative excellence but on an ideological one about the nature of art manufacture. As Bell shows, Stafford Northcote, a legal assistant at the Board of Trade, brought forth the same objection that his predecessor, J. Henley, had complained about, that Cole cared more for the aesthetics of design than the construction of ornament:

A doctrine appears to have been broached by one of the students of the School, which has formed the text, we believe, of some lucubrations in a periodical called the *Journal of Design*, that the School ought to be the best market for the manufacturer 'in want of designs' or the students to furnish designs for all the furniture of the Government Offices and Royal Palaces, and setting them up for sale to manufacturers, appears from some documents printed in the appendix of the Report, to have been some time ago submitted to the Board of Trade by Mr. Henry Cole, better known perhaps to some of our readers under his assumed name of Felix Summerly. But though Mr. Cole was examined at some length before the Committee, we do not find that he gave any explanation of his plans – of which he has probably, on further consideration seen the inexpediency. ... It strikes us that a private designer might fairly complain if the Government were to apply the public funds for the establishment of a mere mart for designs (Bell, 1963: 241).

This accusation struck a devastating blow to Cole's case for reform; however, he fought back with tenacity over the next three years, threatening at one point to set up a rival set of Schools to those that already existed with the support of the Society of Arts. This would have proved a crushing blow to the Schools of Design. They would have been unable to compete with the newly proposed Schools, especially as Cole had the backing of Prince Albert. Opposition to Cole's ideas subsequently ceased.

The plans for the Museum at Marlborough House had formed part of Cole's plans for the new Schools; now they were incorporated into the existing structure of the School of Design at Somerset House:

Already, before the end of 1851, Cole was engaged on the business of the school. He and Redgrave were asked to select exhibits from the Crystal Palace for use at Somerset House and on January 5th, he saw the Prince Consort and discussed a plan to buy ground at South Kensington and there to make a Museum of Manufactures and a reformed School of Design to be called a College of Applied Art (Bell, 1963: 248).

In 1852, Cole wrote a detailed letter to Henry Labouchere, President of the Board of Trade, outlining the arrangements he thought suitable for the Schools of Design. They follow on from the experiences gained from his Felix Summerly enterprises and work for the Society of Arts and the Commission for the Great Exhibition:

In respect of the best way of reorganising the management, my opinion is that a Department of the Board of Trade should be created, analogous to the Naval and Railway Departments, having a special secretary, through whom all business should pass for the decision of the President or Vice President. I submit, that, on the whole, this arrangement would best ensure individual responsibility and attention, and would work better than any special board consisting of several persons. If such a change were made. I would venture to suggest that the name of the 'School of Design', which is subject to misinterpretation, should be altered to one more nearly expressive of the objects in view. Such a name as the 'Department of Practical Art' would, I think,

be well understood and appropriate. This would embrace the three distinct divisions of work which has to be performed, and each of which appears to require more or less of a separate direction: (a) Elementary Instruction in Drawing and Modelling – a branch which is likely to extend very much (b) Practice of Art connected with processes – a branch which is a great desideratum (c) Cultivation of the power of designing – a branch that requires to be made precise and systemized (Cole, 1884: 295–6).

The scale of public investment for Cole's plans to be put into operation was going to be large. Yet, in order to circumvent the problems incurred in involving the Government in the funding and administration of such a project, and to calm the nerves of the officials being drawn into cultural matters, Cole set up a hybrid form of government, again rather like a present-day quango: the Department of Practical Art it was different in being firmly linked to a government department, the Board of Trade.

The evolution of State arts patronage: philosophical and religious climate

The Government kept a close financial scrutiny, in theory at least, of the monies that went to the Museum at Marlborough House and the Schools of Design under the aegis of the Department of Practical Art. Cole had to work within the system of Government, so in effect there was still direct Government scrutiny and accountability of public funds. The accountant of the Board of Trade was empowered to watch over the accounts of the Department of Practical Art set up to administer the Art Schools and Museum; any surplus funds being re-routed to the Exchequer. There was, therefore, at least some provision for internal accountability in the system of administration, which had been lacking in the administrative arrangements of the Art Schools and its centre of administration at Somerset House. The arrangements also ensured that in his capacity as secretary, Cole was able to control what went on within the department. Labouchere agreed with most of these proposed arrangements. Already in these plans one can detect the autonomy that Cole

was to enjoy. However, Labouchere insisted that there should be an artist in charge in the Department at the same level as the Secretary to even out the responsibility. Cole disliked the idea but was persuaded to accept; the person appointed to the post was Redgrave – an old ally.

Although not as sophisticated as today's quangos, this Government department with its partial guarantee of autonomy, can be seen to be a forerunner of those that were set up after 1945. Under these administrative arrangements the Museum began to blossom. When difficulties arose between the Commission in charge of planning the future site of the Museum at South Kensington and Lord Derby's Government, the Department of Practical Art was found to be such a useful tool of government and administration that the duties and responsibilities of the commission were assigned to it. This happened after the Commission and Prince Albert broke with the Government and raised a mortgage for the South Kensington site, repaying their half-share in the land to the Government. Thus, in effect, the Government retained the money of the Commission and the accrued interest. In turn the Government provided £10,000 for the move to South Kensington: it was now fully involved in subvention of the visual arts and of museums.

Yet, in terms of extending Government involvement in funding ventures of this kind, especially as regards the Museum, Cole was to remain judiciously modest. In the First Report of the Department of Practical Art the now centrally funded Museum was to serve as a model for the establishment of other such institutions:

It is hoped that this Museum may be made the means of originating and fostering similar institutions throughout the country. The Board of Trade has sanctioned arrangements by which local schools of art may not only borrow articles from the Museum, in each year, during the period betwen the 15 July and 15 September, for exhibition in their own localities, but may also have the opportunity of purchasing any duplicates, or superfluous quantities, at half the original cost of them to the Department. By this means, the whole country is made to participate in the advantages and prosperity of the central Museum, and its benefits are not limited to residents in the metropolis (Cole, 1884: 286).

Henry Cole took charge of the move of the Museum to its permanent site at South Kensington and continued working for it until 1873 when he officially retired. Even after this, Cole maintained a watchful eye on events at the Museum until his death in 1882. However, as the years progressed, Cole's time at the Museum became increasingly embittered as the cultural status of the objects collected for the Museum were fought over between administrators like Cole and curators like Sir John Charles Robinson, the Museum's first keeper, who was responsible for its collection of Italian Renaissance sculpture. It was J. C. Robinson who was to place a greater emphasis upon an aesthetic, stylistic approach to object appreciation. Their disagreements reflect, in part, the complexity of the system of arts patronage that developed in Britain in the nineteenth century, and are linked with the ways in which the cultural values assigned to the museum's collections were subject to the continual flux of redefinition. Donald Horne gives a sweeping summation of the values the Victorians placed on such developments, with particular reference to the development of the South Kensington Museums and buildings like the Royal Albert Hall:

These South Kensington buildings represent the voice of nineteenth-century capitalism at its most enlightened, buoyant with optimism and reason and belief in improvement. Education, science, art and technology would bring light. Free enterprise would bring abundance to the world and this abundance facilitate eternal progress (Horne, 1984: 121–2).

The evolution of arts patronage to a system of State subvention embodying these values, which eventually led to the funding by Government of the South Kensington Museum, can be seen to have been effected on three different levels. Firstly, there are the practical developments that made the arrangement and classification of objects a practical proposition through contributions like those made by Linnaeus and Thomson in developing a classification system, which in turn helped to encourage the growth of learned societies. Secondly, there are those which herald 'attitudinal' changes as defined by Harrison in his notion of political culture. Thirdly, there are the complex

constitutional changes that took place between the Crown, Government, institutions, and the roles of individual administrators some of which have been discussed here. These developments were wrapped around an emerging nineteenth-century consciousness which incorporated an awareness of national identity, as Alexander (1974) suggests, and the realization of the need to preserve objects of the past to create a common heritage and cultural tradition. In order to do this, suitable places had to be built. Also, an awareness of the contributions that foreign cultures could make towards the cultural enrichment of Britain was fostered and encouraged and, at the same time, existing cultural traditions were inspected, analysed and revalued. For instance, in terms of artistic tradition, the values associated with the academy system and embodied in the institution of the Royal Academy were re-examined.

T. S. Eliot noted the ramifications of what such an exploration entails, invoking the historical sense which goes to make up tradition:

Yet if the only form of tradition, of handing down, consisted in following the ways of the immediate generation before us in a blind or timid adherence to its successes, 'tradition' should positively be discouraged. Tradition is a matter of much wider significance. . . . It involves, in the first place, the historical sense . . . and the historical sense involves a ¡erception, not only of the pastness of the past, but of its presence (1976: 49).

This process of reflection spread outwards from the art itself to social revaluation, a process in which Cole became deeply involved, taking up a position similar to that of Pugin. As Williams readily acknowledges: 'The most important element in social thinking which developed from the work of Pugin was the use of art of a period to judge the quality of the society that was producing it' (1985: 138).

In association with these developments was the widespread acceptance of the philosophy of utilitarianism, from which was distilled an objective that was held to be of fundamental importance: self-improvement in both economic and educative terms. This objective was to be met, also, at a level above that of the individual, in the private organizations, companies and

public institutions of Victorian society. Thus, the developing institutions and private societies that gave shape to the patronage system were given powerful intellectual justification. Mill, however, saw how the dynamics of this philosophy and its acceptance within the society at large posed a threat to individual freedom:

A philosophy like Bentham's . . . can teach the means of organizing and regulating the merely business part of the social arrangements. . . . It will do nothing (except sometimes as an instrument in the hands of a higher doctrine) for the spiritual interests of society (Williams, 1985: 72).

Cole, endeavoured to make a link between his ambitions for the Design Schools and the Museum with the concept of a 'higher doctrine' that Mill had talked about. This involved his ideas about fine art and design, but over-arching these ideas was the spirit of religious evangelical revival. The Museum, especially, was to be seen as a place where uplifting spiritual experiences could be had, as well as, for instance, a place where examples of what Cole thought was good design could be shown. As a consequence, some of the needs of the individual and the society could be met in the struggle for material improvement.

Cole's endeavour neatly dovetailed into those aims of the Christian Socialist Movement, imbued with the ameliorating principles of liberal philosophy. Thompson gives a brief and useful account of this movement:

It was liberal in tendency and led by F. D. Maurice (1805–72) and Charles Kingsley. They began, in 1854, their series of 'Tracts for Priests and People', concerned with current social problems: and thus religious fervour was again directed towards social and material improvement (1985: 109).

Clearly then, Cole was well able to justify his ambitions for the Design Schools and the Museum, not just in terms of the perilous state of industrial design, but on the wider assertions that the spiritual well being and material health of humanity in general were implicated in his endeavours.

Curiously, although a reaction to utilitarianism, and in opposition to the evangelical movement, the claims of Newman and the Oxford Movement can be seen to be reaffirming the ideals of men like Cole:

There is a physical beauty and a moral: there is a beauty of person, there is the beauty of our moral being, which is natural virtue; and in like manner there is a beauty, there is a perfection, of the intellect. There is an ideal perfection in these various subject-matters, towards which individual instances are seen to rise, and which are the standards for all instances whatever (Newman, 1852: 197–8).

This, as Williams (1985: 121) suggests, was targeted towards the improvement and perfection of humanity itself and, as such, coincides with Cole's ideals. Indeed towards the end of his life, Cole met frequently with Cardinal Newman to discuss and exchange ideas.

The plethora of intellectual ideas and the religious impulses that informed Henry Cole's thinking are clearly visible when he talks about the museum soon after its installation at its South Kensington site in 1857:

The working man comes to this museum from his one or two dimly lighted, cheerless dwelling rooms, in his fustian jacket, with his shirt collars a little trimmed up, accompanied by his threes and fours, and fives of little fustian jackets, a wife in her best bonnet, and a baby, of course, under her shawl. The looks of surprise and pleasure on the whole party when they first observe the brilliant lighting inside the museum show what a new, acceptable, and wholesome excitement this evening affords them all. Perhaps the evening opening of public museums may furnish a powerful antidote to the gin palace (Cole, 1884: 293).

This description is infused with religious overtones; it is as if the humble visitor has entered into the splendours of a cathedral. It appeals to notions of self-improvement with its reference to 'wholesome excitement' and is linked firmly to the fortunes of the family with its references to the generations of 'little fustian jackets' who accompany their parents to the Museum, which

Cole saw as a place of learning and inspiration, both material and spiritual. The fortunes of the family were becoming an increasingly important factor in Victorian thinking, as it led, by extrapolation, to the fortunes of the nation. Future generations would therefore benefit from the spiritual encounter with the 'brilliant lighting' of the Museum and so contribute to the health of the nation.

Later, Cole was more explicit than this. By 1873, he was quite willing to exploit the religious analogy in a speech of encouragement and affirmation to students at the Nottingham School of Art:

I am afraid that there are more devil's chapels than God's chapels. One way, I believe, in meeting the devil in this encounter is by a Museum of Science and Art, and I shall be much surprised if the clergy do not think so. I am looking forward to the time when, as well as having a Hospital Sunday in Nottingham, you will have a Museum Sunday. This will be defeating Satan by an indirect process. Religion will co-operate with Fine Art I am sure (Cole, 1884: 345).

As an aside, it is significant to note that design is not included in this formula to rid the land of the devil: it is replaced by the notion of fine art. This neatly reflects the shifts that had occurred in the Museum's preoccupation with the design of an object and its function, to that of fine art and connoisseurship.

In the latter part of the speech to the students at Nottingham, Cole extended the religious analogy even further:

Every centre of 10,000 people will have its museum, as England had its churches far and wide in the 13th Century. The churches in the 13th Century were receptacles of all kinds of work. Every church had its paintings, sculpture, metal decoration, architecture, music, and was in fact a museum (Cole, 1884: 345).

These appeals to the *geist* of the nation were backed by Cole's belief in the material benefits that could be derived from the activities with which he had been engaged. It is reflected, for example, in his activities for the Art Summerly Manufactures and his contributions to the 1851 Exhibition. In 1857 he made a statement which firmly linked art to material progress, and this

is also seen as a justification of public expenditure on the Schools of Design and the museum:

To offer to everyone in this Kingdom the elementary knowledge whereby his labour may have the best chances of fruitful and profitable development, appears to be the aim, in its broadest sense, of all public expenditure on behalf of Science and Art (Cole, 1884: 289).

Cole's views as to the value of education could afford to be aired with more robustness and openness than his faith in public sector finance and planning. He swept aside the doubts that were held against learning, associated, as it may have been, with movements like Chartism. He would, no doubt, have approved of the activities of people like Hannah Moore: 'No doubt a little learning is surrounded with dangers, and so is a little food, or a little courage or a little of any other virtue, but we must all admit a little is better than none' (Cole, 1853). Nor was Cole in any doubt about the lessons that could be learnt from the appreciation of art and good design. In the context of what was considered to be good or bad taste, for example, conclusions could be made that need not necessarily be assigned to subjective choice. In his refutation of proverbs like 'everyone to his own taste' and in his belief that a person can be usefully engaged in the cultivation of taste by, for instance, being made sensible of the symmetry of form, Cole would have found his modern counterpart in a critic like Peter Fuller. Not only is there an interesting coalescence of view as regards the role of religious belief in artistic endeavour, but there is a coalescence of ideas in what the concept of taste is about. Fuller has drawn out the common misconceptions and problems to do with the concept of taste within the context of design:

Design likes to present itself as clean-cut and efficient. Taste, however is always awkward and elusive; it springs out of the vagaries of sensous response and seems to lose itself in nebulous vapours of value. Questions of taste have thus tended to be regarded by designers as no more than messy intrusions into the rational resolution of 'design problems', alternatively, others have attempted to eradicate the issue altogether by reducing 'good taste' to the efficient functioning of mechanisms (Fuller, 1985: 24).

Fuller disagrees with those who would attempt to excise the problems of taste from design, and using the example of the Taste Exhibition held at the Boiler House, Victoria and Albert Museum, as a purchase for his argument, concludes that: 'Judgements about sense experience imply an underlying concensus of qualitive assumptions' (1985: 45). This is a conclusion with which Cole would, no doubt, have agreed. In 1853 he had noted: 'that we are always ready to recognise principles of good and bad taste to some extent . . . what lady present is prepared to trust to the taste of her cook to make the purchase of a new spring muslin dress for her?' (Cole, 1853). He goes on to give further instances of the exercise of taste as when, for example, the flavours of Souchong tea are compared with those of Pekoe tea. In another example, Cole discusses the different prospects that Kensington Square or Ladbroke Terrace present to the onlooker or inhabitant compared with Jennings Buildings in Gore Lane with its 'pungent gasses from smoke and tobacco smoke and formented liquors and animal exhalations generally' (1853). We would all, he opines, prefer to live in Kensington Square than the unappealing buildings in Gore Lane that he describes, and avoid the risk of typhoid fever also. This is, he asserts, an exercise in taste. It is an exercise that can be translated into the domain of design and industrial art. It can also be applied to the museum, in the choice of objects that the Museum displays and in the way in which these are displayed. As a consequence, the visitor is able to participate in the exercise of taste also.

To enable such participation by the visitor and to allow for a proper discussion to take place on what were the principles associated with good art and design, Cole was concerned that the labelling of exhibits throughout the Museum, both at Marlborough House and South Kensington, was clear of ambiguity, easy to read and accessible. He likened visiting the Museum to reading an informative book:

that everything will be seen and be made as intelligible as possible by descriptive labels. Other collections may attract the learned to explore them, but these will be arranged so clearly that they may woo the ignorant to examine them. This museum will be like a book with its pages always open, and not shut (Cole, 1884: 291–93).

To reinforce his message about design, travelling exhibitions were organized, and a catalogue was produced which gave 'details of the processes employed in the production of each object with some critical observations on its design' (Cole, 1884: 129). Soon after the establishment of the Museum at Marlborough House, Henry Cole set up a permanent exhibition at the Museum which was meant to demonstrate what was good design and what was bad. It was dubbed by critics as the 'Chamber of Horrors'. The display was set up on the first floor of Marlborough House and was entitled 'Examples of False Principles in Decoration'. This was contrasted with another display entitled 'Correct Principles in Decoration'. The items in the exhibition had been selected from the Great Exhibition by Cole, Redgrave and Owen Jones. However, it is interesting to note as Shirley Bury points out in her article for *Apollo Magazine* (1967) that none of the items produced for the Felix Summerly Manufactures found its way into the display of what constituted good design. Bury alludes to Cole's dismay and disappointment as to the quality of items produced. This was probably linked to the profound impression the Great Exhibition made on Cole and the collective aesthetic consciousness of his colleagues which is so readily apparent in the writings of Owen Jones in his reaction to the exhibition. Some of the labels to those objects which Cole disapproved were succinctly acerbic. This upset many of the manufacturers who were associated with the items so labelled who called for the exhibition to be closed. The earnestness of Cole's endeavour was also mocked by Dickens in an article called 'A House Full of Horrors' which appeared in a weekly periodical called *Household Words*. Eventually, the outcry against the exhibition forced its closure.

This episode clearly illustrates the sensitivity the issue of what made for good design held for the Victorians, and what a nodal point of expression the Museum was becoming. Indeed, the Museum developed quickly into a barometer of aesthetic opinion which succeeding Governments were wary of supporting: this was reflected in the increasing hesitancy of Government to fund the Museum's purchases. In fact the Government became so alarmed at the demands made upon governmental munificence by Cole and his colleagues during the early years of hectic acquisition, that Gladstone often intervened in the

purchasing adventures that were undertaken. He demanded that every object be properly priced and any money left over from a purchasing spree was to be given back to the Treasury. It became the norm, also, to hold public viewing days of items due to be acquired by the Museum to ascertain their popularity. This became a way of legitimizing the use of public funds in the acquisition of items.

The debate about the role of art and design

Behind these views of Cole's about the principles of good and bad design, and their transmission, stood a major nineteenth-century debate, involving both intellectual and institutional forms, which, if it had not directly challenged conventional thinking on fine art and design, at least provided a platform from which a challenge, like that of Benjamin Robert Haydon's, could be made. Much of the thinking had been dominated by the academy system imported from Europe and represented by the Royal Academy in Britain. The system was based on the view that the study of the human figure and its form as represented by classical sculpture was all important for the study of Man, and that it was the painter who had the most important role to play. As Bell puts it: 'The view that the proper study of the painter is Man assumed such capital importance in academic teaching and was to exert so powerful an influence at the time of the foundation of art schools in this country' (1963: 3). Academies provided a forum for such teaching. Also, through a process of selection and grading of its members an academy became a source of status and recognition as Bell explains:

Academies of Fine Art had two purposes. They were to give students a kind of teaching that could not easily be provided in the workshop; they were also intended to give artists a new and improved status, to make them the equal of poets and philosophers who had already formed academies in the late fifteenth century (1963: 10).

It is ironic that despite the fact that the monopoly of this system was going to be rapidly overtaken, the academy system, as

represented by the Royal Academy, in Britain, provided a template for the manoeuvres that took place in the establishment of the Art Schools and Museum. The Royal Academy inhabited the strategic middle ground between the Crown and Parliament:

the Royal Academy could take to itself some of the authority and legitimacy of being 'state' and 'official', without at the same time being seen as an instrument of Government. The Academy was in the classic position of a major modern day quango – of the state, while not being directly of Government. As it was, in essence, a quango the nineteenth-century Academy was always ambiguously related to Parliament and Government. It was an official body, a national authority, it had a public role and public functions; but it was at the same time 'private' and independent (of Parliament and Parliamentary Government) (Pearson, 1982: 10)

It was just this strategic position that the Department of Practical Art and later the Department of Art and Science was to adopt.

Changes were also occurring that affected how artists functioned and how they saw themselves functioning; indeed the art work that they were involved with producing was increasingly different from the concerns of the Royal Academy. These changes were clearly demonstrated in a recent exhibition at the Victoria and Albert Museum, *Painters and the Derby China Works*. The exhibition demonstrated also that curators at the museum are now more willing to deal with function and industrial design as well as the stylistic and aesthetic concerns of the art connoisseur.

Evidence for the new ways in which some artists were working was clearly articulated by one of the text panels of the exhibition which described an agreement made between three artists working for the Derby China Works: Joseph Bancroft, John Brewer and John Stanesby. The agreement concerned the purchase of *The Cabinet of Arts* which they were to use as a source of designs for their work.

This agreement shows the workers themselves investing collectively in material useful if not essential for their work, an interesting sidelight on the nature of industrial organization at

this date. All three of the painters party to the agreement had independent livings as teachers, illustrators, and jobbing artists, so were not wholly dependent on regular waged employment inside the works (Murdoch and Twitchett, 1987: 123).

It was just this kind of artist that the Museum trusted it would appeal to in its efforts to promote industrial art. The agreement signifies that artists were prepared to operate outside the system of the academy.

The artistic endeavour of these artists and others like them have often gone unrecognized – even by historians of water-colour like Martin Hardie whose histories of watercolour artists tend to a predilection for notions of art associated with the academy. The aim of the exhibition, according to John Murdoch, was to pin point the developments which the art schools and the Museum's officials had to grapple with:

So the interest of the exhibition is to show that the trade of china painter was not separate from the 'central' tradition of draughts-manship as it seemed to Martin Hardie. The interest lies in the use of terms like 'workroom' to describe both the place and the people – the creative nexus of the china painters: in establishing the idea that creativity and production are collaborative as well as individual activities. It lies in the glimpses of organisational detail, in the ticket for the China Painters Society and in the agreement between three workers to subscribe to *The Cabinet of the Arts*, which show how in conditions of proto-industrialisation individual craftsman organized themselves in relation to the employer. It lies in the hints of the importance of church and chapel organization, and the moral burden of conscience that men might bring to their day's work. (Murdoch and Twitchett, 1987: 11).

These changes were reinforced by the growth in adult education in Britain and associated developments that were occurring abroad, along with the development of Britain's industrial economy: 'During the latter half of the eighteenth century, and the first half of the nineteenth century, many institutes, literary and philosophical societies, and some Athenaea were estab-lished in the towns of Britain' (Macdonald, 1970: 35).

In France an industrial school was set up by Jean Jaques

Bachelier in 1762. It received immediate support from the French Government and remained an encouraging example of public subvention in industrial art. Not until the Schools of Art were set up in 1837 did Britain have a public organization that could be compared to the industrial art schools of the French. Although the Royal Society of Arts had been established by William Shipley at the same time as the French School his plans for an industrial school of art had collapsed through a lack of initiative. However, the initial ambitions for the 'Plan for an Academy' anticipated much of what Cole was later to encourage and foster:

The 'Plan for the Academy', published in 1755, seems not only to have envisaged the training of artists for industry, but also a whole system of certificated drawing masters together with a museum of applied arts very similar to that established by Henry Cole a hundred years later (Bell, 1963: 26).

It was not only art that began to be propagated in new conditions but science also, with the establishment of mechanics institutes like the one that Birkbeck set up in London in 1823. The way in which the mechanics institutes operated had important implications for the development of the Schools of Design and particularly for the Museum.

A Mechanics Institute usually rented rooms for a library of books and prints, a lecture theatre, and a museum of machines, minerals, models, antiques and stuffed animals. ... Lectures were organized for at least two evenings per week on literary and scientific subjects, and fine arts, and elementary classes were formed for normal school subjects and architectural, mechanical, ornamental, figure, floral and landscape drawing (Macdonald, 1970: 38).

Many of these features were carried into the reforms of the Art Schools and the Museum that Cole had promulgated.

Of great importance also was the fact that the museums that already existed in mechanics institutes had proved to have a central role in the learning opportunities provided by these institutions. In the context of scientific instruction Frostick precisely sums up their role: 'The museums, therefore, with

their emphasis on collection, research, observation and inter-
pretation of primary natural phenomena, formed an integral
part of the development of scientific method' (Frostick, 1985:
67). The theories of interpretation and material culture that
Dr Susan Pearce and her colleagues have recently formulated
forcefully restate the important position that museums have in
the didactic role of education and cultural reassessment (e.g.
Pearce, 1989).

A political event which was to have a major impact on the
development of the Museum and the Art Schools was the Select
Committee of Arts and Manufactures 1835–6. It provided a link
between the ideas surrounding the issues of fine art and design
and the institutional changes that were taking place. It also
fostered a concensus view about what was meant by fine art and
design and provided a number of recommendations as to how
to improve the state of manufacturing design in Britain, many of
which were later enacted: it was due to this Committee that the
Art Schools were set up and its findings contributed much to the
thinking that led to the formation at the South Kensington
Museum. More importantly, it set a precedent for engaging in
such a debate at parliamentary level, and provided the impetus
for 'attitudinal change' that Cole was later to exploit.

The Select Committee of Arts and Manufacture was set up
with the following aims:

That a Select Committee be appointed to inquire into
the best means of extending a knowledge of the Arts and
the Manufacturing Population of the country; also to inquire
into the constitution, management and effects of Institu-
tions concerned with the Arts (Select Committee Report,
1835–6).

As Pearson points out, the Society for the Encouragement of
Arts had been debating such issues for some time. At last,
however, these issues were being debated, as has been noted, at
parliamentary level and a broad spectrum of advice was called
upon, including manufacturers, artists and experts who had
knowledge of the nineteenth century cultural scene: 'the Petition
of Artists and Admirers of the Fine Arts, and several Members of
the Society of British Artists were severally refered' (Select

Committee Report, 1835–6). The committee was chaired by William Ewart, MP for Liverpool, who had supported Haydon in his attack on the Royal Academy and the academy system.

One of the key witnesses who gave evidence at the enquiry was a German academic, Dr Gustave Federick Waagen. It has been suggested that there may have been a conspiracy between Poulett Thompson, President of the Board of Trade, and officials within the same department to foist Dr Waagen on to the committee in order to persuade its members to adopt the *gewerbschulen* system of design schools and methods of teaching which they favoured. Suspicions were aroused because, at the time, French teaching practices and French design had been much admired by committee members and politicians alike. According to Stuart, however, it is unlikely that there was such a conspiracy: Haydon, a keen supporter of French teaching practices and a man sensitive to the slightest snub, never objected to Dr Waagen's presence. William Ewart did not register any objections either and was an enthusiastic supporter of the committee's work. Also, with Prince Albert kindling his ideas of cultural improvement in the background, it was perhaps not unnatural that a German academic was invited to contribute to the committee's proceedings. Perhaps the greatest motivation of all for his invitation was the belief that he could contribute usefully to resolving the perceived crisis surrounding the quality of British design which, in turn, was seen as inhibiting the marketable qualities of British goods.

Whatever the true reasons for his invitation, the evidence that Dr Waagen gave was to have a great impact on the eventual development of the Museum. His description of the institutions in Prussia for the 'instruction of the manufacturing population in the Fine Arts' have a remarkable resemblance to the final form of the Schools of Design and the Museum:

At Berlin, in the chief Institute, there is a collection of models representing the newest discoveries of Europe, and particularly in England; there is also a very complete collection of the finest ornaments and designs of the Greek and Roman and middle ages in plaster of Paris; also some of the most distinguished works of naked sculpture, especially the pure Grecian; the pupils there are also instructed in drawing, modelling, in

mathematics and perspective; each one chooses his own depart-
ment of manufacture; they are taught also the founding and
casting of metal works and other manufacturing operations
(Select Committee Report, 1835–36: para. 7).

Many of Dr Waagen's ideas about museums also provided
encouragement for those who wished to establish an art
museum, and were later to be adopted by Cole and his col-
leagues. For instance, Dr Waagen was an advocate of a vigorous
collecting policy: 'It is the duty of the directors to collect from
different countries the most remarkable specimens of patterns
that are produced' (Select Committee Report, 1835–6: para.
56–7). This was linked to the ability of a museum to fulfil a
distinct educational role in encouraging the application of art to
manufacture. In answer to a question as to how this was to be
achieved he said:

By giving the people an opportunity of seeing the most beautiful
objects of art in the particular branch which they follow; by
having collections of the most beautiful models of furniture and
of different objects of manufacture. It is not enough merely to
form these collections; there must be instructions to teach
people on what principles those models have been formed;
furthermore, for the purpose of exercising the hand and eye, it
is useful that young people should draw and model after those
models (Select Committee Report, 1835–6: para. 81–82).

He was then asked: 'What is the best mode, in your opinion, of
extending taste and a knowledge of the fine arts among people
generally?' To which he replied: 'The best means of forming the
taste of the people is by the establishment of accessible collec-
tions of the most remarkable monuments of antiquity and of the
middle ages' (Select Committee Report, 1835–6: para. 63).

Like Cole, Dr Waagen believed there were common principles
which could be appealed to: 'It is in no case right that any man
should judge his own case'. In order to encourage this exercise
in judgement, Dr Waagen was convinced that exhibitions had a
useful part to play: 'The second mode of distributing knowledge
among the people would be by means of public exhibitions'. He
also asserted the usefulness of a committee convened to decide
upon what should be displayed and collected for a museum: 'In

order to avoid partiality, it would be effectual if the state was to appoint a committee which should be composed of artists and connoisseurs of taste and judgement' (Select Committee Report, 1835–6: para. 96). This description shows remarkable anticipation of the committee which was set up to decide purchases for the museum, which included Cole, Pugin and Redgrave, and the kinds of arts organization that exist today: for instance, the arts panel of the Arts Council.

Although Cole was to follow through these ideas, and others like them (even to the opening of the museum on Sundays), it is important to note a discrepancy of approach to the problem of design and art manufacture which was going to afflict those who were to be involved in the organization and operation of the Art Schools and the Museum a decade or so later. In his enthusiasm for the encouragement of what he termed art manufacture, Dr Waagen expressed the wish to acquire 'the most beautiful of the objects of art' (Select Committee Report, 1835–6: para. 81–2). This is made more explicit when he talks of 'the most remarkable monuments of antiquity'. This view of aesthetic connoisseurship guiding the hand of the artisan conflicts with his concern for the practice, function and material concerns of art manufacture. Yet, Dr Waagen does not acknowledge the antagonism between these two points of view, nor attempts a resolution of the difference. The administrators of the Art Schools and the Museum were to encounter the same problem. It is ironic that the adoption of aesthetic concerns for the past motivated the collection of casts for the Art School at Somerset House under Heath-Wilson despite the fact that so much concern had been expressed about the state of industrial design and art manufacture in the Select Committee of 1835. It was this collection of casts which formed the basis of the Museum.

During the committee's proceedings Robert Peel had complained bitterly about the quality of British design: 'but, in the pictorial designs, which were so important in recommending the production of industry to the taste of the consumer, they were unfortunately, not equally successful; and hence they had found themselves unequal to cope with their rivals' (Minihan, 1977: 39). For Peel the issue had a particular pertinence since the family wealth derived from Calico printing.

That it was not the actual manufacture of objects that caused British businessmen problems in marketing their goods is made clear by the evidence of James Morrison Esq described as a 'Purchaser of Manufactured goods home and abroad, through the company James Morrison & Co.' He gave his evidence to the committee on 30 July 1835:

Do you consider the English manufactures superior as far as regards the manufacture of goods, but inferior in the portion of them connected with the arts? – I have found generally that we have been very much superior to foreign countries in respect of the general manufacture, but greatly inferior in the art of design (Select Committee Report, 1835–6: para. 166.).

It was Morrison's view that English articles failed on the grounds of taste. What so impressed members of the Committee was that the German art schools, through the contribution they had made to the quality of design, had dramatically improved sales of German goods, especially textiles. What was also of such significance to the committee, was that Government funding of the schools had been the catalyst for this desired economic uplift. Dr Waagen, in his evidence, affirmed that the changes in economic fortune had taken place: 'Has the cotton manufacture increased lately in Prussia to any great extent? – There has been a very great improvement in the cotton manufacture, particularly in the excellent patterns' (Select Committee Report, 1835–6: para. 46).

Cole's influence and its implications

Given the range of Henry Cole's ideas, it can be seen that he absorbed and inherited many of the intellectual cross currents of his time, and he manipulated the institutions that were, in part, a response, or outward manifestation of these ideas. This characteristic is reflected also in the range of people with whom Cole worked, such as Pugin and Redgrave, and those whom he admired, like William Dyce. Yet, fortunately for Cole, he was able to cut a mental swathe through philosophical complexities, as he was to do with governmental bureaucracy, by the exercise

of prodigious practicality, discipline of mind, and intent. Macdonald makes the following comment on Cole's attitude to intellectual pursuit, which includes a wry remark on his fellow Benthamites:

Bentham's principles of utility and facility were manifest in Cole's educational activities, but as far as utility was concerned, he felt, like Mill, the weakness in Bentham's principle of judging one's actions and objects by what would cause the 'greatest happiness of the greatest number'. He was more pragmatic than Bentham or Mill and prided himself on being very modern and practical; on one occasion he quoted his friend Charles Buller, MP, as saying 'that the Benthamites had very good hearts, but wanted intellect!' (1970: 231).

Cole became the self-appointed judge of cultural matters, much to the distaste of others including Ruskin, who ironically, was to give lectures at the South Kensington Museum. As judge he was able to make and carry out decisions with the sanction of the Crown and, ultimately, with the backing of Parliament.

The position Cole assumed is revealed in his riposte to the Lords Commissioners of the Treasury's Report on the Science and Art Department (1858). It concerned the position and status of the Keeper of the Museum which Cole thought the Commissioners had undervalued, both in terms of salary and in what the job actually entailed. Although not directly affecting him personally, it is fair to assume that the issue intermingled with his own notion of his role in the Department of Science and Art. It was his opinion that the role of Keeper of the Museum at South Kensington was more important than that of the National Gallery asserting caustically that: 'The latter does not originate purchases, but simply conserves them' (Cole, 1859). This remark is followed by a clear statement of the role of keeper, in terms that could well describe the role of an arts administrator in the present public subsidy system for the visual arts in Britain.

But the art curator at South Kensington has had to form the collection, to attend public sales and to – [have] artistic taste and judgement he must have the experience of a dealer. His post is one of great trust and responsibility exposed to constant temptation to make profitable purchases on his own account (Cole, 1859).

In essence, the role of keeper, as viewed by Cole was that of judge. By implication this applies to Henry Cole too. It is an unconscious admission of his own role.

Henry Cole had an implicit faith in the ability of the public sector to realize his ambitions for the Museum. Similarly, he considered public sector participation and investment to be equally important for the future of the Schools of Design. It is important to note that their funding by Government was to prove a useful precedent for the funding of the Museum. Although the Schools of Design were already receiving public funds which amounted, according to Cole to £75,000 he considered this to be a small sum compared to other economic determinants. The funding of the Schools was, he claimed, 'less than five thousandth part of the estimated annual production, and is about a thousandth part of the annual taxation of the country' (1884: 290). As such, in Cole's view, Government expenditure on the Schools of Design was not therefore excessive or irresponsible. Anthony Burton remarks that: 'He could even suggest switching expenditure from defense to education' (1988: 52). And goes on to cite a comment Cole made in the *Art Journal* for 1854: 'One ship-of-war ... costs more by far to the nation than the whole yearly grant made by government to support of Art Education' (1988: 57). As well as the monies required to run the Museum, Cole considered that public funds were necessary for the purchase of objects too on any consistent and systematic basis: 'The collecting of casts and examples of art from national museums of other countries, could only be systematically carried on by a Government Agency' (Cole, 1884: 287).

Despite Cole's belief in public participation and funding, he often voiced the opinion that the Museum and the Art Schools in particular ought to be self-financing, or at least partially so. However, it is likely that Cole expressed these sentiments in order to soften opposition towards the spending of public monies on his department: politicians and government officials were extremely chary of making such expenditure. The question of spending public monies in this way had been posed during the proceedings of the Select Committee on Arts and Manufactures. Mr Joseph Robinson, editor of the *Mechanics Magazine*, was asked:

Supposing that by residents in any given district an offer was made to contribute a certain considerable proportion towards the formation of a gallery of casts, or a public library, or a collection of works of art, open freely to all the public, you think it wise in the Government, without the slightest degree of interference to assist in the completion of the design?

To which Robinson replied:

I should think it highly expedient and highly honourable in the Government to give every encouragement in that way, to promote by all possible means the establishment of museums and galleries so that they leave the management of them to the people themselves (Select Committee Report, 1835–6: para. 1660).

This view that the Government's role was to participate in the establishment of museums and galleries up to the point at which they could be run independently, was still one that was widely shared in the 1850s. Also, as the question implies, the Government's role in supporting such organizations was to be strictly limited to providing the necessary funds. Any other type of involvement was to be abhored.

In order to shield the Museum from such criticism, Henry Cole went to great lengths to assure politicians and civil servants alike that the Department of Science and Art and the Design Schools would become autonomous and self-supporting. In the First Report of the Science and Art Department, he claimed: 'It was designed that the motive power of the United Department should be local and voluntary, and the system self supporting as far as practicable (First Report, 1854). The duplicity of such statements of intent is frankly revealed by Anthony Burton, who suggests that Redgrave had to intervene to dampen Cole's enthusiasm for intrigue and fabrication:

So Cole made a virtue of being against public subsidy. He gloried in the claim that his art-education system would generate income. It would do without government interference. . . . In fact, he got hold of as much government money as he could. But he managed to suggest that it was with regret that he accepted the subsidies that the public insisted on thrusting upon him.

In due course they would learn the error, and abandon the mixed economy for the free market. 'Meanwhile, we have to administer the mixed principle adopted by this department.'

Surely he had his tongue in his cheek. He never saw a moment in his lifetime when the system's income from fees balanced its payments to teachers, leaving aside its other expenditure. Although he made great play with the idea that the system would become 'self-supporting', a Select Committee in 1864 concluded that it would not. Cole's sense of mischief always inspired his rhetoric to run away with itself. It was obviously one of Redgrave's functions to drag him back when he was in danger of going too far (Burton, 1988: 52).

Cole's enthusiasm for such intrigue may well have stemmed also from the stinging rebuke that he had received from Stafford Northcote in 1848. Northcote had, in effect, accused him of laying plans for the nationalization of the Art Schools when Cole presented his reports on them in the same year. It had made him aware of just how far he could go in pursuing a co-ordinated plan of public investment and policy for the Art Schools within the framework of the public sector. Hence, whenever he discussed investment policy for the Museum, Cole would affirm his commitment to self-sufficiency. For instance, he made it clear that charges would be made for those institutions and local museums which wanted to borrow items from the South Kensington Museum either for their own exhibitions or for long term loans: 'I propose therefore that when an application is made simply to have examples a grant of them should be made by the Department, upon condition that the applicant is willing to pay half the cost of them' (Science and Art Department Minute Books, 1852: minute 11).

Towards the end of his life Henry Cole came to see it as a duty of Governments to involve themselves in public education and support for science and art. He wrote two papers which, by their explicit titles, show that he had lost his reservations about voicing his opinion as to the value of public sector funding. One was entitled *The Importance of National Investments in the Purchase of Objects of Science and Art*, and the other *The Duty of Governments Towards Education, Science and Art*. In the former he called for such investment that would not suffer the changing fortunes of Governments, but would be continuous and thereby become a

secure source of funding. In the latter he placed his faith in museums that would be so funded:

The demand for increased and better Education, for more and general instruction in Science and Art and for the teaching by objects in museums, shows wisdom and advancing independence of character in the Nation and is not at all the cringing of a suppliant for benevolence as from a despot.

This paper has tried to present the complex interactions between ideological, social, economic and historical factors that contributed to the establishment of the Museum and the formation of its collections. In particular, an attempt has been made to show how these were manifested in the institutional frameworks of the period, which in turn influenced the thinking behind the founding of the Museum. An endeavour has been made to conceive these factors through the vision and energies of one man who acted as a catalyst to the establishment of the Museum, Sir Henry Cole.

Cole's efforts to impose items of art manufacture – ornamental art – on the political culture of the nineteenth century produced great unease, as Cole was ready to admit in an address he delivered to the Manchester School of Art on 21 December 1877:

When an artist paints a picture, unless he gets anybody to help him, he begins and ends it himself, and then it is called Fine Art; if on the contrary, an artist makes a design, and it is repeated by another process, even so closely that nobody can tell it from the original, that is repudiated as 'base and mechanical'.

This unease may be accounted for by the fact that items of art manufacture brought objects into a wider cultural matrix than, perhaps, those objects designated as 'high' or 'fine' art; and this at a time when the political culture of the nineteenth century was changing rapidly and State subvention activities of Government were in the process of developing. Just as it was safer to justify public expenditure on the grounds that it would generate private finance in the future, so it was reassuring for those involved in the funding of the Museum to know that what

was being collected was indeed 'high art' and most valuable. Throughout the correspondence between the departments responsible for the Department of Science and Art it appears to be undeniable that the knowledge that the collections were worth something eased the consciences of the administrators and politicians who had to part with the money. It is ironic that utilitarianism, the intellectual motor that contributed to the formation of the Museum, should help to effect a preoccupation with 'high art' and connoisseurship. For utilitarianism tends to idealize expressed preferences through its reductionist approach to choice and the methodology by which choice is arrived at.

Through a publicly funded system, Cole had fervently wished to extend the availability of well designed objects of manufacture to the greatest number and generate informed public discussion about art and the design of manufactured objects. In his 1873 prize-giving address to Nottingham School of Art students, he said:

The taste of England will revive although with different manifestations. It will not be the revival of fine art producing objects like a Gloucester Candlestick, or St Patrick's Bell, or a Lynn Cup, but repetitions of hundreds of thousands of copies of works of Art-Manufactures to be used by all classes of people (Cole, 1884: 345).

As it transpired, the Museum that Henry Cole founded came to assume the character of a fine art museum rather than a museum of art manufacture with an explicit educational function.

Bibliography

Alexander, P., *Museums in Motion* (American Association of State and Local History: Nashville 1974).

Bell, Q., *The Schools of Design* (Routledge and Kegan Paul: London, 1963).

Bonython, E., *King Cole. A Portrait of Sir Henry Cole, KCB. 1808–1882* (Victoria and Albert Museum: London, 1982).

Burton, A., 'Richard Redgrave as Art Educator, Museum Official and Design Theorist' in *Richard Redgrave: Exhibition Catalogue* (Victoria and Albert Museum: London, 1988).

Cole, H., *On Public Taste in Kensington*. Rough draft in H. Cole's own hand. Miscellanies xi 1853 (National Art Library, Victoria and Albert Museum, London).

Cole, H., *Observations on the Treasury Report 1858 and Memorandum May 8th 1859*, written by Cole to General Grey. Miscellanies xi 1859 (National Art Library, Victoria and Albert Museum, London).

Cole, H., Cole, A., and Cole, H., *Fifty Years of Public Work*. Vols 1 and 2 (George Bell and Sons: London, 1884).

Eliot, T. S., *The Sacred Wood* (Methuen: London, 1976).

First Report of the Department of Science and Art, 1 January 1854. Miscellanies viii: x (National Art Library, Victoria and Albert Museum, London).

Frostick, E., 'Museums in Education: a neglected role?' in *Museums Journal*. 85, 2, 1985: 67–74.

Fuller, P., *Images of God: The Consolations of Lost Illusions*. (Chatto and Windus: London, 1985).

Glaser, J. R., *The American Museum Experience: In Search of Excellence* (Scottish Museums Council: Edinburgh, 1986).

Harrison, R. J., *Pluralism and Corporatism: The Political Evolution of Modern Democracies* (Allen and Unwin: London, 1980).

Horne, D., *The Great Museum: The Re-Presentation of History* (Pluto Press: London, 1984).

Lords Commissioners of Her Majesty's Treasury: *The Report of the Commissioners Appointed by the Minute of 7th January 1858, to Inquire into the Establishment of the Department of Science and Art*, 24 February 1858. Miscellanies xi (National Art Library, Victoria and Albert Museum, London).

Macdonald, S., *The History and Philosophy of Art Education* (University of London Press, 1970).

Minihan J., *The Nationalization of Culture* (Routledge and Kegan Paul: London, 1977).

Murdoch, J. and Twitchett J., *Painters and the Derby China Works* (Trefoil Publications: Derby, 1987).

Newman, J. H., *On the Scope and Nature of University Education* (Longman: London, 1852).

Pearce, S., (ed.), *Museum Studies in Material Culture*. (Leicester University Press: Leicester, 1989).

Pearson, N., *The State and the Visual Arts*. (Open University Press: Milton Keynes, 1982).

Physick, J., *The Victoria and Albert Museum – The History of its Building* (Victoria and Albert Museum: London, 1982).

Saumarez, Smith, C., 'The Philosophy of Museum Display: the Continuing Debate' in *The V & A Album*, 5, 1986: 31–8.

Science and Art Department Minute Books 1852–3. Minute dated 11 September 1852. ED. 28 (2), nos 1, 6 (Public Record Office, London).

Select Committee of Arts and Manufactures Report Together with Minutes of Evidence and Appendix, 4 September 1835–6. Microfiche file 2HC1 10061–62 (Public Record Office, London).

Summerly, F., *Being Short Treatises on the Amount of Elementary Knowledge of Art, Which Every Workman Who Has to Produce Art Manufacture Ought to Possess*. Miscellanies viii 1847–52 (National Art Library, Victoria and Albert Museum, London).

Thompson, D., *England in the Nineteenth Century*. (Penguin: London, 1985).

Wolff, J., *The Social Production of Art* (Macmillan: London, 1987).

Williams, R., *Culture and Society* (Penguin: London, 1985).

2

The discursive object
Edwina Taborsky

Introduction

Museums are, uniquely, institutions which exist to interpret objects from the past and present to each succeeding generation of society. However, even so simple a definition throws up a crucial series of questions. Among these (but not exhausting them) we may distinguish problems surrounding the nature of society, the nature of objects, and the ways in which objects generate meaning and interpretation. This paper sets out to consider these questions in the light of concepts developed by such influential thinkers as Peirce, Eco and Bakhtin, all of whom have worked within the broad field of semiotics. Of necessity, we must cast well beyond the museum walls before returning, in the final part of the paper, to place our ideas in the firm museum context. As a way into the topic, I am going to try to outline the definitional and descriptive assumptions about both objects and society, which I have been exploring over the past few years.

Objects, society and the operation of the sign

Let me begin with my understanding of the nature of a society. An immediate description would be a group of people living together in some consensus about behaviour and beliefs relating to their subsistence and existence as a group. They presumably share a language and possibly other forms of signification to communicate these behaviours and beliefs. Such a description may at first seem adequate but I feel that it does not account for

a great deal of significant behaviour in a social group. We may indeed be able to total up statistically all the beliefs and all the behavioural patterns of a number of people. But does all this 'content', although fully and accurately descriptive, actually *define* a society? It answers the 'what' but does it answer the 'why'? Why does a society – or perhaps we should first consider these people a group, for I have still not come up with a definition of what a society is – why does a group have such behaviour and beliefs? Many of these may seem totally unnecessary to the existence of the group, and explanations which may be given may seem both irrational and inadequate.

Why do the Navaho classify animals and plants in a correspondence relation with natural elements, so that a crane corresponds to the sky, the red songbird to the sun, the eagle to the mountain, the heron to water (Levi-Strauss, 1966: 40)? Why do the Carrier Indians explain their knowledge of animals as having originated long ago when men married them and acquired this knowledge (Jenness, 1943: 540)? Why do the Bororo explain men as associated with the right side of man and first in the concept of linearity, and women with the left side and temporally after (Levi-Strauss, 1966: 145)? Why does a Catholic abstain from meat on Friday? Why does an orthodox Jew refrain from eating bread during the Passover? Why do people identify themselves with a flag? Why does a member of a Teddy Boy group wear a drape coat? Why does wearing a tie mean more formal behaviour than not wearing one? In the painting *The Dream of St Ursula* by Carpaccio, *c.* 1495, why does the male figure on the right, have wings? Why is Pegasus

se questions by referring
iages in question. Instead
nification', which can be
ig which is not inherent in
gned to it. Peirce's defini-
stands to somebody for
ity' (Peirce, 2: 228). The
'standing for something'
l is not inherent but is an
in the case of that winged
not even physically exist.

Anth. Arch, Semiotics

Above all, we cannot adequately explain the behaviour or beliefs of any of these various groups as directly related to the physical nature of the objects in question. Husserl notes of our understanding that 'part is perceived ... and part is contextually supplied by our memory' (Husserl, 1970: 13). Mead comments that 'meaning arises ... within the field of the relation between the gesture of a given human organism and the subsequent behaviour of this organism as indicated to another human' (Mead, 1934: 75). Meaning is, therefore, social, involving both interaction and a shared communication system, and we can call this social meaning a sign.

What is a sign? If we accept that meaning exists within 'an information structure that is mentally encoded by human beings' (Jackendoff, 1988: 81) then we must explore that system which creates and carries meaning. Eco writes that 'everytime there is the possibility of lying, there is a sign-function' (Eco, 1976: 58). This at first glance, is a rather derogatory definition of a sign, for the word 'lying', conveys a sense of an intentionality to deceive. We must remove such intentionality from our usage of signs. Groups do not use signs in an attempt to deceive others. The sign is simply considered to be a 'lie', because its meaning is not directly attributable to its physical nature. Thus, a sign does 'not, in principle, designate any object, but on the contrary *conveys a cultural content*' (Eco, 1976: 61, my emphasis). And here, we come up with the requirement that the meaning of the sign must be socially supplied by the group. For 'whenever something is interpreted as something, the interpretation will be founded essentially upon fore-having, fore-sight and fore-conception'. An interpretation is never a 'presupposition-less apprehending of something present to us' (Heidegger, 1962: 191). Meaning is socially determined and assigned. We do not gather meaning directly from the object, but create it using our own 'fore-knowledge' about our society. A meaning is arbitrarily assigned, which makes it changeable and, therefore, a potential lie (if we must believe in eternal truth). So a material object, let us say a pair of torn jeans, can be understood to mean poverty and a lower-class alignment, as it does in many films; it can also be understood to mean sensuality and freedom, as it does in many modern advertisements – if those descriptions can be understood in any way as contradictory to each other.

Another important concept to the understanding of a sign is that its meaning as a sign-unit is 'closed'. The object is not available for all possible assigned meanings at any one time; rather the number and style of meanings assigned to an object are limited, or closed. And it is the group which has assigned the nature of these meanings, 'We cut nature up, organize it into concepts and ascribe significances as we do, largely because we are parties to an agreement to organize it in this way' (Whorf, 1969: 213).

The sign is a social creation, and is not directly related to a physical reality. Peirce notes that, a 'Sign can only represent the Object and tell about it. It cannot furnish acquaintance with or recognition of that Object' (2: 227–9).[1] And the object of a sign is 'that with which it presupposes an acquaintance in order to convey some further information concerning it' (2: 231). In other words, Peirce insists on the object being involved in the interaction of the sign and meaning. This object can be a material unit, an action, a dream, another sign. Peirce is saying that the sign is a *mediator*, an interpretative interaction between two communicative poles, which he terms object and interpretant. The sign is not a copy of the object; it is a creation by the interaction of the object and the interpretant (which is Peirce's term for the individual's interpretation or understanding of the sign).

We have a concrete beginning in the search for the definition of both an object and society. First, we know what an object is *not*. It is not meaningful to the group in any direct, linear, mirror-like copy of its material nature. (This is known as the 'referential fallacy'; see Eco, 1976: 58–62.) Its meaning is assigned to it, and may or may not have anything to do with the physical characteristics of the material object, if indeed that object even materially exists. This suggests that not only is the meaning socially assigned, but there is a consensus in the group about this meaning. Foucault notes that 'whenever . . . one can define a regularity . . . we well say . . . that we are dealing with a "discursive formation"' (Foucault, 1972: 38). The meaning has been socially, in a conscious or unconscious consensus or discussion, agreed upon. Further, 'the rules of formation are conditions of existence . . . in a given discursive division' (1972: 38). These 'rules of formation', which we can understand as

being the social guidelines which form the existence of a sign, are not to be understood as existent only as anyalytic tools, which we would use only when we were researching the cognitive structure of a sign. Rather, a society, which uses signs as 'meaningful units' in its discourse as a society, must have a sign-making system. Foucault's statement is that these rules 'are [not] deployed when the object is being analysed; ... [they are] what enables it to appear, to juxtapose itself with other objects, to situate itself in relation to them, to define its difference, its irreducibility' (1972: 45). In that sense, we can understand that the rules of formation of social signs are not analytic methods but are socio-structural systems. They contribute to the structural existence of a society. The systems which a group uses to make its signs are part of the total infrastructure and the ongoing interactional operations of the group. For 'a society, like a mind, is woven of perpetual interaction' (Bloch, 1965: 59). I have elsewhere written that society can be analysed as a 'text', for 'the group ... is a text, operating not as a finite and single content of meaning, but as a generative infrastructure for the creation of meaning within a discursive interaction' (Taborsky, 1989). A group 'can be defined as a socially created systemic and singular discourse, operative within a long-term and distinct infrastructure, which is created by agents understood as both authors and readers'. The cognitive content of a society is 'written, rewritten and read' or interpreted within this infrastructure. Within the textual confines of a society, knowledge exists as long as the infrastructure exists, and is above all, valid only within those confines' (Taborsky, 1989). Essentially, knowledge, which exists by the mediating agency of sign-units, is created within a social discourse; it is understood within a social discourse. What does this discourse mean?

The three realities

We can here introduce what I have termed the 'Three Realities', which are loosely modelled on the analytic frame of the semiotic triangle. The three realities is an analytic tool to help describe and define the formation and usage of meaning within the

group. This formation and usage of meaning is what I mean by 'social discourse'.

Let us first say that there exists a *material reality*, a *group reality* and an *individual reality*. These terms are comparable but not identical with the Peircean semiotic terms of *object*, *sign* and *interpretant*, which are used for analysing the development of meaning. My reason for using such terms when I am analysing the nature of the group is to switch analytic focus from the distinct and separate nature of the object to the whole group. I locate understanding of the object within the group, not within the particular object or the individual. The meaning of an object exists only in its nature as a sign, and the sign occurs only within a group-based interaction. This interaction which forms the sign can be analysed as an interaction between three conceptual realities.

I will try to explain these concepts. The group exists, as a physical number of people, who are all temporally and spatially bound within a specific material environment. That is, there is some physical reality as a whole – the environment – with which the group is involved. The requirements of sustenance, interaction with that particular environment, the reality of birth and death – these are all physical or material realities which the group must deal with. This *material reality* is made up of both actual objects, and also actions. Again, this concept is not incompatible with the Peircean definition of the object, which includes both unit and action.[2] I am, however, focusing attention on the whole environment of the group, and not on a single unit or action. The group must deal with the whole material environment and with all the material facets of human existence. This can be considered material reality. However, material reality is never perceived in a direct sense, but only in a social, interpreted sense, as a system of signs, which develop meaning.

This social concensus or understanding can be termed the *group reality*, which is the meaning of existence as understood by the group and is what makes a group a distinct society. Group reality consists of an infrastructure which provides a frame in which discourse and interaction can take place, which in turn provides the group members with 'a particular way of viewing the world' (Bakhtin, 1981: 333) which is specific to their group. This 'particular way' organizes their behaviour and beliefs

within their spatio-temporal material reality. The group reality is totally created. It accepts unicorns and winged horses as readily as it accepts trees and birds. There is essentially no distinction between the validity and acceptability of either. Both are meaningful, and therefore real, to the group. Group reality has above all a stabilty to it which can be compared to the dependability of habit or law, or what Peirce defines as 'thirdness', which includes such concepts as 'continuity' and 'the being of law that will govern facts in the future' (Peirce, 1: 236). Let me explore this concept of stability.

What makes something meaningful to the group? Here, we must bring in the requirement for 'habit' or 'law'. For a group seems to require a certain stability in its meanings and its interactions in order both to derive and use meaning. So as to exist as a society, a group must have the ability to maintain a stability of belief over a spatio-temporal period. If the meaning of an object is, as has been discussed, arbitrary, unrelated to its physical nature, then a meaning can also be 'inexhaustible'. An object can mean whatever we want it to mean. Its meaning can vary from person to person, from moment to moment. Without it communication would be impossible, and no society could exist. The requirement for some stability of meaning is of such importance to the existence of a society that an element of habit or continuity of meaning is a basic requirement. Habit, or 'thirdness' is described by Peirce as 'that which is what it is by virtue of imparting a quality to reactions in the future' (1: 343). This suggests the necessity of an ongoing continuity of both society and its signs, so that a meaning can last beyond the immediate and isolated perception. When we refer to the word 'church steeple' it will mean, more or less, the same thing tomorrow as it did today. And it will have that same continuity of meaning so that we can discuss its nature with another person. When I refer to group reality therefore, I refer to both meanings and meaning-production systems which have a common (and therefore communicative) stability within the society, and last over a certain period of time. We must also consider that both the size of a group and the temporal period of its existence are never infinite but limited. The 'fax machine' may mean something different to a society one hundred miles away and two hundred years ago. But within a

certain spatial and temporal area, the meaning is relatively stable and communicable.

The third reality is, *individual reality*. This refers to the individual and personal interpretation of the sign (called by Peirce the 'interpretant') which an individual produces when he uses that sign. Because we use the term 'individual' does not in any sense mean that this interpretation is also extremely unique. A society, made up of a number of individuals who share a stock of signs, who share a certain stable meaning of those signs, who share a communication system which they use for the discursive production and communication of these signs, cannot have interpretations of these signs which are so different that they are, in a sense, different signs. A sign, which is a stable meaning, can have a number of interpretations, which can be understood as all versions of that one sign. This is what is meant by individual reality. An individual can 'interpret', but not entirely change, the basic consensus of a sign's meaning. So a sign, 'Raven', has individual interpretations which, however, are common enough with each other that their meaning can be communicated and understood as versions of one basic sign.

If the material object exists in society only as a sign, which is a socially created reality, and is interpreted within a limited variation within individual reality, then this analytic concept is telling us something more about the understanding of the object. The object does not, indeed cannot, exist without an interaction with someone. In order to create a sign, which is a physical unit-of-meaning (physical because it is encoded in a sound, a vision, a touch, a smell, a taste) there must be some action of a human being which makes this physical unit into a sign, a unit of social meaning. And then it must be *used*, interacted with, in order to be existent as a unit-of-meaning. In order to have meaning, there is a requirement for interaction, for 'every concrete act of understanding is active ... understanding comes to fruition only in the response. Understanding and response are dialectically merged and mutually condition each other; one is impossible without the other' (Bakhtin, 1981: 282). In fact, Eco says that 'properly speaking, there are not signs, but only sign-functions' ... 'a sign-function is realized when two functives (expression and content) enter into a mutual correlation' (1966: 49). So a sign is actually an

action of mediation between an object (existent on the expression plane) and the interpretant or meaning (existent on the content plane).[3] Peirce notes that a sign 'addresses somebody, that is, creates in the mind of that person an equivalent sign, or perhaps a more developed sign.' (2: 227). As such, it functions as a mediating action. The interaction structure would be object→sign←interpretant. Or, material reality→group reality←individual reality. The sign interacts with both the (material) object and the (individual) interpretant. It is the bridge between material and individual reality, for as I have said, we do not understand the object directly in its own physical essence but only within a group or social reality.

Discourse and meaning

We may now examine two cognitive paradigms that set up a structure to carry out this group interaction which provides us with our knowledge of objects. The interrelationship of the Three Realities – material, group and individual reality – can be structured in two different paradigms, which are totally incompatible with each other. One structure provides for an interaction based in discourse, and the other is based in observation. What does this mean, and why are they different?[4]

Simply, the discursive paradigm says that in order to gain knowledge about an object (as a unit, as an action, as a sign) you enter into a discursive interaction with it.[5] The pattern, as noted in the object→sign←interpretent interactional frame is similar, so that it is object→meaning←observer. For this interaction to take place, you, and the object, have to exist in some shared spatial and temporal area, and your interaction with it defines its meaning at that moment. It is very important to understand that the meaning (or sign) of an object in a discursive interaction, comes about in the interaction with that object. You establish the meaning of the iron hammer when you are actively using it; you develop a meaning in the painting when you are in the action of either painting or looking at it; you understand the novel when you are writing or reading it. (These meanings need not be the same.) In the discursive interaction, you and the object are interactive, in a shared spatial area and temporal

period. I call this interaction 'the action-of-textuality', and it simply means that the meaning of an object is created when you are in the act of 'doing something' or interacting with that object. The meaning did not exist prior to your interaction with it. Meaning appears via the sign's mediation between the object and the interpretant, between the object and the observer. This triadic discourse is the basis for the development of all meaning. It is the basic format for all cognition.[6]

Albert Lord, speaking of oral epic poetry says that 'what is important is not the oral performance, but rather the composition *during* oral performance' (Lord, 1971: 5) The oral song is created in the performance, and exists by being 'listened to', by having an audience which: (1) listens to the actual physical song {consider this the object}: (2) which is expressed in the words of the society's language {consider these the signs}, so that (3) each individual understands and interprets the song {consider this the meaning or interpretant} within the social text. There is no original song, original in the sense of having a basic unalterable meaning, which we could define as its 'material reality', and understand as the 'patented' original. For, as Lord continues, 'I believe that once we know the facts of oral composition we must cease trying to find an original of any traditional song. From one point of view, each performance is an original' (Lord, 1971: 100).

Bakhtin writes that meaning in the novel is created by means of methods which permit the reader to 'enter the novel' and interact with the words, combining his current spatio-temporal image with their image to create a current meaning, a current sign, for 'the word is born in a dialogue' (Bakhtin, 1981: 279). Searle's analysis of the illocutionary speech act, is that it includes a potential discursive interaction between a speaker and hearer, so that the discourse is recognized as particular to that situation and, therefore, as meaningful (Searle, 1969: 1983). We have seen a recognition that meaning is contextual and interactive. This analysis says that there may or may not be an actual physical material reality. But reality is known in its nature as a sign as a unit-of-meaning which is only known, or 'perceived', in a cognitive interaction. The object cannot exist as a sign or meaningful unit on its own. We must remember this for our discussion of the object within the museum.

Observation and meaning

However, there is another analytic method which concerns itself with understanding the object. This is the observation paradigm, which sees the observer and the object as two autonomous realities, each separate and complete in their own identity. There is no interpretative interaction between them. Rather, as in empirical physics, the object exists as 'a complete description, independent of any measurement that may or may not interfere with it' (Sachs, 1988: 156). This theory feels that there is 'an underlying, objective reality, independent of an observation' (Sachs, 1988: 129). Therefore, the object exists prior to any contact as a complete 'unit of knowledge', that is, a sign. The only way to obtain any knowledge of this object is, as observer, to explore its material and social nature by nondiscursive methods of abstract (and presumably socially unaffected) techniques of analysis, such as measurement, data collection, statistical tables. Here, the understanding is that there are such things as impartial observation, impartial means of measurement and that the meaning of the object is uninfluenced by the perception of the observer or the social nature of the object.

This is a dyadic model, which considers that the meaning of the object is equivalent to its measured content. There is no social discourse between the object and the meaning. The interpretative pattern is linear: object→sign→interpretant. We would here consider that the sign would simply be a duplicate of the object (encoded only for communicative and not cognitive purposes) and that the interpretant could only be correct if it were also a duplicate of the sign. Bakhtin, whose analysis of the novel can be considered an analysis of the discursive production of the novel-as-sign, says that the epic form is not a novel, for it does not permit discursive interaction. The epic is 'an absolutely completed and finished generic form' (Bakhtin, 1981: 15), which means that there is nothing to be added by any reader or observer. Therefore, the epic is inaccessible to interaction, and can only be 'viewed' as a complete and finished unit of meaning, which you must accept as given by its authorial agents. Derrida calls such an absolute form of meaning, the 'book', in comparison to the 'text'. The book 'as was the case with the

Platonic writing of the truth in the soul, in the Middle Ages too it is a writing understood in the metaphoric sense, that is to say a natural, eternal and universal writing' (Derrida, 1976: 15). And 'the idea of the book, which always refers to a natural totality, is profoundly alien to the sense of writing' (Derrida, 1976: 18).

This requires some explanation of terms. The book can be understood as the object viewed in that linear dyadic infrastructure which only permits a non-interactive observation and a non-interactive acceptance of its nature, as fully defined, by an authorial namer/author/curator. Writing, to Derrida, exists in the discursive interaction, and 'it is writing, which is actually the act of making sign-units, which 'permits thinking' (1976: 43) for 'from the moment that there is meaning, there are nothing but signs. We think only in signs' (1976: 50). This analysis fits into the discursive paradigm. However, the observational paradigm considers that the meaning of the object is existent only in the object (not in the mind of the observer), and is completely measurable by impartial means. If we analyse a cultural object, such as a ceremonial spear, within the observational paradigm, then we would consider that both the cultural content and the material content had been 'put into' the object by some original agent as author/creator. And the content of this object (both its material and meaning-content) could be completely understood by an observer, even if he was not a member of the society which used that object as a social sign. This understanding of knowledge expects that an observer will receive the knowledge, which is inherent in the object, in an intact form. The communication act falls in a straight, unhampered line, from object to knower. If there is any problem with reception (which is also defined at one and the same time as understanding), it is because the knower's mind has been clouded with misconceptions, and prejudices. This is a simple outline of the mechanical and empirical analysis, and has been called the 'scientific theory', which held that 'nature is transparent to human reason' (Westfall, 1971: 1) and knowable by the inductive and objective observations of man. It is perhaps obvious that I have serious doubts about the validity of this paradigm.

Gadamer notes that 'understanding is not a mere reproduction of knowlege' (1975: 45). This suggests that understanding is not a copy or even version of whatever we define as knowledge,

and therefore understanding does not come from direct observation. Further, there may not be any such thing as 'knowledge' inherent in the object, which we may then observe or copy. In favour of the discourse theory of knowledge, Gadamer suggests that there can be no such thing as an 'open' or 'empty' mind which simply receives data, for 'it is not so much our judgements as it is our prejudices that constitute our being' (1975: 9). Prejudices 'are simply conditions whereby we experience something – whereby what we encounter says something to us' (1975: 9). By prejudice, he did not mean misunderstanding, or untruth, but rather, knowledge which we already hold (compare this with Heidegger's 'fore-having, fore-sight and fore-conception'). Peirce also notes, in his criticism of the Cartesian empirical method (which I have described under the observational paradigm) that 'We must begin with all the prejudices which we actually have when we enter upon the study of philosophy' (5: 264). Understanding operates within understanding. The knowledge which we have developed exists as a logical structure within which we make further observations, perceptions and then derive understanding. Bakhtin's theory of the 'utterance' is similar, for the utterance is 'necessarily produced in a particular context that is always social' (Todorov, 1984, 43). The utterance, which can be understood as a sign, 'is addressed to someone (which means that we have at the very least the microsociety formed by two persons, the speaker and the receiver) second, the speaker is always already a social being' (Todorov 1984: 43).

If we examine these statements, we see that understanding an object can only come about when we experience it as a sign, as a social unit, not simply as a material reality. And it is only a sign, which is a group reality, when it is experienced in an interactive relation, such as discourse, an utterance. There is no experience outside its embodiment in signs. It is not experience that organizes expression, but expression that organizes experience (Bakhtin, 1973: 101). That is, the sign, which is a social state or group reality, is the only form of existence which we experience. As a social state, it is a cognitive system, an organized state within which meaning exists. We know or understand only via the systemic format of the sign. It is in that discursive format of the sign that both the object and the observer come into

existence as signs, or units of meaning, within the experience of the interaction.

If we were to try to establish a simple communication diagram of these two models of knowledge, then the 'observational model' would require (1) a static object, complete in its own data content; (2) an observer of similar format; and (3) a clear communicative path, a media channel (vision, hearing, touch, taste, smell) along which the data-units would move, without interference, from the object to the observer. This model would lay great stress on the powers of the individual to ferret out the knowledge which was stored in the object and then to organize it and recognize its mechanical interactions. It would also stress the ability of the channel to move information without interference. A museum using this model might have the curator gather all the data about the object, and visualize it in some media channel so that the museum observer would receive it exactly as presented. We know now that meaning is not created in such a linear and non-interactive moel, but many of museum systems use this model, and we must consider it in our later discussion of the modern museum.

The discursive model would consist of the object and the observer, but neither would exist as separate, static material units. Rather, they would exist only within an interactive format. The object would only be understood, and therefore, be existent, within the interaction of observing and being observed; the same would be true of the observer. This communicative interaction or expression forms the basis for meaning. Existence therefore is only possible within meaning, as a sign. The sign can really be considered to be a discursive interaction, not a simple unit. This model of meaning would not include the concept of a communicative channel from one unit to the other; for the two units do not exist, ever, separately; rather, the two units would come into existence together, within the one interaction. Knowledge about one unit (let's say, about a tribal robe) would exist within the tribe's use of the robe as a meaningful sign. Meaning would only come when an agent 'made meaning' with his actions, with his usage of the robe as a sign. If he did not understand his actions as meaningful (being from another tribe), then the object, in its tribal identity, would not exist.

What if this agent, who was from another tribe, used the robe (whether by touch or simply by vision), but in another way from the normative act. Would the robe, as sign, exist? Yes, but only within its new meaning. It would no longer exist within its old meaning. If we take this analytic method into the museum, then we can perhaps say that the object exists in a pre-sign, a form of existence which has a potential to be a meaning. A particular mask which is to be used in a particular ritual will have meaning only when it is being used in that ritual. Before that, it exists in what could be considered a 'state of suspended animation', waiting to be 'made meaningful'. This state of pre-existence in the discursive paradigm is very important. We can say that an object exists in what Bakhtin refers to as 'text *in potentia*' (Todorov, 1984: 18). Essentially, it means that an object or concept has been admitted to the social frame, that it is considered, in its form as a sign, as a valid unit-of-meaning. It exists in what we could describe as Levi-Strauss' 'bundle of relations' (1963: 211), where a unit, such as an action or an object, is also linked with its interactive usage. The bundle of relations, which are the interactive actions within which the unit will become existent and meaningful, are stored within the social knowledge of this 'text *in potentia*', as the potential to be meaningful. It is not the actual object which is stored, for in itself it has no meaning. It is the bundle of relations, the set of interactions with the people in that society that will make the unit meaningful which is stored in group memory. Therefore, the mask in the museum, which exists in a state with a potential for meaning, will not be understood as it was used. It will be understood within the context of our own social meanings, within the text of our 'bundles of relations'.

We must not forget that this discursive theory creates not only the existence of the object, but also that of the observer. For the observer also exists only within a discursive interaction. If he is not interacting, creating a sign, then he too does not exist as a socially meaningful unit (even if his social 'group' consists only of himself as a hermit). The repetitive actions of rituals, epic songs, of social behaviour in all social groups, both tribal and industrial, are understood not simply to be for the existence of the object as a meaningful sign, but also for the agent as a meaningful social being, a positive member of the group. It can

be easy therefore to understand the rationale when one tribe considers the person from the other tribe as a 'non-existent being'. For the person from the other society is not interacting with the objects, creating meaning in the same way as the other members. Therefore, quite literally, as a social unit, he does not exist. A museum display using this paradigm might try to present the multiple signs of the robe; as used by the tribe at various times in its history, as created by another tribe, as created by a current museum visitor.

These two methods of understanding, the discursive and the objective, seem entirely incompatible with each other. Not only are their methods in 'making meaning' very different from each other, but their methods in 'observing meaning' are also very different. I consider that the discursive paradigm has a greater validity in explaining the nature of meaning. Can it be used within a museum?

We must further consider the actual objects of a cultural group. A society does not accept all units of its material world as meaningful, but is highly selective. What is valid for one group will be meaningless in another group. What one group will consider truthful, another group will consider false. To give one example, 'The old time Hawaiians used to talk often ... of the terrible custom the Whites had of using a sheet sometimes to lie upon and sometimes to lie under – they [the Whites] did not seem to know that what belonged above should remain above and what belonged below should stay below' (quoted in Levi-Strauss, 1966: 144). A first point is therefore that objects-as-signs are specific to their group. They cannot be moved from society to society and retain the same meaning; the meaning will change and the object may even become meaningless. No matter which paradigm of knowledge the society uses, its signs are meaningful only within a specific social group. We can now begin to consider what we may call the 'original society' and the 'museum society'.

The original society and the museum society

A society requires systems which permit its social knowledge of the world to be organized, enduring, interactive and coherent. It

requires social systems which *name* its units-of-meaning or signs; which *store* these signs over both time and space; which *teach* them to young and new members of the society; and which set up correct formats for their *usage* in daily life. These Four Verbs (Taborsky, 1988) form the basis for a coherent pattern of understanding within a group. They are what make a group not simply a sum of people, but a society, with a stable set of behaviour and beliefs which bind them together into a meaningful and productive organization.

A namer can be considered a social agent, who has the social right to give a unit, be it material or mental, a 'name'. This name can be considered its social right of existence, for the name, which is also a sign, provides that material/mental unit with meaning. It is no longer 'noise' or 'nothing'; it becomes a germ cell, an atom, a tree, a national flag. It becomes part of the long-term social identity. Once named, the meaning of that object may have a limited range of interpretation in the society. You can have a discursive interaction with it and create an individual interpretation, but the potential to change fully the basic meaning is limited. Namers are powerful agents in societies. They can be considered gods, tribal prophets and elders, the government, the supreme courts, the teachers. Non-namers are understood in a derogatory fashion, when we call them (name them) by such terms as 'blue-collar workers, illiterate, poor, uneducated'.

How do these actions of developing meaning work in a modern museum? First, we should realise that we are dealing with two societies. The original group is one society; the museum, its curators and its visitors, is another society. Therefore, we must recognize three namers. Firstly, there is the original namer, who defined the object in its existence within the original society, secondly, we have the curatorial namer, who defines the object in its existence within the museum society, and finally there is the visitor namer, who defines the object in its existence within his current society. Their definitions of the object may not be the same. For instance, a tribal namer may consider that the real source of meaning of that object lies within the powers of the astract tribal gods. He considers himself to be only an intermediary agent, moving the object, the mask, into a spatio-temporal situation where it can be used and made meaningful in a ritual. Further, the meaning of

the object is valid only within the ritual, and only in that society. Outside the ritual and outside the society, the mask is considered meaningless and even potentially harmful, for it may be invested with wrong meanings by other interactions. A curatorial namer may consider that the meaning of the object lies in the object, and his analytic, objective assessment of the object's role in the social group. He does not consider that the meaning is existent only within a ritual interaction; that it can change, and that it now has a different meaning to the original tribal group. And, he may consider that his interpretation, expressed by labels and articles, will be similar to the original namer's interpretation. Finally, the visitor namer may interpret the mask within his understanding of tribes as 'people who believe that trees are gods'. Indeed, the mask can be considered to be three different objects; one in the tribal society, one in the curatorial museum society, and one in the visitor's society.

Let us look at another example. The collection of rifles from a specific battle in the First World War is understood differently by the two different societies which use it, the original war society and the museum society. The original namer, that is, the one who exists within a discursive spatio-temporal interaction with the rifles, at the same time, in the same space as their usage, has an understanding of their usage, their social meaning, which includes their current usage. He may not include in this meaning an understanding of the whole role of the war in the changing socio-economic structure of societies. He may not include in this meaning an understanding of what gunpowder means in its spatial interactional powers, and its destructive capacity. He will, however, include in his understanding an immediacy of the sound, smell, touch and sight of the rifle, and the results of its actions, which will be all missing in the curatorial namers's understanding of the rifle.

Are these two different societies and their signs incompatible with each other? Is one more valid than the other? The answer to the second question is, of course, that neither is more valid. The signs are each valid, within their different societies. The original namer's understanding includes the meaning of the rifle in its current spatio-temporal frame, in the immediate war. The curatorial namer's understanding includes the meaning of the rifle in its current spatio-temporal frame, in the museum, in

the area where objects and meanings are abstracted from current discourse, and stored, analysed and not used in what was their original current interaction. Now, are the two meanings incompatible with each other? They may be, but only if we consider that one *or* the other meaning must be accepted. For instance, if we consider that the Bororo's understanding of their ritual of returning their dead to water restores energy to life, is a less scientific understanding of the nature of energy than the Western interpretation of atomic energy waves and particles, then we have made a decision that only one meaning is acceptable as 'truth'. But if we consider that the two interpretations are both valid within different social frames, then the two explanations would be compatible. The Bororo signs, their understanding of what we consider energy, and matter, are entirely different from the Western terms. And it is not simply that the terms are different; we could not simply substitute our word 'energy' for theirs, for their terms are not equivalent, but the role of energy, the role of water, the role of the body, are entirely different in their society. If we consider that the two explanations are both correct, but in different times and places, in different societies, then the meanings would be compatible.

This relativism may well be distasteful to readers who are searching for a unified meaning, but I suggest that such unity, which requires reductivism of all diversity, cannot be done. The validity of meaning is based around its being relative, its being specific to its spatio-temporal existence. It is 'oriented' as an interaction between two units, the object and the observer, the speaker and the listener, the text and the reader. I would mention here Searle's understanding of the illocutionary speech act as the basic unit of meaning, for 'the unit of linguistic communication is not, as has generally been supposed, the symbol, word or sentence, or even the token of the symbol, word or sentence, but rather the production or issuance of the symbol or word or sentence in the *performance* of the speech act' (Searle, 1969: 16, my emphasis). And the nature of the speech act is that it has an intention to produce meaning; it includes in its existence, the concept of the 'other', of the listener, reader, receiver who will be affected by the statement. 'Even the baby's crying is "oriented" toward the mother' (Todorov, 1973: 104).

The meaning in both societies is specific to the interaction,

and we must therefore consider this in our assessment of the object in the museum. The sign may be translated, but the interaction which is mediated by that sign is not so easily transferable. An object has meaning only within a social framework. A totemic mask means something different to the observer in the tribe and the observer from another society (Western urban). If the interaction, let us say with this mask, is not a straight linear movement of the definition of the mask from the object to observer, but, as an action, helps to define both mask and observer, in their social existence, then we should perhaps be asking the observer to clarify what this interaction is doing to his own definition of himself, and also to the object. Is it identifying him as separate from such a culture? Is it encouraging him to seek objects in his own socio-cultural horizon which work in similar ways to define his own society's meaning? Is it encouraging him to be aware that he cannot, in his interaction, fully define the object as it is defined by someone in the tribal group? Is it exploring the many ways in which this object is defined, by both members of the owner group and members of the museum group?

Where does this analysis take us so far, particularly with regard to museums? The analytic frame which determined the nature of museums for many years has been based on a belief in the uniqueness of the individual and the object, and on their separation from each other in time and space. This analysis decided that meaning is a separate unit, a message, which moves, intact, between spatio-temporal sites. Therefore, it rested in the object and was meant to move intact to the observer in the museum.

Modern analysis of cognitive action is saying that this is not how meaning arises, by a straight path from site to site. The meaning of the object only becomes existent in an interaction between observer and object. Where the former theory believes that the distinctive nature of the observer and object is basic, a given, and that the action of 'interaction' is simply an untrammelled movement of a message from object to observer, the discursive paradigm says that there is no definitive reality of the observer or object, which is inherent in either. Such identification, such meaningfulness, only occurs in interaction. Without such interactions, the object/observer would 'melt' into meaningless bits it would have no definitive identity, no meaning.

Such actions, which are also the basis of biological life, only occur in interaction. Therefore, interaction is crucial to the existence of both observer and object. Then, this analysis leads us to think that there is no basic meaning within the object. No basic message which is being transferred from object to observer. The discursive paradigm considers that the interaction between the two is not for the movement of a message but the establishment of each being's spatio-temporal reality. This interaction, then, establishes meaning or identity for *both* the observer and the object. Each unit defines itself in this interaction. Thus there is no such thing as a single meaning, inherent in either, which is being communicated to each other. The meaning of both observer and object is being defined by the interaction. However, this interaction can only be done within a conceptual framework which is socially based. This discursive paradigm has essentially moved the site of knowledge from the single unit (the object, the observer) to the group. Knowledge is based within the group and becomes existent only by a discursive interaction which is contextually based within the society. What kind of a museum can deal with what are, essentially, two objects – observer and object? What is a discursive interaction, in a museum?

We should now see that there are a number of areas to concern ourselves with when we are searching for meaning in the object. First, the meaning of an object, which becomes a sign when we assign a meaning to it, appears only within a discursive interaction of the observer with the object. Second, the observer is always 'grounded' in a specific society, which provides him with a conceptual base which he uses for developing meaning. There is no such thing as a 'free' or cognitively unattached observer. Therefore, we are always dealing with two societies in the creation of meaning, the original society and the museum society. The meaning of the object in the original society and in the museum society may and usually will be entirely different.

The discursive object

There are several key factors to consider about objects of meaning. First, an object exists as a sign, which is a meaning

defined and existent within a group consciousness. Second, this definition is existent as a social truth and not a material truth. Social truths are more powerful than basic material reality, for the meaning of material reality is only understood within a social framework. As Peirce notes, 'A Sign mediates between its object and its meaning' (Peirce, 2: 229), understanding the object as the material unit, and the sign as the social unit. Third, meaning only becomes existent in the moment of interaction. If the sign is abstracted from usage, it is meaningless, as an amulet, unused for several centuries, hidden in the ground, is not only meaningless during its burial, but may also be when unearthed and is not understood as an object of any social meaning. And fourth, a meaning exists only within a social group, and not the same meaning to other groups.

I am going to deal with the nature of the object, as a sign or unit of meaning, under Peirce's division of signs. I hope that division may help museologists to understand the discursive object. The sign, according to Peirce, exists in a number of meaning formats. The first division, the 'qualisign', considers signs in relation to the observer, as *qualities*, not as meanings. The 'Qualisign is a quality ... it cannot actually act as a sign until it is embodied; (2: 244) and 'a Qualisign (eg. a feeling of "red") is any quality in so far as it is a sign ... it can only be interpreted as a sign of essence' (2: 254). A qualisign exists in what Peirce considers the 'first' mode of being. 'Firstness is the mode of being of that which is such as it is, positively and without reference to anything else' (8: 328). The key factor about the qualisign is that one experiences it without any understanding of the experience. For it is not yet a distinct and separate sign, which one can understand. It is a 'feeling of redness, of heat, of something' ... 'without reference to anything else'. What would be a qualisign experience? The sensation of being in a heritage house, of smelling the cooking, feeling the rough floors, feeling the heat from the fire. That is all. A qualisign is an experience, but does not move beyond that into an awareness that the smell refers to cooking, that the feel refers to a rough floor, that the heat refers to the fire. A qualisign is an experience with no reference.

The second category of sign, is the 'sinsign'. A Sinsign (where the syllable sin is taken as meaning 'being only once' as in

71

single . . .), is an actual existent thing or event which is a sign. It can only be so through its qualities; so that is involves a qualisign, or rather, several qualisigns. But these qualisigns are of a peculiar kind and only form a sign through being actually embodied (2: 245–6). A sinsign exists in the mode of 'second-ness', which is 'the mode of being of that which is such as it is, with respect to a second' (8: 328). An object which exists in secondness, is *differentiated* from a second object, and is an actual sign, with its own meaning. It exists in a steady state, clearly intact and differentiated from another sign. If we use the same example, then our sinsign experience of the heritage house is a distinct awareness of heat, as being warm (as differentiated from being cold), as coming from the wood fire (and not from a gas furnace); that the floors are rough, as differentiated from smooth, and this is because they are wood and not carpeted. It is an understanding of the singular identity and the casual forces of those sensations.

The 'legisign' is 'a law that is a sign. The law is socially created. Every conventional sign is a legisign. . . . It is not a single object, but a general type which, it has been agreed, shall be significant'. (2: 246). The legisign exists in the mode of 'thirdness' whinh is 'what it is by virtue of imparting a quality to reactions in the future' (1: 343). There is a sense of habit, of law, of stability of the social meaning of this sign into the future. In the heritage house, the legisign experience is an understanding that these objects exist within a social frame of meaning, which by social habit, agreement or 'law', used fire for cooking and heating, built their homes of wood, made many goods in their home, rather than by the market system, and so on. It is the understanding of this 'object', the heritage house, within a social group in a particular time and space.

How do these three forms of the sign operate in a museum? We must first be aware of the distinct nature of all three and, above all, we must use all three forms of the sign. Many museologists are highly aware of our current cognitive emphasis on 'interaction' as a means to knowledge. But, this interaction does not mean a confinement to only a qualisign interaction, based on simple sensation. There are two other forms of the sign, and the museum, as a public system involved with the meaning of the object, cannot confine itself to only one sign-form

of the object, but must include all three. An exhibition based only on the qualisign does not provide a situation for the discursive production of meaning which has some relevance to the object in its 'original society'. Rather, a qualisign exhibition provides a situation where the meaning is created only within the context of the observer's society, the museum society.

An example would be an exhibition of totemic symbols of Australian tribes. If these objects are considered only as qualisigns, then the observer in the museum society may well understand them, in his discursive interaction, as symbols of a primitive and unscientific culture, for 'totemism served for a time to strengthen the case of those who tried to separate primitive institutions from our own' (Levi-Strauss, 1963: 103). Or he may see them only as artistic representations and not as the signifying and classificatory social signs which they are in their original society (Levi-Strauss, 1966). He will interact with them, quite naturally, as qualisign sensations, but will only be able to move on to the next stage of meaning, the sinsign, within the cognitive legisign boundaries of his own society, which classifies signs by a totally different system (Levi-Strauss, 1966). The museologist must be aware that we make meaning within a discursive interaction with the object, and that this interaction has *three sign stages* of developing meaning. The qualisign experiences the sensation, the sinsign uses both that sensation plus the legisigns of habitual belief which are in the observer's social memory, to come up with a sign-meaning. An example would be that the observer uses the qualisign visual sensation of an Australian churinga and uses his own long-term legisigns, which are valid only within his own society, and develops a sinsign current meaning of the churinga as an unscientific and simple-minded 'analysis'.

We must be aware that we are always dealing with two societies, the original society and the museum society. The conceptual format of both may be entirely different. We cannot expect that the observer can abandon his social horizons, his legisigns, and move immediately, if ever, into the original society's conceptual format. If we accept that meaning is created within a discursive format, and does not come as a packaged unit-of-meaning from the object to the observer, then we must accept that the observer is a participant in the creation of

the object's meaning as a sinsign. I do not believe that the observer can ever function within the original society's conceptual format. He cannot 'be' a discursive member of an Australian tribe. He cannot exist in the seventeenth-century heritage era. He cannot abandon his own social conceptual base; he remains in the museum society, and the museum should not deceive him into thinking that he can abandon his conceptual base. It should not simply present the qualisigns of an exhibition (the sensations), for that would mean that the legisigns (the habits, social laws) which fill in the sensual data and provide the meaning – the sinsign – would come from the observer's own society. This is a distortion: it acually splits the sign up and puts it into two different societies. The qualisign is in the original society; the legisign and the sinsign are in the museum society.

This is, in fact, the same analytic action which the early colonists and explorers used when they met natives, observed their social behaviour, and judged these peoples as primitive and uncivilized. It is the same method used by early historians who viewed the medieval peasantry as backward and illiterate. The museum must present all three parts of the sign and locate them within the original society. It should also help the museum visitor to understand that there are three parts of the sign. It must acknowledge that the sinsign, created by the observer, will never be a duplicate of the original sinsign, but at least, it will not be an extreme distortion. The museum could present the legisigns, the analytic base for these Australian meanings, within the whole exhibition. The museum could also provide the observer with some awareness that his own society has a different analytic base, which is answerable only within its own society. Then the observer could interact with the exhibition, not simply on the qualisign level, (for his own legisigns and sinsigns about the objects would be valid only within his society). The museum must provide 'objects' or data from the original society, for all three phases. Otherwise, the observer will use data from his own society for the legisign and sinsign phases. The museum has the social obligation to inform, not to misinform.

The museum, clearly, has an important social function – to explore objects as signs, that is, as objects which are socially meaningful. An object on its own has no meaning, objects exist

only as signs. Our discursive interaction with that object moves it into a meaningful state, a sign. The discursive object is a far more complex 'situation' than the simple object, and should be recognized as such. The museum should base exhibitions around the discursive object. This would include the conceptual interaction with that object, both in the original society and the museum society. It is not enough for museums simply to provide the object, or even the object within its (original or museum) surroundings. The discursive object exists not as a unit in interaction with its environment, but as a unit in interaction with conceptual beings. It is this object which I am urging museums to explore; the object as a sign.

Notes

1. Perhaps for this reason, both Saussure and Barthes place little focus on the object. Saussure is most emphatic on the arbitrary nature of signs and their differential nature, as distinguishable from other units. He sees no need to involve the object. However, Peirce insists on a sign being 'grounded', by which he means that it must relate to an experience of reality (Peirce, 2: 231).
2. See Peirce's Ten Classes of Signs (2: 254–63).
3. The terms expression and content refer to Hjelmsely's terms of expression plane and content plane.
4. I have in previous papers called the discursive paradigm Syntax A and the observational paradigm Syntax B (Taborsky, 1985).
5. Hjelmsely calls the object an expression, which might be a better term to suggest its active aspects; however, I will use the Peircean term of 'object'. See discussion by Tejera (1988) and by Eco in Sebeok, (1975).
6. Recent discussion on dialogue discourse can be found in Bakhtin (1981); Derrida (1976, 1988); Searle (1983); Todorov (1973). These are recent works, but the research of Peirce, Huserl, Heidegger, Buber and others should be included.

Bibliography

Bakhtin, M., *The Dialogic Imagination* (University of Texas: Austin, 1981).
Barthes, Roland, *Elements of Semiology* (Hill & Wang: New York, 1967).
Bloch, M., *Feudal Society*, vol. I (Routledge & Kegan Paul: London, 1965).

Derrida, J., *Of Grammatology* (Johns Hopkins Press: Baltimore, 1976).

Derrida. J., *Limited Inc.* (Johns Hopkins Press: Baltimore, 1988).

Eco, Umberto, 'Looking for a logic of culture' in Sebeok T (ed.) *The Tell-Tale Sign* (Peter de Ridder Press: Lisse 1975): 9–18.

Eco, Umberto, *A Theory of Semiotics* (Indiana University Press: Bloomington, 1976).

Eco, Umberto, *The Role of the Reader* (Hutchinson: London, 1979).

Eco, U. Santambrogio, M. and Violi, P. (eds), *Meaning and Mental Representations* (Hutchinson: London, 1988).

Foucault,Michel, *The Archaeology of Knowledge* (Tavistock: London, 1972).

Foucault, Michel, *The Order of Things* (Tavistock: London, 1973).

Gadamer, H. G. *Truth and Method* (Sheed & Ward: London, 1975).

Heidegger M. *Being And Time* (Basil Blackell: Oxford, 1962).

Hjelmselv, J., *Prolegomena to a Theory of Language* (University of Wisconsin Press: Wisconsin, 1961).

Husserl, E., *The Idea of Phenomenology* (Nijhoff: The Hague, 1970).

Jackendoff, R. *Semantics and Cognition* (MIT Press: Cambridge Mass., 1983).

Jackendoff, R. 'Conceptual semantics' in Eco, U. et al (eds) *Meaning and Mental Representations* (Hutchinson: London, 1988): 81–98.

Jenness, D., 'The Carrier Indians of the Bukley River', *Bullètin of the Bureau of American Ethnology* (1943): 133.

Levi-Strauss, C., *Totemism* (Merlin Press: London, 1963).

Levi-Strauss, C., *The Savage Mind* (Weidenfeld & Nicolson: London, 1966).

Lord, Albert, *The Singer of Tales* (Harvard University Press: Harvard, 1971).

Mead, G. H., *Mind, Self and Society* (University of Chicago Press: Chicago, 1934).

Morson, G. S. (ed), *Bakhtin: Essays and Dialogues on His Word* (University of Texas: Austin, 1981).

Peirce, C. S., *Collected Papers*. Edited by P. Weiss, C. Hartshorne, A. Burks (1931–58) 8 volumes (Citation in text is by volume and numbered section). (Harvard University Press: Cambridge, Mass.)

Sachs, M., *Einstein versus Bohr: The Continuing Controversies in Physics* (Open Court: London, 1988).

Searle, J. *Speech Acts: An Essay in the Philosophy of Language* (Cambridge University Press: Cambridge, 1969).

Searle, J., *Intentionality: An Essay in the Philosophy of Mind* (Cambridge University Press: Cambridge, 1983).

Stanford, M., *The Nature of Historical Knowledge* (Basil Blackwell: Oxford, 1986).

Taborsky, E., 'Syntax and society' in *Canadian Review of Sociology and Anthropology*, 22, 1, 1985: 80–92.

Taborsky, E., 'The semiotic structure of societies: the four verbs of cognition' in *Methodology and Science*, 21, 3, 1988: 202–14.

Taborsky, E., 'Society as Text' (in press).

Tejera, V., *Semiotics from Peirce to Barthes* (Brill: New York, 1988).

Todorov, Tzevtan, *Mikhail Bakhtin: The Dialogical Principle* (Seuill: Paris, 1973).

Westfall, R., *The Construction of Modern Science* (John Wiley: New York, 1971).

Whorf, B., *Language, Thought and Reality* (M. I. T. Press: Cambridge, Mass., 1969).

3

In the lair of the monkey: notes towards a post-modernist museography[1]
ANTHONY ALAN SHELTON

A later version of a paper originally given as a lecture in the Faculty of Art History, University of Ghent, 1988

Art does not discover, it constitutes; and the relation of what it constitutes to the 'real' . . . is not one of verification.

Castoriadis

It is not possible for power to be exercised without knowledge. It is impossible for knowledge not to endanger power.

Foucault

Introduction

The monkey in the title of this paper alludes to a character which appears in Borges, *The Book of Imaginary Beings:*

This animal, common in the north, is four or five inches long; its eyes are scarlet and its fur is jet black, silky and soft as a pillow. It is marked by a curious instinct – the taste for India ink. When a person sits down to write, the monkey squats cross-legged nearby with one forepaw folded over the other, waiting until the task is over. Then it drinks what is left of the ink, and afterwards sits back on its haunches quiet and satisfied (1974: 101).

The monkey drinks what has been left unwritten by the writer or what has been undisplayed by the exhibitor, unrecorded by the archivist or unclassified by the metaphysician. He swallows, as well, all trace and knowledge of the programme which instigated the endeavour to do these things which can be 'seen' to be 'done'. Alicia Borinski (1977) has discussed some further questions that the fable gives rise to. The silence of the beast 'is

BEAR in mind!

, never-
forth by
estion is
lf. Every
organisa-
e accept-
It is such
calls the
n' of an
he truth

ims only
succinctly from the position of the writer, and after acknowledging the contributions of this line of enquiry, turn to the world as it is seen by the monkey. The juxtaposition of the positions of writer and monkey are paired with two divergent trajectories represented by modernist, or pre-critical, modes of discourse and post-modernism. Modernism and post-modernism are used in the sense defined by Lyotard: 'modernist is used to refer to sciences that legitimate themselves by the generation of a meta-discourse which appeals to a philosophical system' (Lyotard, 1984: XXXIII). Post-modernism is essentially an attitude of 'incredulity towards metanarratives' (1984: XXXIV). It will be necessary in the course of this discussion, and in the light of Lyotard's work itself, and that of the authors at one time associated with the group *Socialisme ou Barbarie*, to question the distinction between metanarrative and 'science', but this definition remains a useful preliminary statement which situates post-modernist thought in an intellectual genealogy which includes Wittgenstein and Bachelard, while accepting no organic principle of descent in the generation of their work.

The world of the writer

Sociological thought has forwarded two principal representations of society. The first is a model based on the organic analogy, where the various institutions are locked together to form a harmoniously working whole, while the second views society as a binary relation between an infrastructure and a

superstructure. Each theory produces a different view of knowledge, but creates similar effects. Bourdieu's early work draws its inspiration from both of these and in consequence is limited by the implicit dualism between the spirit and the material, the ideal and the real, and culture and society.

For Bourdieu, the museum or art gallery plays a similar role to that performed by the educational system on which he has written in much detail. He argues that it is not sufficient to characterize ideology as a nebulous and ungrounded corpus of false-knowledge presuppositions whose chimeric qualities mask the effects and mechanism of the working of a social formation. Such a corpus not only has to be itself produced, but also invested with its own legitimacy and transmitted over time from generation to generation if it is to provide the legitimating creed in which the society can reproduce its socio-economic relations. Bourdieu views the educational system not only as the mode of transmission of official culture, but as an institutionalization of that culture which prescribes competence in its attainment, regulates access to ownership of knowledge, and encourages the constant renewal of its central truths by their teleological referral to a series of object phenomena which it claims are constituted outside, and are independent of it.

The educational system provides the institutional organization which enables a prescribed type of pedagogic action to realize itself. The purpose of all such actions is to impose a set of values derived from a cultural milieu on to heterogeneous segments of a population as a means of creating a community of concensus. Not only is pedagogic action ideologically compromised but its contents and organization are arbitrarily constituted. For Bourdieu, pedagogic action serves to masquerade an arbitrary corpus of knowledge, made up of different epistemes, as 'universal knowledge'. He argues that such a corpus is derived from a distillation produced by the dominant classes designed to naturalize their interests and continue to enlist the subordinated classes into labour relations on projects whose pedigree is made to appear above partisan interests. Pedagogic action thus serves to create a misrecognition of the conditions of society as a part of a strategy to promote its social reproduction. Since cultural institutions are entrusted with the reproduction of these power relations they themselves must possess an

irreproachable efficiency, since any failure on their part also endangers the organization on which their own actions are predicated. The educational system manipulates a semantic repertoire which is directly concerned with the reproduction of power relations within a social formation. Since the corpus of 'knowledge' which it transmits is arbitrary, and particularistic, its programme conflicts with other semantic fields produced by subordinated groups within the same social formation. By attempting to impose its 'official' version of the world on these groups – whether they be defined by class, gender or ethnicity – it devalues their own cultural productions either explicitly or simply by excluding them from the definition of the category and ignoring them: 'all pedagogic action is, objectively, symbolic violence insofar as it is the imposition of a cultural arbitrary by an arbitrary power' (Bourdieu, 1977: 5).

Clearly, every type of pedagogic action implies a pedagogic authority on the basis of which it is implemented and accepted by the different social groups. The necessary legitimacy which sanctions all such authority is derived directly from the work to which all such actions are dedicated. By mystifying the source of knowledge, by displacing it from the site of its social production and identifying it as natural or even divine, knowledge is held to be discovered and not produced. The source of this knowledge is at the same time held to be the basis of its authority, so that the educational system guarantees the authority of knowledge, as the values such knowledge encapsulates, give their support to the educational system.

Pedagogic action, by reproducing the power relations on which the social formation is predicated, establishes a 'habitus'; a 'system of schemes of thought, perception, appreciation, and action' (Bourdieu, 1977: 40). It is on the basis of constructing an efficient habitus that the system guarantees the preparation of future operators capable of sharing the values to which the dominant classes are predisposed and the educational system mandated with upholding. The efficiency of the system is dependent, therefore, on the exhaustiveness of the habitus it produces. Although not taken up by Bourdieu, there is here an interesting suggestion that social formations strive towards an optimal performance by attempting to achieve greater systematization of the habitus, which results not only in the ever clearer

crystallization of structural principles, but the danger of their successive loss of opaqueness. The ability of agents to function in the social formation, to acquire 'habits of taste' which enable them to be effective manipulators of knowledge, depends on the variegation pedagogic work has accomplished in the specialization of roles prescribed by the habitus. Access to cultural institutions, although apparently open to all, demands the recognition of a code upon which the act of 'appreciation' is dependent.[2] This point brings Bourdieu to consider specifically the museum as a form of pedagogic work whose codes and classifications are first apprehended through other institutions, but whose presentations are specific to it (1977: 51). While the educational system is the principal mode of pedagogic action, it is clear, from Bourdieu's theory of symbolic violence, that it exists with other agencies which are dependent on the habitus it creates, and, furthermore, which predicate their very existence by projecting specialized continuations, parallel reinforcements, and/or secondary modes of legitimation by a commitment to similar strategies and principles of operation.

It is in the context of this general scheme that Bourdieu situates the practices of 'secondary institutions' concerned with the transmission, manufacture and conservation of cultural objects. In no other sphere of society do institutions so vehemently disavow economic interest as among the publishing trade, theatre producers, galleries and museums, but this apparent situation is effected by a misrecognition of the operation of the field of institutional practices, which, far from subsisting outside of bourgeois political economy, is well integrated into it. Bourdieu's 1977 work examines the development of these institutions over time and, by modifying a Marxist concept of capital, is able to demonstrate how this field builds for itself a practice of consecration which enables it to accumulate economic capital.

To conform with the principles of the habitus in which they function economic interest must be disavowed before aesthetic recognition can be bestowed on a cultural agency.[3] Such agencies must consecrate a name for themselves and construct a genealogy on the basis of which they will be invested with a signature. It is during these initial moments that economic capital on 'art' leads to the accumulation of symbolic capital in

the process of constructing a genealogy of sponsored works. Once this genealogy has been successfully produced, it provides the agency with a power to consecrate objects and convert aesthetic value into financial profit. At this point, a distinction should be made between publicly-funded institutions dedicated to conservation, exhibition and education, and private agencies, although, as Bourdieu argues, at no point does either of these institutions fall outside an economic analysis. Value, however, in all these cases is accrued by an object according to its insertion into a classification legitimated by an institutional signatory, and not as popular ideology supposes, derived from its creator. A parallel practice operates between the configuration of educational institutions such as those discussed, and those which consecrate objects. Both are engaged in the articulation of classifications by prescribing registers, through the selection and exclusion of practices and by the arrangement of the products of such operations. They define the 'creative' field and prescribe the values attached to the position of discrete objects within it.

The ideology of creation, which makes the author the first and the last source of the value of his work, conceals the fact that the cultural businessman (art dealer, publisher, etc.) is at one and the same time the person who exploits the labour of the 'creator' by trading in the 'sacred' and the person who, by putting it on the market, by exhibiting, publishing or staging it, consecrates a product which he has 'discovered' and which would otherwise remain a mere natural resource (Bourdieu, 1980: 263).

Not only through marketing, but by investing his prestige in the creator to produce value, the cultural broker acts as a 'symbolic banker' within this 'bad-faith economy'.

Cultural agencies within any particular creative field, occupy different terrains. They are arranged hierarchically and function to ascribe value by imputing a series of relations founded on difference. For a plastic work of art, the mechanisms of its consecration attempt to extend increasingly its value by moving its creator into ever more exclusive spaces. Inclusion into each of these successive spaces marks the work as distinct from those in a preceding category, and although not mentioned by Bourdieu, acts to juxtapose it with the members of new classes already

contained in these spaces and so raise to a greater power the symbolic capital attached to it and, by implication, its exchange value at which it can be converted into financial capital. The alignment of summer exhibitions, group exibitions and one-man shows which continue after its displacement from the sphere of circulating capital to its inclusion as part of a reserve, conserved in prestigious collections or national museums, all conspire to guarantee the investiture of an increasing symbolic value to the work: a value which, it must not be forgotten, at any one time exists as a ratio to financial value.

Cultural objects are manipulated and articulated by reference to a market. As with any other market, the consumers are not homogenous and demand different products as a result of their over-determination by the precepts implicit in the specific habitus which they occupy. It is the orientation of the cultural agencies to particular markets that not only create hierarchical relations within them, but coterminous relations predicated on their occupations of distinct horizontal relations between agencies that can themselves manifest hierarchical principles, which enables Bourdieu to attribute to them a reproductive function. He argues that this is accomplished by successive waves of newcomers who appear to be over-determined by the rules each agency sets at a determinate juncture of their hierarchical configuration. Taken together, the organization of these institutions is not unlike an age-grade society, although instead of regulating access to knowledge *per se*, they serve to regulate the ascription of value to the knowledge implicitly held.[4] At the lowest level of this organization, the recently established agencies commit themselves more to repudiating commercial interests. Their mode of operation leads them to the accumulation of the symbolic capital already described, which progressively, as they ascend the hierarchy, consecrates the signature which infers them the ability to produce economic wealth. At the one end, this cycle of reproduction guarantees the constant reiteration of the ideology which creates the misrecognition of the practices inscribed within the field, while at the other end of the scale it reproduces those practices which themselves form a part of bourgeois political economy, and which enable the replication of the power relations between the constituent agencies, the agencies and their artists, and the agencies and their public.

This leads Bourdieu to distinguish between two factions of the dominant class: the one dominant through its monopoly over economic and political power, which has monopolized the ability to consecrate an object as 'art' within the limited field which we are discussing, and the other, dominated by the first and at certain stages of its history dependent on it. This factionalism which is not only restricted to the creative field, but is also found in the academy (cf. Bourdieu, 1985), produces two aesthetics – the avant-garde and the orthodox – which compete to claim the monopoly over the legitimate vision of the world. In Bourdieu's scheme, this conflict is clearly constrained, and is contained within the movement of objects from one category to another without any displacement occurring. Such a movement is coterminal with the advance of artists and agencies and, far from revolutionizing the process of creativity, is necessary for the reproduction of power relations following identical structural laws as are contained in other sectors of political economy. A change in artistic forms or conventions of representation does not entail any corresponding mutation of the power relations articulated by the institution.

Bourdieu is repeatedly concerned to emphasize that sociological discourse must not isolate its object arbitrarily but approach it from its position in a particular field and the relations and effects which manifest themselves therein (1971; 1977; 1977 (with Passeron); 1985). For this reason, the museum or art gallery must first be understood within the context (1) of pedagogic action which defines the primary network of agencies and their associated reproductive and legitimizing practices, of which (2) cultural institutions integrated within the art world form a similar and complementarily juxtaposed field dedicated to similar purposes. Only within this order can we consider (3) individual institutions such as museums.

It has been necessary to detail Bourdieu's conception of the field and to describe some of its effects before examining other works which, while methodologically distinct, nevertheless, appear to me to required an understanding of his position. Bourdieu constantly refers to discourse as an area of ideas written or verbalized, which are juxtaposed to the institutional system as something distinct and tangible. The universe of discourse itself is ordered according to certain strategies which

are intended to produce particular results. The results themselves are the instrument to procure the continuity of a society. Discourse and discoursive strategies which together with certain practices, comprise the habitus, are distinct from the social formation conceptualized as a set of relations defined by powers exercised by specific groups over others. The habitus is a middle category in this scheme, analogous to the role of agents of socialization in Durkheimian theory, which enables Bourdieu to bridge the dualism implicit in his discourse which continues to reproduce the opposition between the ideal world and nature. In Bourdieu, this dichotomy manifests itself as the opposition between culture and society thus revealing the continual roots of the discourse in a postivist epistemology, albeit a very refined varient.

While Bourdieu attempts to reconcile this dualism, he is nevertheless confronted by the problem of establishing relational identities between aspects of culture and aspects of society. This project leads ever futher from empirical canons implicit in the initial descriptive data providing strata after strata of ideological formations, until the attempt to provide a relational grammar ends by the establishment of causal relations, whereby culture is seen to reproduce society as society guarantees the reproduction of culture. It thus inscribes a world of reality which is self-regulating and hermetically sealed from space and history. This is functionalism taken to a more abstract level where the programme of its theoretical practice leads to the reaffirmation of a binary universe which phrases the problem in the terms appropriate to the set of presuppositions on which it is founded. Furthermore, his work rests on the same epistemology as the system which it attempts to criticize and reasserts, with greater vehemence, the relation between signifier and signified as a product of natural logic, rather that as a cultural arbitrary.

In the final instance, therefore, Bourdieu's method conspires against the position he attempts to demonstrate. But it is the logical inconsistency between method and theory, an inconsistency which he raises in *Outline of a Theory of Practice* (1977), that enables us, while noting the limitations of method, to uphold the insights instigated by his theoretical practices. In this way we can write beyond Bourdieu. Whereas he answers the question of function which has presented itself as a corollary to that

of the nature of existential relation, the analyst must confront other problems consigned to silence by this method. Essentially, these consist in explaining why a certain meaning or value is generated rather than another, and the reason for its ascription to a particular object. Although Bourdieu's theory leads to such questions, the epistemological underpinning of his programme prevents him from pursuing them. And so we leave the consideration of the functions of the museum to come to investigate the axiology of the use of the ink and the properties of the unused ink from which the museum has been drawn.

The world of the monkey: the post-modernist menagerie

If one cannot fully understand institutions through their functions, neither can much success by achieved by reducing the analysis purely to the symbolic systems which they manipulate. Analysis posed at the level of an ethnographic description of the institutions of the art world is as limited as a pure archaeology of the symbolic operators which it uses to legitimate itself. As Castoriadis (1975) argues, all such symbolic systems do not refer to themselves, but to something which stands at their back and is never entirely contained within them. Museums might be legitimated by the function they serve in relation to the materials that they contain, but how is the collection and conservation of such objects themselves justified and to what impetus do they derive their significance as desirable practices? Castoriadis objects equally to a reductionist structuralism and a superficial functionalism because they are unable to provide answers to the questions implicit within their very discourse. A conspiracy of silence seeks to prohibit the phrasing of such questions as: (1) Why was one specific symbolic system chosen in preference to another? (2) What is the relation between a system of signifiers to a system of signifieds? (3) Why and how do symbolic systems sometimes gain autonomy over that which they signify? Castoriadis writes:

One cannot maintain that meaning simply results from the combination of signs. One might just as well say that the

combination of signs results from meaning. After all, the world is not just made up of those who interpret the discourses of others. In order for the former to exist, the later must first have spoken, and to speak they must have chosen signs, hesitated, collected their thoughts, rectified signs that they had already chosen – and all as a function of meaning (1984: 20–1).

And elsewhere:

To consider meaning as simply the 'result' of the difference between signs is to transform the necessary conditions for the reading of history into the sufficient conditions of its existence. And while these conditions of 'reading' are intrinsically conditions of existence, since history exists only because men communicate and cooperate in a symbolic milieu, this symbolism is itself created (1984: 21)

Castoriadis finally accuses the most extreme type of structuralism of not only seeking to deny meaning except in the most limited sense, but to abolish man himself as an effective protagonist within history. When taken with the Kantian critique most piquantly made by Cassirer (1953, 1955, 1957) against meaning as a natural quality genetically inherent in the sign, the limitations of functionalism and structuralism become agonizingly transparent.

Exhibitions share many of the epistemological underpinnings of these methods and result in similar effects. Clifford's (1985) criticism of ethnographic museums and exhibitions such as 'Primitivism' sponsored by the New York Museum of Modern Art, fails to take sufficient note of the differences between museums and the variety and types of exhibitions which they organize. Like Foster (1985), Clifford's main concern is with the decontextualization of non-Western art from the values of its society of origin, and its reintegration into a Western art historical category on the basis of shared psychological affinities between its creators and twentieth-century Western modernists. The relationship between Western societies and small-scale societies, differences in culture, value and the integration of art with other institutions, as well as the political relationship between them is ignored in order to emphasize similarities of style and universal psychological propensities of imagination.

However, while art historical exhibitions are often contrasted with ethnographic shows, their underlying presuppositions may not be that far removed. Conextualization often means ethnographic reconstruction based on a Western natural-realist model. While such exhibitions may well introduce non-Western values, they may, nevertheless, be couched in functionalist terms. Both models naturalize meaning: the first by reducing it to universal psychological processes and the second by situating it as part of a process of adaptation to an environment or to other elements within a closed and coherent cultural pattern. Both types of exhibitions create continuity from essentially discontinuous phenomena by imposing a Western logical framework on the relations between objects and the connections between objects and their meanings. Clifford fails to overcome this dualism between art history and anthropology and the naturalization of value in our understanding the significance of meaning and objects with which they are associated.[5]

Such deflections and misrepresentations have their origin in the metanarratives which underlie the theory and organization of scientific research and the practice of exhibitions and other didactic representations. In *The Postmodern Condition: A Report on Knowledge* (1984) Lyotard identifies the West's dominating metanarrative to be the 'scientific'. The epistemological foundations on which science is said to be founded conceive of linguistic and non-linguistic representations as the reproduction of an external objective world for the subjective consciousness. The effectiveness of the methods, based in such axioms, is evaluated by reference to the accuracy of the concordance and the status of the truth value it conveys. Similar presuppositions have resulted in the uncritical montage of museum and gallery exhibitions. Exhibitions have a predisposition for natural-realism which provides clear advantages for educational projects. However, here education is conceived as an informative and not a formative function. Particular exhibitions have been determined by different approaches, each conceived of as superior or breaking with the previous ones, but all nevertheless constrained by the tyranny of their epistemological foundations. From the Great Exhibition of 1851 to contemporary world trade fairs, the exhibits are intended to stand as the material representation and sometimes demonstration of specific principles

guaranteed by science. A written or spoken text or narrative 'explains' the exhibit object which itself represents or demonstrates an abstract principle, creating a chain of similarities which on occasion can reach the point where the principle is mistaken and colluded with the object that gives it expression as with time equated with the motion of the clock.[6]

Notable in this regard, is the Pitt-Rivers Museum of Oxford University, which identifies the configuration of the objects displayed with the material representation of the laws of natural evolution.[7] At the very inception, General Augustus Pitt-Rivers committed his resources to making a collection of weapons from around the world to demonstrate the stages in the evolution of their technique and design. Later, this enterprise was extended to include all types of ethnographic object, which, when the new museum was opened to the public, under its first curator, Henry Balfour, in 1890, were arranged sequentially as sets under such headings as 'charms', 'weapons', 'clothing', and so on, to demonstrate the universal workings of a transcendental process which reduced history to the homogeneity of a mechanical and organic development (Cranstone and Seidenberg, 1984). The laws of this process were found inherent in the order of a world which was taken as completely natural. Once such laws were discovered they could be demonstrated by representing the material evidence of their workings and the ensuing exhibition held up for public enlightenment. As first described by Marx and developed as a general strategy within legitimating practices by Baudrillard, the idea of evolution began its life as a social category which was projected on to nature which invested it with a scientific value. Once naturalized, it was extended to incorporate a model of social movement and to legitimate the trajectory of the development of a socio-economic formation which had as its most recent achievement the establishment of a bourgeois political economy. The means of enunciation was shared between educational institutions and museums, the enunciation itself was concerned with the legitimation of a new type of society and the politics of the enunciation were a politics of legitimation of emerging power relations which cut across pre-industrial class distinctions.

For Lyotard, all scientific discourse is accompanied by

metanarrative. Such a distinction between these modes of discourse is made on the basis of the type of enunciation they claim to articulate. This typology of enunciative modes usually consigns denotative statements to be the only proper subject of scientific discourse. Although other enunciations may be involved, they are nevertheless subordinated clauses prefacing the denotative statement of scientific enquiry. On the contrary, metanarratives contain prescriptive statements which construct justifications, and therefore modes of legitimation for other discoursive traditions. Science is justified by recourse to two principles: (1) science as a fundamental right of all men whose practice is intended to better the human condition, and (2) scientific research, as a necessary activity for the discovery of general laws which articulate forms of knowledge, tracing its ancestry, and unifiying the principle and ideal in a single idea. Sponsorship of scientific activity depends on justifying its practices and, as Lyotard argues, such activities presuppose not only their legitimation, but also the principles of their operation. The prescriptive rules governing such operations are not, therefore, only foreign to the status of scientific discourse and themselves unverifiable by it – that is, their truth value is unascertainable – but they criss-cross and frame this discourse producing language games whose strategies are defined outside the field of science itself.

The neutrality of scientific discourse is thus assailed. Lyotard sees institutions as being nothing more than the formalization and institutionalization of certain language games. In this view the research institutions seek to test the performability of the games already envisaged, attempt to provide paradoxes by which their extendability can be measured, and eventually negate them by still more general laws. In carrying out such work, research institutions, by doing science, are engaged in creating the conditions of cultural reproduction and originating modified strategies which are the basis for social reproduction.[8] However, if research institutions are the place where classificatory logic is monitored, filtered, reproduced and modified, it must still be disseminated. Transmission depends on creating a community of addressees who share a concensus on the nature of this knowledge, a condition not applicable among its generators, and who ensure that the rules of the game are placed in

general circulation. Let us call those who man the research institutions, bricoleurs, and those personnel of the institutions of dissemination, the primary addresses, the curators.[9] Finally in this argument, let us suppose that the pragmatics of the institutions of curatorship endorse the alchemy of misrecognition, as argued by Bourdieu; the spells of objectivity, as deconstructed by Castoriadis; and the execution of language games which supernaturalize science to naturalize a social system, described by Baudrillard and Lyotard. Some tentative and, at this stage, necessarily speculative, answers suggest themselves to explain the existence of museums and art galleries as institutionally autonomous agencies, and provide possibilities of understanding their relation with the broad configuration and articulations of juxtposed institutions, occupying adjacent spaces in the social topography.

The institutionalization of learning and art is split between museums/galleries and libraries. Although both institutions follow a common set of legitimations, the practices are deflected to treat (1) the conservation of objects illustrative of some scheme of the evolution of civilization, or the appreciation of one extraordinary period within it to better the temperament of the present, and (2) the conservation of knowledge, as a document of the stages of evolution and the resource for building a future. Both the museum and the library are repositories of the collective memory of a socio-historical formation. The problems associated with the organization of objects are similarly present in the organization of the library. The classification of discrete volumes can follow the original scheme which framed the writer's project, since to some extent, barring the problem of an usympathetic history, the creative subject, the created object and the rules of the game institutionalized within the library are of the same cultural milieu. Classification thus arises from the same field of rules which governed and/or silenced the production of the text to be classified. The situation is more complex and inventive in the case of the ethnographic museum, as will be discussed in the final section of this paper, since objects, whose meaning resided in extraneous relations of class are detached and placed in new juxtapositions according to the predilections of a Western classification

The separation of library and museum, which corresponds to the estrangement effected between writing and artistic representation, between knowledge and affect, the opposition which finally incorporates as polar elements, denotative statements and connotative objects, defines the former as the only possible interpretation of the latter.[10] The curator works to conserve and research the material object so that it can be adopted as a reliquary of the memory of the milieu from which it derived but in the terms of the present and at a specific juxtaposition in a language game whose stategies and intentions are radically distinct from the former but whose performability is extended by its absorption and adaptation to it. In this sense, every exhibition represents the deconstruction of a classification and the reclassification of an object within a new series to produce a new code established by the intentions of an evolving strategy of adopting the past or the distant to the present–future. The junctures at which such activity falls are multiple and not singular. In a large museum with an elaborate resource base any public display of objects is finally the product of the exhibitor and the projections of a legitimate demonstration of a theme but, in addition, it may be influenced by a budget, the cultural politics practised by the institution, the dictates of taste and aesthetics often monopolized by the design department and, in cases of sponsorship, by commercial institutions.

Museums represent exhibitions as impartial, objective, coherent and factually-based disclosures of aspects of the phenomena world. Their legitimacy is guaranteed by the institution and the emphasis it places on the truth value of denotative statements. Interpretation is usually discouraged unless it rests on well-grounded factual data. However, despite these precautions, the institution is integrated into wider language games which cannot help but influence the organization and practice of its aims. Lyotard has described how this wider universe of discourse, much of which is based in connotative statements, provides the metanarratives which justify and orient scientific research. They guarantee the status and legitimacy of knowledge by 'misrepresenting' it as objective and empirical and naturalizing their own relationship to it.

Towards a post-modernist museography

It has already been noted that every exhibition is a reclassification of objects, as the permanent exibitions of the nineteenth century were reaffirmations of classifications thought to be final. Reclassification involves the production of new meanings, and the task of the curator lies therefore in the reproduction and the production of meaning by providing material manifestation of supposedly immutable knowledge.[11] The process of selection and juxtaposition of objects depends on a familiarity with the knowledge corpus, which allows a definitive set of statements whose truth value is guaranteed by the signature of the institution as denotative and definitive, to be created. The ascription of truth value itself, however, represents a problem. While our picture of the world unmistakably varies as a result of knowledge acquisition, the criteria by which the validity of new statements is measured is made to appear constant, by excluding epistemological questions from discourse. Epistemology is therefore assumed to be absolute and common sensical and critical scrutiny is deflected away from the source which guarantees the value of legitimatory practices. However Collingwood (1946), and more recently Baudrillard (1984), have defined the shifts in the articulations which structure knowledge, and that have occasioned fundamental transformations in the conception of value since the Renaissance. Baudrillard has identified three simulacra: 'the counterfeit', 'production' and 'simulation'. The counterfeit sign had its origins in the classical expression of a non-arbitrary symbol which bound itself to a particular person or a caste. However, after the Renaissance, with the increase in social mobility, there occurred a proliferation of signs as a result of the differentiation of demands which began to enter general circulation. The counterfeit does not imitate some original quality of the latter, but passes off as general quality whose clarity depends on its restricted circulation. It no longer discriminates but nevertheless presents itself as a necessary relation to the world. It presents itself as a referent of the world on which it feeds, but is able to produce only neutral values by which it can be exchanged with equivalent signifieds.

The Industrial Revolution, far from being dependent on an older corpus of signs drawn from an inappropriate context,

produces its own repertoire together with new types of objects. The relationship between these signs is not one between an original and its counterfeit, but a relationship of identity where any one in a series is an equivalent of another member. Not only are objects transformed into the simulacra of one another in a parallel movement to that of the sign which is used to designate them, but the same occurs to the people that produce them. Whereas in the first order simulacrum value was an indice of the relationship between sign and natural object, this becomes transposed after industrialization to a function of the relation between sign and an artificial object, but an object, nevertheless that desires to masquerade as natural. Both these orders are subverted in the contemporary world where the sign achieves autonomy from the object which it represents. Value is no longer conceivable either as a ratio of equivalence between sign and object in simple attached juxtaposition or between series of signs and parallel series of objects which engage in a general exchange network. In this third order simulacrum, the sign detaches itself from the signified to engage itself with other autonomous signs in the formation of codes according to the laws of value which determine a kind of valency.[12]

Baudrillard argues for the arbitrary nature of value which is misrecognized and projected as an empirically arrived at indice between object and sign. The history of value then not only exposes an evolution which discloses its relativity but also enables one to see through the cloak of misrepresentation which clouds the real nature of its status which it tries to represent as the continuation of a second order simulacrum. This breaks the exposition of classical economy where exchange value is said to be a function of use value, since usage as a term cannot, as Baudrillard demonstrates, represent a minimal and natural referent independent and transcendental of the determination which constructed it. Even when value is measured as a function of objects essential to the production of necessary subsistence activities, there always opeates a prior determination which constructs the organization of the field of the worth of objects as well as that which defined and contains the activities with which they are coupled. Reversing the equation of classical political economy, it is then exchange value which determines use value. In as much as exchange value is a

synthetic product and a determinant of use value, the two can be compared with the relationship between signifier and signified and resolved in a simple series of equations which Baudrillard has reproduced in his paper on a general theory (1981: 128):

$$\frac{EcEV}{UV} \; \frac{Sr}{Sd} \; / \; SbE \text{ (symbolic exchange)}$$

As with Bourdieu, Baudrillard insists that not only does the exchange value determine the use value, but that the former is only legitimated by the latter which acts as the source of naturalization. A similar process may be applied to signs: it is the signifier which constitutes the signified, yet it is always by reference to that which is signified that the signifier justifies its own existence. Both value and signification act to constitute an external condition of which they claim only to be a mirror-image, but once having produced it, they then use it to legitimate their own existence. The world is nothing but the effect of the sign, 'the shadow which it carries about, its "pantographic" extension' (Baudrillard, 1981: 152).

The museum and gallery both predicate their existence on the function they perform in conserving objects of special value. More often than not, the value ascribed to the objects in their collection is described as transcendental and excludes their mere monetary wealth which it dismisses as vulgar and irrelevant to the real terms by which their materials should be evaluated. In categorizing a class of objects as 'invaluable', and by removing them spatially from the sphere of the general circulation of goods modulated by the rules of general political economy, they are elevated to a special position of veneration. But as we have seen, the fact that 'value' is an arbitrary category, having no natural innate residency within objects, but having its origin within a social classification that hides behind the object, severely compromises the claim of such institutions and negates the most common justification made for their existence.

As already argued, museums both collect and conserve, and are actively engaged in a process of selection and classification and reclassification. They constitute the essential mechanisms of a ministry of truth. The objects that form a collection are chosen

from a wider classification of objects which have already been disriminated by the supposed criterion of value. Between the wider classification of objects which participate in a general exchange and the domain of restricted objects, there operate further discriminations which divide the latter class into those which can enter restricted circulation and are translatable into economic value by the auction house, and those which are 'invaluable' and are conserved within the museum/gallery. These objects are conserved not because they are valuable or invaluable in themselves, but because they are decreed to be so. It is not that objects are collected, conserved and exhibited because of intrinsic worth, nor that the institution of museum/gallery shields them against the effect of history, but that the museum/gallery constitutes their status as being precious, which it guarantees by the power of its signature. A figure or icon of Christ or a saint is an object of veneration within a church, but when sold in an art shop dealing with such representations becomes an object with a commercial equivalent. So too with the contents of the museum/gallery once removed from their place of appropriation (which may be a sale room or a temple). The value ascribed to them, even when it is denied to be monetary, is autonomous of the object itself and is a signifier which is constrained only by its indexical relation to other signifiers composing a discrete field which works to establish ratios of comparative worth.

Everything within the composition of the museum/gallery institution connives to adhere the value to the object. Architecturally, the museum/gallery houses its collections in an imperially styled building, most often in Europe displaying an affinity with the classicism of ancient Greece. In England, this style was the preferred imperial signatory which incorporated many institutions of State, in addition to all the major national museums and galleries. The grandiose architecture removes them from everyday life and the building signifies itself as a place of lofty veneration within which the treasure is guarded. The materials of which it is built are chosen because of their aesthetic effect – an effect which stimulates the veneration of the object and surrounds it in a befittingly conspicuous and sumptuous luxury. The architecture is monolithic, involving the enclosure of a space which is always disproportionate in its exaggerated

dimensions to the objects which it frames. The halls are administered by conventions of respect and an indifferent awe which manifests itself in the silence of the interior, the prohibition of daily activity and the hushed conversations. Exhibitions are rarely reflexive and neither arrange objects so that their categories question those of the dominant culture, or invite speculation of the conditions of their own classifications. The semantic universes which they display are distanced from the everyday life of their addressees.

The huge spaces which signify the alienation of the object from its context, the sumptuous design, the imperial architecture and the cloistered silence all effect the alienation of the individual from the object. Now twice removed, the distance between the addressee and the original significance of the object recedes intractably. The museum speaks but cannot be spoken to. Its exhibits, torn from prior conditions of significance, are arranged in determinate series, each and every one part of the encyclopedia which the language game tries to complete. Files of objects ordered by the military formations of fields of knowledge, structured by the rules on which that knowledge is predicated, humiliated by the terms of its epistemology, and all the time subjected to a constant reclassification and re-evaluation, as the signs, which supposedly accrue to them, playfully produce new relations and juxtapositions among themselves which delude the armies of addressees into mistaking the one for the other.

That which gives without accepting any principle of reciprocal exchange accumulates power. Museums come to procure for themselves a monopoly over the knowledge exhibited in their halls, and from this emerges a pedagogic authority that establishes an impeccable and unquestionable expertize which exercises a solitary reign over their empire of signs. By constant enunciation through a monopoly over objective, alphabetical and pictorial representation, the museum/gallery demonstrates its lessons, while consigning the public addressees to silence. They are forbidden to make their own story, to create their own epic, but are only offered the possibility of learning the rules of the games in which the signifiers play, the better to understand and accept solemnly the game to which they can only ever be admitted as spectators and not protagonists. Museums of mass

culture create an ever more acute alienation which isolates them from the public they seek to address. This alienation cannot be overcome by changing the message they transmit, nor by substituting another ideological commitment, as long as the power relations which it buttresses continue to persist. Nor is it clear how Eco's call to change the reading code can subvert the pervasity of the simulacrum (1979), or Baudrillard's appeal to an expansive symbolism to multiply the modalities of the signifier until all referential meaning becomes lost. The absorptive and extensive qualities of the simulacrum limit such subversion by their ability to incorporate or restrict the production of paradox.

But what produces the characteristic alignment of the codes and games in which the signifiers participate? For Castoriadis and Baudrillard there exists an order of orders, an 'imaginary' around which classifications evolve rules of formation and negation. For Baudrillard, the imaginary up until recent times has been theology, but with industrialization this has been replaced with a theology of use which determines all functional discourse and provides the cloak by which an objective idealism has substituted one status of the object for another excluding discussion on the conditions of its signification. The language games which take place in this masquerade are articulated as institutions which are themselves imaginary in the sense intended by Castoriadis' use of the term. The museum/gallery is but one instance of such imaginary institutions which legitimate themselves by the supposed qualities of the objects which they possess. But if the monkey only imagines the writer and hides in his shadow, any attempt to de-monkey the monkey must proceed according to a new set of critical rules whose very formation results in the creation of a new writer, and so on *ad infinitum*. Perhaps, finally through the very raising of such questions as have been treated in this paper and others like it, not by their absloute resolution, but in the attitude of imagination which attempts, at best, only an imaginary resolution, can we approach the problem of how 'to make ourselves at home in our alienated being'. The museum shares with the theatre and the cinematographic arts, the propensity to allow us to explore ourselves critically through our juxtaposition with the 'other', and in this resides its most extraordinary contribution, as yet little realized: the development and redefinition of our

consciousness of ourselves and the phenomenal world and the expansion of our field of liberty.

Notes

1. I am grateful for discussions and comments on earlier drafts of this paper from Professor Gillsenan, Magdalen College, Oxford, and Professor R. Pinxten of the University of Ghent.
2. All rules of aesthetic judgement are predicated on particular mis-recognitions of the 'real'; that is to say, on a specific epistemology. While it is not necessary to grasp the epistemology which is nevertheless implicit in aesthetics, familiarity with the vectors and categories of taste are indispensable to read an exhibition. Education serves not only to inculcate denotative statements, but to transmit affectual predicates which are at the basis of an act of judgement.
3. Many museums prohibit their curatorial personnel to carry out any business activity relating to similar classes of objects with which they work. Similarly the public service performed in dating and identifying objects specifically excludes their valuation. Not only does the museum apparently constitute its existence outside of bourgeois economics, but its passive voyeurism guarantees its functioning as a strongroom for symbolic capital.
4. In this context, by knowledge, we mean familiarity with the code which determines a form of pictorial representation, and a corresponding acquaintance with the system of objects which compose its repertoire.
5. Clifford appears to believe in the possibility of a knowledge of the original cultural context of ethnographic objects. He states, for example that: 'an African statue was a ritual object, belonging to a distinct group; it was displayed in ways that elucidated its use, symbolism and function' (1985: 171). Or on the same page 'an ignorance of cultural context seems almost a precondition for artistic appreciation'. The whole endeavour to achieve cultural translation is as endemic to ethnographic discourse as it is to the aesthetic.
6. See Anthony A. Shelton, 'Desociologising time and space: an essay on the collusion of "scientific" categories'. Forthcoming.
7. This organization of objects, which makes the Pitt-Rivers 'a museums museum', has been preserved as a result of the wishes contained in the charter which conditioned the bequest to the university.
8. This is a cybernetic model of society which Lyotard holds.
9. This partly accounts for the division of labour between museums as

primarily being associated with apparently mechanical operations concerned with classification and conservation and higher institutions of learning being the preserve of research.

10. It will be clear by now that the legitimation of connotation by demonstrative statements is a fiction, since denotation is just another form of connotation

11. It is his mastership over 'knowledge' that makes the curator an expert. His insertion within the game by the institution sanctifies this 'knowledge' while he continuously adds to the institution's archive of expertise. The accumulation of such 'knowledge' is the authority behind the legitimacy of its signature which consecrates the status of the objects in its possession and its evaluation of those which are brought to it for 'consultation'. It should be noted, however, that this 'knowledge' is made up of different denominations. It is composed of supposedly denotative statements, some of which rest in affectual claims of feeling and experience, i.e. the case of authenticating an object and arbitrary denotations; as in the case of providing an exchange value for symbolic value. All such judgements are legitimated by the reputation assembled by the museum's signature.

12. The three orders of simulacrum are equivalent to (a) a natural theory of value, (b) the commodity theory of value, and (c) the structural theory of value (Baudrillard, 1984: 61).

Bibliography

Baudrillard, J., *For a Critique of the Political Economy of the Sign* (Telos Press: St. Louis, 1981).

Baudrillard, J., 'The structural law of value and the order of simulacra' in Fekete, J. (ed.), *The Structural Allegory: Reconstructive Encounters with the New French Thought* (Manchester University Press: Manchester, 1984): 247–73.

Borges, J. L., *The Book of Imaginary Beings* (Penguin: London, 1974).

Borinski, A., *Repetition, Museums, Libraries: Jorge Luis Borges*, Johns Hopkins Textual Studies 2 (Baltimore, 1977).

Bourdieu, P., 'Outline of a sociological theory of art perception', in *International Social Science Journal* XX, 4: 589–612, 1968.

Bourdieu, P., 'Intellectual field and creative project' in *Social Science Information* 8, 2: 89–119 (Paris, 1969).

Bourdieu, P., *Reproduction Culturelle et Reproduction Sociale: Social Science Information* (Paris, 1971).

Bourdieu, P., *Outline of a Theory of Practice* (Cambridge University Press: Cambridge, 1977).

Bourdieu, P., 'The production of belief: contribution to an economy of symbolic goods' in *Media, Culture and Society* 2, 1980: 261–93.

Bourdieu, P., *Homo Academicus* (Minnit: Paris, 1985).

Bourdieu, P. and Passeron, C., *Reproduction in Education, Society and Culture* (Sage: London, 1977).

Cassirer, E. (trans. Manheim, R.), *The Philosophy of Symbolic Forms*: vol 1 *Language* (1953); vol 2 *Mythological Thought* (1955); vol 3 *Phenomenology of Knowledge* (1957) (Yale University Press: Yale, 1953–7).

Castoriadis, C., *L'Institution Imaginaire de la Societe* (Editions du Seuil: Paris, 1975).

Castoriadis, C., 'The Imaginary Institution of Society' in Fekete, J. (ed.), *The Structural Allegory: Reconstructive Encounters with the New French Thought* (Manchester University Press: Manchester, 1984): 6–45.

Clifford, J., 'Histories of the tribal and the modern' in *Art in America*, April: 164–215 (New York, 1985).

Collingwood, R. G. *The Idea of History* (Oxford University Press: Oxford, 1946).

Cranstone, B. and Seidenberg, S. (eds), *The General's Gift: A Celebration of the Pitt-Rivers Museum Centenary 1884–1984.* (Oxford, 1984).

Eco, U., *The Role of the Reader: Explorations in the Semiotics of Texts* (Hutchinson: London, 1979).

Fekete, J. (ed.). *The Structural Allegory: Reconstructive Encounters with the New French Thought* (Manchester University Press: Manchester, 1984).

Foster, H., 'The "Primitive" unconscious of modern art' in *Art in America*, October: 45–70 (New York, 1985).

Lyotard, J.-F., *The Postmodern Condition: A Report on Knowledge* (Manchester University Press: Manchester, 1984).

4

Object lessons in the museum medium
GHISLAINE LAWRENCE

The correct definition of the word museum has concerned most authors attempting general accounts of such institutions. Many conclude that the essence of a museum lies in its being a collection of artefacts and, on this assumption, create an historical continuity that extends from the curiosity cabinet to the present-day institution (eg. Impey and Macgregor, 1985). A definition in terms of the work museums perform in their wider societies might prove more insightful. One activity which virtually all modern museums have come to share is that of exposition. Using artefacts and other devices, museums make statements – provide meanings – for their audiences. This being so, one obvious context in which their practice might be examined is that of the other media. In Britain, a major change in the structure of the mass media began shortly after the Second World War with the introduction of television broadcasting on a significant scale. Like museums, television is a primarily visual medium. This paper explores how controversy

c (medicine) in the new
ects of its more conven-
at of museums. It will be
ns of television coverage
relatively short history,
mained substantially un-

the columns of the British
Association passed con-
Medical Journal produced
3b; Anonymous, 1958a).
perpetrators could only

103

choose whether to admit to hypocrisy, or to sensationalism. The event that so upset the medical men of 1958 was the showing of the first programme in the BBC television series *Your Life in their Hands* (henceforth YLITH) – a weekly documentary which provided, through a mixture of outside broadcast and commentary, coverage of medical and surgical procedures being performed in British hospitals.[1] The profession's reaction to the exposition of modern medicine on television might be compared with their response to another attempt to display the workings of contemporary medicine, a few years earlier. In 1955, the Wellcome Historical Medical Museum in London held an exhibition which included coverage of modern medical techniques (Underwood 1955). The event was barely noted in the medical press, the *Lancet* (1955) confining itself to giving details of opening times, and other journals publishing favourable, if rather short, reviews. In tone, they were no different from those which had been accorded to museum exhibitions of medicine in Britain for much of the century – moderate, rather 'low-key', but generally appreciative.

The message here seems unmistakable: museums, yes; television, no. Why were museums perceived as a 'safe' medium, while television coverage was apparently positively threatening? Medical exhibitions had, of course, often directly involved the medical profession in an advisory capacity. The BBC, however, in the making of YLITH, had also enlisted medical 'endorsement', engaging Charles Fletcher, an eminent doctor, as adviser to the series (Jennett, 1986: 26.) And yet charges were levelled at the television presentation of modern medicine that had never been laid at the door of museums, even though the latter had been occasionally presenting exhibitions in this field for at least three decades.

Several of the charges were first made in an organized discussion held at the Royal College of Surgeons of England as a direct result of YLITH (Anonymous, 1958c). The medical men present seem to have been almost unanimously opposed to the programme. The BBC was again charged with 'sensationalism', with pandering to the 'more macabre instincts of the public', and with reducing medicine to entertainment, 'to a peep show', as one doctor put it. A rather separate group of fears concerned the likelihood of creating 'a nation of hypochondriacs'. The

eminent physician opening the discussion of the BBC spokes-
woman's apologia was reported as saying that he 'did not
realize "this" was going on: "it" seemed to have developed to a
tremendous degree'. The 'this' and 'it' were apparently hypo-
chondriasis which, he continued, was 'running through the
world'. He was 'appalled by it'. Almost in an opposite, but
equally critical camp, were those who worried that too much
information would frighten the patients away. Programmes on
smoking and lung cancer were all right, and those dealing
with the prevention of illness were useful, but who was a
film about ether abreaction going to help? Patients had been
encountered who were not willing to be treated by electro-
convulsive therapy and ether abreaction because they had been
frightened by television coverage. The programme's medical
advisor entered the discussions to say that, following the
showing of a complex operation on the circulatory system, the
general public had been reassured on seeing 'what medicine
was able to do'. In particular, 'Some builders had remarked that
they never thought surgeons were as good as that – they were
'as good as plumbers' (Anonymous, 1958c: 1352). The dis-
cussants seem to have taken little comfort from this. Complaints
in the medical press continued for several weeks. Clearly, those
with a vested interest in the way medical meanings were
constructed for the general public perceived that issues of power
and authority were at stake.

These were issues which had been widely discussed by critics
of various persuasions when television broadcasting began in
earnest in Britain in 1946 (Briggs, 1979a: 4–5). Two related
perceptions of the new medium were widespread, and it might
be argued that, over a decade later, they still lay at the heart of
the medical profession's concern. Firstly, television was per-
ceived as both an extremely powerful medium, and secondly, as
one which was likely to prove uncontrollable. Several factors
contributed to this potent image. Television rapidly became a
truly mass medium. It had taken nearly a quarter of a century
for the number of wireless licences in Britain to reach the ten
million mark (in 1946). It took only fourteen years for television
licences to pass that figure (in 1960) (Briggs, 1979b: 11). Not only
increasing licence numbers worried critics during television's
early years. The medium was considered to have a particularly

intrusive character – an ability to bring sound and vision right into the nation's living rooms. It was also apparently compelling. In the doctors' debate over YLITH, they still considered there was 'something queer about television whereby people seemed to have to view' and solutions such as 'lock and key' television were again suggested (Anonymous, 1958b: 1352).

Certain genres employed in the new medium had fuelled controversy over control more than others. Documentary – the genre of YLITH – was often a particularly sensitive area. Given the content of today's television programming, it is perhaps surprising to discover how little coverage of 'actuality' was included in its early years. A television news service, for example, was not begun until July 1954 (Scannell, 1979: 97). Within the BBC, a Talks Department (later known as 'Current Affairs') handled 'political' issues, while a separate department was, from 1953, responsible for 'documentaries'. These dealt with 'social' subjects. The term documentary rapidly came to be applied particularly to a specific form, that of the drama-documentary. This was a studio-based 'live' production, scripted and rehearsed, using actors, with filmed inserts for continuity and location sequences. Initial research on a 'social' issue led to the creation of 'an ideal-typical representation distilled into a narrative line' (Scannell, 1979: 102). Settings such as the factory floor were meticulously recreated in the studio (Ross, 1950: 22). Drama-documentary flourished in the decade from 1946–56, but was then to be supplanted by a new mode – that of the documentary film made for television – the genre of YLITH. The forerunners of both modes of television documentary had been the radio feature, the television talk and the documentary film movement (Ross, 1950: 20), but the documentary film for television in particular was indebted to the work that British directors such as John Grierson and Basil Wright had done for the larger screen, principally during the 1930s (Sussex, 1975). Grierson, in films such as *Drifters* (1929) and *Night Mail* (1936) took on the job of 'explaining society to society'. One of the movement's leading exponents, Paul Rotha, was appointed to head the new television Documentary Department at the BBC in 1953 (Scannell, 1979: 97).

In its association with this genre, television documentary acquired many of the conventions that were coming to be

associated with conveying 'reality'. As media scholars well recognize, conveying reality, and conveying it convincingly, involves complex issues (Collins, 1983) which I do not intend to pursue further here except to make the point that part of television's perceived power was its apparent ability to convey reality, and that documentary, the genre of YLITH, was by 1958 closely associated with this ability. None of the medical critics of YLITH suggested that the programme *misrepresented* medical practice – all apparently accepted the 'reality' of what was shown on the screen. The debate was instead about the wisdom or 'ethicity' of allowing the general public access to this reality. Unease was fuelled by the second widespread perception of television's power – that the medium's producers were likely to act autonomously in the matter of editorial control (Briggs, 1979b).

This perception was largely accurate. Historically, the origins of practice in broadcasting, both radio and television, lay in journalism. In Britain, the rhetoric of the free press that had been forged in the mid-Victorian era was well established (Curran, 1978). Precisely because the classic model of the press, the 'free market of ideas', could not apply to the air waves, and because there could be no 'unlimited entry of voices', the modes of organization and control of the broadcasting organizations in Britain were devised to insulate them from external influence, the perceived neutrality legitimating output from a single, central source (Collins, 1984: 33). When the British Broadcasting Company became a public corporation in 1927, approval was expressed in parliament that it was now 'free of the interest groups of shareholders'. There remained concern, however, that it might become 'too subservient to Minister or Government' (Briggs, 1979b: 51). The subsequent history of radio broadcasting, and of the early years of television, was indeed one of constant negotiation, sometimes stormy, with government, but it was negotiation from which Reith and others at the BBC, sustained by the rhetoric of public service broadcasting, often emerged with positions strengthened. Where medical subjects were involved, The Ministry of Health, the medical profession and the BBC's programmers and producers had often, in the years preceding 1958, found themselves in contention about what, exactly, the public should be told on

matters related to health and medical practice (Karpf, 1988: 49–56).

If these were some of the reasons why the medical profession might have viewed medicine on television with alarm, then how might the complacency with which they viewed museum exhibitions on the same subject be accounted for? If the origins of mass media practice lay in journalism, those of museums resided in rather different forms of mid-Victorian enterprise, forms which might be subsumed under the category of self-improvement, both spiritual and economic, personal and national. The new museums created in abundance in Britain and America in the second half of the nineteenth century couched their aims in explicitly educational terms of self-betterment (Pearson, 1982: 24–38; Follet, 1978: 1–4; Fox, 1963: 9–25). It was hoped that art museums, for example, would help to develop a discriminatory sense simply by exposure to great works. They would teach the general public 'taste', to distinguish good art from bad. 'Raising the taste' of 'the great mass of artisans' preoccupied those who led the movement for State-run art education in Britain which was closely associated with the newly founded museums of industrial design. Ultimately, it was hoped, 'raising taste' might result in a reduction in undesirable behaviour, and increased industriousness. 'Nobody expects that the whole of the working classes will at once take to drawing and entirely renounce strong liquor' admitted one protagonist, 'but many may be secured from temptation to excess' (Pearson, 1982: 18).

Direct economic benefit, both to the nation and to the individual, featured prominently in the rhetoric of science and 'industrial' exhibitions. The South Kensington Museum had its origins in what amounted to a trade fair – the Great Exhibition of 1851, whose commissioners proposed that the profits be devoted to the establishment of an institution which would 'serve to increase the means of Industrial Education and extend the influence of Science and Art upon Productive Industry' (Follet, 1978: 1). As is well known, the Exhibition's residual collections were divided into 'art' and 'non-art', the former providing the basis for the Victoria and Albert Museum, and the latter, with the addition of further material, finally acquiring a separate existence as the Science Museum (though not at this

date with a separate building or director) in 1885 (Follet, 1978: 4). The goal of science education, in order to further industrial prosperity, was pursued very directly through the Science Museum by the Department of Science and Art, under the Board of Trade, and, from 1899, the Board of Education.

Exhibiting the workings of new industrial machines to artisans had been a feature of mechanics institutes earlier in the nineteenth century. Such events resounded with 'the noise of engines, machines, and scientific process' and were 'calculated to illustrate how intimately the greatness and prosperity of our country depends on its mechanics and artisans' (Kusamitsu, 1980: 77, 79). The Lords of the Committee of the Council of Education initiated a national collection of machinery and inventions to amplify the South Kensington holdings in 1867. Its object was 'to afford in the best possible manner information and instruction in the immense variety of machinery in use in the manufactures of this country' (Follett, 1978: 2). By 1911, the aim of displaying machines and inventions at the Science Museum was not so directly concerned with instruction in their use. They were now to illustrate to 'students and others ... the general principles which underlie all [engineering's] branches, and to offer to the engineer suggestions or ideas from other branches of his profession that may prove fruitful in the work upon which he may be engaged' (Follett, 1978: 11). In short, objects were to be displayed to the public as a means to very specific ends. In America, the Assistant Secretary to the Smithsonian Institution in charge of the United States National Museum, George Browne Goode, had already taken this approach to museum exposition to its logical conclusion in 1895, deciding that the ideal museum might be described as 'a collection of instructive labels, each illustrated by a well-selected specimen' (Goode, 1901: 1).

Whereas in art museums labelling was sometimes condemned as 'impertinent', interfering with the emotional appeal of the art, in 'non-art' museums, mediation by label came to be considered essential (North, 1957: 30). This was because, as Henry Lyons, director of the Science Museum from 1920 to 1933, put it, the objects shown in such museums were chosen for their utility, for the function they had, not their aesthetics. Function was not deducible by the senses but by the intellect, and, unlike

109

great works of art, the apparatus of science and the machinery of applied science did not convey the 'desired messages' without assistance. This point was made repeatedly by Lyons: 'some introductory information must be placed at [the visitor's] disposal in such a form that it will readily furnish those main ideas which should be in [his] mind if he is to understand the collection which is before him' (Lyons, 1924: 117).

After two years at the museum, Lyons came up with what he considered to be the ideal formula for explaining the importance of the artefacts displayed. Introductory exhibits would provide 'bird's eye views' of particular areas of technology. These were to be provided by oval-framed labels stating 'the principles which underlie the use or development of these exhibits'. Individual objects would then have further, detailed labels of up to four hundred words (Follet, 1978: 101). The museum object was thus to be an educational device – an illustration of general principles. As such, it required decontextualization. It might be argued that the information conventionally contained in museum labels came to serve this purpose very well indeed.

Firstly, for example, both in Lyons' day and subsequently, labels tended to omit information which might detract from either the clarity, or the authority, of museum objects as examples of general principles. They did not conform, for example, to the conventions of academic writing. The source of their content was unacknowledged, since footnoting was not usually employed. Reference to current areas of debate, or alternative interpretations, was almost never included, and the label content escaped mechanisms of peer reviews, comparable to the book review system, or the presentation of academic papers. This is despite the fact that there was available by the 1920s a corpus of academic work on the history of science and technology and, in Britain, an established journal, the *Transactions of the Newcomen Society* (Pacey, 1983a: 44–51). Secondly, although Lyons' contemporaries acknowledged early on that their collections grew, not by a process of rational acquisition, but because they tended to attract to themselves 'all those pieces of large lumber in London and the provinces which people found too good to destroy, inconvenient to keep, impossible to sell and unsuitable for wedding presents' (Follet, 1978: 156), information about the *particular* history of museum

artefacts was rarely given in labels, it being irrelevant to, or indeed detracting from, the new, representative function of the object in the Museum. An influential manual for small museums in the United States considered such details 'occasional neces- sary evils' in label writing (Coleman, 1927: 228). It was still, in the 1950s, one of the tenets of good labelling in both British and American museums that sorts of information pertaining only to individual exhibits, such as the circumstances of acquisition, donation, or construction, were to be excluded from label text or relegated to very small type (North, 1957: 32–3; Weiner, 1963: 148).

Thirdly, labels were to decontextualize objects from certain sorts of information common to all examples of their kind. The price, for example of technological artefacts, many of them production models, seems never to have been considered for inclusion, the assumption being that information of this kind had no bearing on what Lyons in 1922 considered the prime reason for including objects in technological museums, that is, their function or what they 'did'. 'A brief explanation of what the specimen is, what it is used for or how it works' was still regarded as the essential content of a museum label in 1963. (Weiner, 1963: 147).

Indeed, these conventions concerning the kinds of informa- tion to be included or excluded from object labels in science and industrial museums are still largely adhered to. This is despite a decade of exhortations, especially from North America, that curators in such institutions pay attention to newer perspectives in several academic disciplines, especially the history and sociology of science and technology (eg. Basalla, 1974). Many historians of technology are coming to the view that their discipline is synonymous with economic history – that it is concerned with the production of technology, or with the technology of a product or commodity, for commercial gain (Pacey, 1983b: 130). From these perspectives alone, what a machine 'does' seems less essential in nature, and from more recent perspectives in the sociology of technology, what a machine 'is' is determined by the interest groups concerned (eg. Pinch and Bijker, 1984).

A cursory examination of the modern medical equipment industry, for example, at the most pedestrian level of analysis,

shows that the sort of machine designed depends upon what the customer will pay, in terms both of initial outlay and running costs. In Britain, the National Health Service accounts for over ninety per cent of the medical equipment market, and the particular way in which the NHS functions largely dictates what is produced for that market. For example, a new imaging machine which can perform twice the number of examinations per day than the previous model would more or less double its income in a North American Hospital, which charges the patient, or his insurance company, on a cost for service basis. But in a National Health Service hospital, the ability to examine twice as many patients provides no increased revenue and may well place an intolerable strain on other services 'down the line'. The direction which innovation takes is clearly influenced by market factors such as this, which, in the end, are to do with health care policies. (Reiser and Anbar, 1984: 135–52; Jennett, 1986: 256–75). The other side of the coin, for the NHS, is that capital outlay for equipment may be easier to obtain than running costs. There are other defining factors of the British market for medical technology, all of which influence what equipment is, actually, *ever* produced.

Business and economic historians now examine technologies in the context of the 'forces of production' – the natural resources, labour, capital and enterprise involved. Only in certain cases will science and technology museum labels provide this kind of information, and then usually when displaying old artefacts with an established market value. Here the conventions of connoisseurship are frequently adopted. (On connoisseurship see the many insights in Rees and Borzello, 1986). The label on an eighteenth-century astrolabe may well reveal that it was made for a certain patron, by a named instrument maker, and may even indicate the length and cost of his labour. That on a modern ECG machine, however, is most unlikely to provide details of its assembly on a production line, the hourly rate of the workers, or the original source of the parts. Once artefacts are mass produced, it seems, yet further sorts of information are omitted from their labels. The so-called 'featureless' box of electronics creates despair among curators, but indication of just why it has the features which it does indeed have – the streamlining or the high gloss finish – would surely be revealing

of the market for such pieces. The appearance of modern technological equipment, from typewriters to image analysers, has been, since the 1930s, no less the result of professional industrial design and marketing than that of any other type of product. (On the typewriter, see Fry, 1982).

The perception that what an object 'is' may be defined by what, in a limited technical sense, it 'does', remains widespread, as do notions that the advances which certain changes in these technical capacities are considered to represent are justification for museum display. The labels given to artefacts such as the computerized tomography (CT) scanner, a sophisticated medical imaging machine developed in the 1970s, will, if they continue in the present tradition, emphasize the superior quality of the image produced over conventional imaging techniques, rather than the cost, availability, reasons for development, or benefit assessments of the technique. This is despite the fact that published work exists in all these areas (Stocking and Morrison, 1978; Baker, 1979; Susskind, 1981). They are unlikely to include the results of Baker's 1979 survey on the acquisition of CT scanners by hospitals throughout the United States. This study concluded that there were then more CT scanners in California than in the whole of Europe, and that the second most frequently stated reason for ordering a scanner by heads of radiology departments was increased cost/benefit ratio, with professional journals and manufacturers' literature cited as the principal source of information. However, as the author points out, there had been, by 1975, when almost all the scanners were installed or ordered, no published cost benefit analysis of CT scanning whatsoever – in either professional or manufacturers' literature. The processes of adoption of a new technology, he concludes, are complex and not necessarily those overtly stated.

Those in the health care professions have themselves become aware that statements of a machine's technical capabilities are not the same as assessments of benefits which may or may not accrue from its use. The museum label which states that the dialysis machine is capable of performing all the functions of the failed kidney, or that the implanted mechanical heart is a replacement for the human organ, ignores the considerable amount of recent work done on the complexities of assessing

113

benefit, and the perceived need for indicators such as the Nottingham Health Profile or the 'Quality of Life' unit (Najman and Levine, 1981).

From the 1920s onwards, with its single messages illustrating general principles, and its air of impersonal authority, the text of museum labels on technological artefacts has most resembled, not surprisingly, the content of textbooks. And just as educationalists, until the critiques of the late 1960s began, held literate communication and verbal form in highest regard, so curators of all kinds have stoutly maintained that the essence of exhibition communication lies in the label content. The Smithsonian Institution appointed George Weiner as Supervisory Exhibits Editor in 1957. Six years later his views on the primacy of labels were emphatic. 'Without a label giving certain sorts of information', an object (Weiner's specific example is a plate) 'might just as well not be on display' (Weiner, 1963). Weiner was clear that labels were 'virtually the only means by which the majority of viewers are able to derive any benefit whatsoever from a museum exhibit'. In Britain, the section of the Museums Association Handbook dealing with labels was equally clear that it was the label which formed 'the link between the curator and the public' (North, 1957: 10).

Were one to accept the primacy accorded to labels by curators, the assumption on which this paper rests – that comparing television and museum coverage is both reasonable and potentially insightful – would be called into question. More appropriate comparisons might be between label text and pieces of text written about similar objects in different contexts, rather than between museums and other media. Some comparisons have been suggested above with academic texts and with textbook writing and more might usefully be made, for scientific and technological artefacts in particular, with forms of text such as advertising copy. Indeed, Lumley has found the suggestion that it is inappropriate to consider museums as a medium at all – that curators have 'taken the museum object and used the museum as a medium of communication, stretching it beyond its proper capacity to do the job' (Lumley, 1988: 22). It is hard to conceive, however, how any exhibition of objects might be created which avoided the construction of messages inherent in the process of mediation, and a small but growing body of work

testifies to both the appropriateness and the insightfulness of treating the museum as medium (Silverstone, 1988; Lumley, 1988: 14–23). At every stage in museum practice, from acquisition to display, choices are made which pre-empt any messages that might be conveyed by subsequent labelling. At a most basic level, object inclusion or omission radically affects what is conveyed. When the contents of the new National Air and Space Museum in Washington were being planned in 1970, several curators wished to include the Enola Gay – the aircraft used in the attack on Hiroshima. Other interests, notably a United States senator, considered that 'what we are interested in here is the truly historic aircraft. I wouldn't consider the one that dropped the bomb on Japan as belonging to that category' (MacMahon, 1981: 294). The senator's view prevailed. (The implications of this decision could have gone further than the exclusion of the aircraft from the National Air and Space Museum – environmental conditions in its storage hangar were such that the plane might not long survive as an embarrassment to the politicians.) The corollary of this situation – that inclusion in a museum signifies approval – is apparently a widespread perception. It is shared, for example, by the author of a recent account of the development of the CT scanner, when he states that the decision to make the scanner an exhibit in a national museum in 1977 constituted 'a special honour' (Susskind, 1981: 75).

There is a further problem to do with showing, or not showing technology, which museums do not themselves create, but do compound. It is one which, again, is exemplified by the development of modern medicine. Not all periods have seen the same rate of technological innovation; not all the specialties into which medicine is currently divided employ technology to the same extent; and, especially in the wider field of health care in general, only some of the identifiable major issues and trends are directly concerned with technology. The museum, whose medium *is* technology, almost inevitably produces a 'skewed' account. Because objects are the museum's prime resource, 'low technology' fields may get little coverage. The making of modern medicine involved changes in medical education, in hospital management, the creation of national health care systems, waiting lists, clinical trials, hospice care – none of these

was centred on the development of increasingly complex technology. But displaying medicine *through* its technology tends to reinforce the impression that medicine has acquired its present form *because* of its technology. Gaby Porter has shown how a similar skewed account is produced of women's work in the home by museum displays of domestic appliances (Porter, 1988).

By displaying innovation, the nature of everyday practice may be ignored. Historians of technology have recognized these problems in various other fields for a good many years, and some have carefully distinguished between inventions and innovations – the latter term only being used for a device which has been widely adopted into actual practice – and by studying, for innovations, the general level of diffused technique, rather than individual instances of best practice (Pacey, 1983b).

If messages such as these necessarily pre-empt the messages contained in labels, they are often strengthened by other, equally non-verbal, elements of display. The details of representation in museums are rarely examined and often 'relegated' by curators to a designer. When the CT scanner is elevated on a plinth, both its celebratory and its representational functions may be underlined. Often in pristine condition, this single CT scanner represents *all* CT scanners – broken CT scanners, non-existent CT scanners, even, if you lived in certain areas of Britain in 1977, for reliability and availability of technologies are yet further sorts of information that museums have seemed reluctant to provide. It has become something of a commonplace to remark on how diachronic display is suggestive of notions of progress, but more fundamental aspects of the juxtaposition of objects remain unexamined. The position of exhibits in the building as a whole, their place in relation to others, their enclosure in glass cases, their arrangement in compositions dependent on the rules of perspective, are all worthy of further study. Perhaps not surprisingly, designers, and historians of design, have to some extent shown themselves more aware of means of communication such as these, realizing the role of the 'idioms of atmosphere', and the evocative nature of 'details of style, both sophisticated and vernacular' (Hall, 1987: 128–30).

The professional designers employed in British museums

since the 1960s, however, often share curators' perceptions that
some form of 'neutral' design is both desirable and achievable
for musuem work, that 'outlandish' displays must not be
produced (Velarde, 1986: 401). Exhibition techniques – the
interior design, case construction, lighting, typography, art-
work, reproduced images, their relation to pieces of text, the use
of dioramas, period settings, or 'realism' in general – seem
often regarded as in some way invisible, merely as means of
allowing the objects to 'speak for themselves', or are marginalized
by some practitioners as 'cosmetic aspects of gallery design,
subject to influence by current fashion' (Hall, 1987: 119). All
these techniques are indeed 'subject to current fashion' but none
the less worthy of analysis on that score. For it is largely they
which carry, to borrow John Tagg's phrase, 'the burden of
representation' (Tagg, 1988). Tagg is speaking specifically of
representation in the photograph. In museums the burden is
shared by the myriad techniques which divide up the three-
and two-dimensional spaces of exhibition. All such techniques
have a history, a wider context of use, and bring cultural
connotations of their own. How much does museum lighting
derive from theatre technique, or their interior design from that
of department stores? Museum expositions are, necessarily,
part of that 'cultural apparatus' which includes 'advertising,
films, books, television talk shows and hotel lobby furnishings'
(Schudson, 1981: 11). Situating their imagery within the context
of visual culture as a whole is essential to understanding the
literal 're-presentation' that goes on inside them. Not only visual
culture is involved. Why, for example, should the triumphal
strains of Beethoven's Fifth Symphony accompany a slide show
on North Sea Gas in a national museum?[2] Though not necessarily
the result of conscious deliberation, the juxtaposition is not
accidental. Other choices such as a nursery rhyme or a folk song
seem 'incongruous' (Lawrence, 1988: 286).

The spoken words used in museums are also subject to
selection processes which may affect what is heard. In taped
commentaries accompanying exhibits, authoritative, male, so-
called 'BBC accents' predominate. Yet the BBC's own producers
were early aware of, and using, the connotations of accent.
In 1952 the 'down-to-earth', northern tones of a particular
presenter were chosen to endow a new documentary on social

issues with a sense that he was 'no routine spokesman of the Establishment, but a man to be trusted – one of "us" rather than one of "them"' (Swallow, 1966: 73). Furthermore, in broadcasting, after the introduction of the magnetic tape recorder in the mid-1950s, the 'closed discourse of the interview gave way to the open discourse of extended and reciprocal conversation.' (Scannell, 1979: 104). In museums even the 'closed discourse' of the interview is rarely encountered. The forms in which the spoken word is heard remain closely akin to the educational ones of early radio and television – the authoritative, short lectures by 'experts'.

The deconstruction of 'formal' elements akin to the above is the bread and butter of current media studies, whose practitioners now largely reject the behaviourist and positivist assumptions of much work done in the 1950s and 1960s, with its emphasis on audience effects and consumer choice, in favour of 'more astringently theoretical, but unempirical marxisant analysis (structural, semiotic etc.) of the media in their economic, political and class denominations' (Curran, 1979: 1). The increasing volume of 'evaluative' studies of museum exposition published in the professional literature of the 1970s and 1980s (see Griggs, 1986) has much in common with the earlier research traditions which media scholars have now discarded, and is open to the same criticisms. These studies, too, are mainly atheoretical and could, like the earlier media studies, also be described as 'ahistorical, largely empirical enquiry into effects, uses and gratifications grounded in an often unexamined acceptance of liberal versions of social democracy' (Curran, 1979: 1). Despite the close historical links between museums and organized education, museum professionals have also largely failed to take on board the changing perspectives of many educationalists, who, in recent years, have studied the construction of classroom knowledge and uncovered a hidden curriculum. So called 'transmissionist' views of education, which hold that 'the point of teaching is to transmit knowledge to pupils that they do not already know, that this knowledge pre-exists the lesson, that it is composed of propositions and that its transmission is under the control of the teacher' are out of fashion (Hammersley, 1987: 235). Though many enquiries have been made into what is learnt in museums, rather fewer studies examine in detail how

knowledge is created in them, and what kind of knowledge this might be. Silverstone (1988) has begun to explore an appropriate methodology, which involves examining entire exhibitions as textual constructions. As in media studies, historical or contemporary case studies which focus on the context and circumstances of production – of whole museums or single exhibitions – may offer considerable insights into the process of museum representation (see Haraway, 1984–5; Macmahon, 1981; Di Maggio, 1982; Durrans and Kattenhorn, 1986; Skinner, 1986).

Clearly, 'museum knowledge' has as much to do with values and attitudes as it has to do with propositions. Equally clearly, the knowledge created in museums, of art or 'non-art', has much to do with the close links of these institutions with the State and with their use as organs of education. As such, museums joined in defining certain forms of knowledge as educational and in turn created expectations that these forms would be found within their walls. A new medium, such as television, threatened to provide new forms of knowledge, forms which, in Britain in 1958, the medical profession did not regard as 'educational'. The more considered medical response to YLITH, seen particularly in three letters to the *British Medical Journal* in the ensuing debate, was that medicine on television was to be applauded only *when it was educational*. Each correspondent described what he considered would be educational. One thought priority should be given to teaching 'healthy human biology' (Warwick, 1958). A second considered it most important that 'both we of the medical profession and the BBC make up our minds as to how future television programmes of this nature are to be handled. ... Properly handled it could be a golden opportunity for us to educate the public in health matters and help them to take a more sensible attitude to physical fitness and the prevention of disease' (Watson, 1958). A third correspondent specifically mentioned with approval the older genres used by the BBC, akin to the television lecture, when they 'presented an account of how things worked, some simple demonstration in physics or physiology, and related this to a simple human story' (Smithas, 1958).

For all three correspondents, YLITH had included too much that was not 'educational', that was neither propositional

nor 'beneficial' to the viewer. The non-educational element, variously condemned as sensationalist, macabre or simply 'incomprehensible to the layman', was identified by all of them as the film of operations in progress. It was the element derived from the genre of documentary film, and the element which rooted the activity in some form of social reality – the one which served to convey, often by non-verbal means akin to the 'natural sound' first used in the 1930s' documentaries, a different kind of knowledge about medicine. Gestures, tones of voice and use of language could reveal something of the surgical team's attitudes to each other, to their patients and to their instruments. They indicated something of professional hierarchies, of the relation of doctor to nurse, of the way in which the work was viewed – as pioneering, or as routine. Such details as the accents or the gender of the staff involved served, for an audience sharing the same cultural background, to limit the possible interpretations of what they saw on the screen. Television documentary provided what museums conventionally removed from their artefacts – a context of use. In doing so, it provided, almost entirely by non-verbal means, new forms of knowledge about medical practice. Museum objects, taken out of their context in museums, could convey virtually any message at all.

It is of course untenable to argue that television is a 'transparent' medium, capable of providing such a thing as a 'true' account. A sizeable body of scholarship examines the constructed nature of 'reality' on film. Grierson's own productions, it has been suggested, achieved naturalness by 'concealed artifices', rejecting more avant-garde film practices (Watson, 1981: 347). The representation of scientific matters in contemporary documentary has been examined in detail by media scholars (Silverstone, 1984) and by sociologists of science (Collins, 1987).

In considering the case of YLITH, the comparison between television and museum coverage of medicine cannot be pushed too far. Anxieties regarding the 'mass' nature of television broadcasting, its scale and its potential for repetition of messages, did not apply to museums. Between seven-and-a-half and ten-and-a-quarter million people watched each episode of YLITH (Karpf, 1988: 52). Just over one-and-a-quarter million visited the Science Museum in London in 1958, most on only one occasion.

Nor did fears about the 'intrusive' aspect of television apply. Nevertheless, one might reasonably speculate that a televized visit to a contemporary medical exhibition in 1958 would not have aroused the controversy occasioned by YLITH, even though it would in some sense have 'brought' such an exhibit into the living rooms of millions of viewers.

Since the 1950s in Britain, television documentaries and museum exhibitions have had common kinds of themes, and both have increasingly adopted a narrative style (Silverstone, 1984). These similarities, however, should not be allowed to conceal the very different origins and conventions of the two media. In 1952 the BBC began a new documentary series, *Special Enquiry*, with the intention of forging 'a new style of television . . . as honest and incisive as British journalism at its best'. (Scannell, 1979: 103). In the ensuing thirty-seven years, no one, it seems, has ever used the phrase 'honest and incisive' to typify British museums at their best. Museums do not have an investigative tradition. Their conventions are largely those of organized education, their rhetoric is concerned not with freedom of expression, but with the unique experience provided by original objects. Particularly in the presumed value-free areas of science and technology the notion that this experience is essentially unmediated, except by labelling, and the predominant use of labels to define objects in propositional terms, has ensured that museum exposition largely remains the safe option which the doctors of 1958 perceived it to be.

Notes

1. Archival material relating to the series is held at the BBC Written Archives Centre, Caversham, Reading.
2. Gas Gallery, Science Museum, London.

Bibliography

Anonymous, 'Disease education by the BBC' in *British Medical Journal*, I, 1958a: 388.

Anonymous, 'Proceedings of the Council of the BMA'. Supplement to the *British Medical Journal*, March, 1958b.

Anonymous, 'Medicine on television: its presentation to the public' in *British Medical Journal*, II, 1958c: 1351–2.

Baker, Stephen R., 'The diffusion of high technology medical innovation: the computed tomography scanner example' in *Social Science and Medicine*, 13D, 1979: 155–62.

Basalla, G., 'Museums and Technological Utopianism' in *Curator* 17, 2, 1974: 105–18.

Briggs, Asa, *The History of Broadcasting in the United Kingdom; volume IV, Sound and Vision* (BBC: London, 1979a).

Briggs, Asa, *Governing the BBC* (BBC: London, 1979b).

Coleman, Laurence Vail, *Manual for Small Museums* (London, 1927).

Collins, H. M., 'Certainty and the public understanding of science: science on television' in *Social Studies of Science*, 17, 1987: 689–713.

Collins, Richard, 'Seeing is believing: the ideology of naturalism'. *Media, Culture and Society*, 1983: 213–20.

Collins, Richard, 'Walling Germany with brass: theoretical paradigms in British studies of television news' in *Media, Culture and Society* 6, 1984: 27–44.

Curran, J., 'The press as an agent of social control: an historical perspective', in Boyce, G., Curran, J. and Wingate, P. (eds), *Newspaper History*, 1978: 51–75.

Curran, J., 'Editorial: the media and politics' in *Media, Culture and Society*, 1, 1979: 1.

Di Maggio, Paul, 'Cultural entrepreneurship in nineteenth century Boston'. *Media, Culture and Society*, 4, 1982: 33–50; 303–22.

Durrans, Brian and Kattenhorn, Pat, 'Representing India: issues in the development of the 1982 Festival of India in Britain', unpublished paper, Representations Symposium, British Museum, 13–15 February 1986.

Follet, David, *The Rise of the Science Museum under Henry Lyons* (Science Museum: London, 1978).

Fox, Daniel, *Engines of Culture: Philanthropy and Art Museums* (University of Wisconsin: Wisconsin 1963).

Fry, Tony, 'Unpacking the Typewriter' in *Block* 7, 1982: 36–47.

Goode, George Browne, 'The Principles of Museum Administration' in *Report of the US National Musuem*, 1901, pt 2.

Griggs, Steven A., 'Evaluating exhibitions' in Thompson, J. (ed.), *Manual of Curatorship* (Butterworth: London, 1986): 412–22.

Hall, Margaret, *On Display* (Lund: London, 1987).

Hammersley, Martin, 'Heap and Delamont on transmissionism and British ethnography of schooling' in *Curriculum Inquiry*, 17, 1987: 235–7.

Haraway, Donna, 'Teddy bear patriarchy: taxidermy in the garden of Eden, New York City, 1908–1936' in *Social Text*, II, 1984–5: 20–64.

Impey, O. and MacGregor, A., (eds) *The Origins of Museums* (Oxford University Press: Oxford, 1985).

Jennett, Bryan, *High Technology Medicine* (Oxford University Press: Oxford, 1986).

Karpf, Anne, *Doctoring the Media* (Routledge and Kegan Paul: London, 1988).

Kusamitsu, Toshio, 'Great Exhibitions before 1851' in *History Workshop*, 9, 1980: 70–89.

Lancet 24 September 1955.

Lawrence, Ghislaine M., 'Museums and science' in *Proceedings Joint Conference British Society for the History of Science and History of Science Society*, Manchester, 11–15 July 1988: 284–90.

Lyons, H. G., 'The Aim and Scope of the Science Museum'. *Museums Journal*, 24, 1924: 114–18.

Lumley, Robert (ed.), *The Museum Time Machine* (Commedia Press: London, 1988).

MacMahon, R., 'The romance of technological progress: a critical review of the National Air and Space Museum' in *Technology and Culture*, 22, 1981: 281–96.

Najman, Jackob and Levine, Sol, 'Evaluating the impact of medical care and technologies on the quality of life: a review and critique' in *Social Science and Medicine*, 15F, 1981: 107–15.

North, J. F., 'Museum Labels' in *Handbook for Museum Curators*, Part B, Section 3 (Museums Association: London, 1957).

Pacey, Arnold, 'The history of technology' in Corsi, O., Pietro, O. and Weindling, Paul, *Information Sources in the History of Science and Medicine* (Butterworth: London, 1983a).

Pacey, Arnold, *The Culture of Technology* (Basil Blackwell: Oxford, 1983b).

Pearson, Nicholas, *The State and the Visual Arts* (Open University Press: Milton Keynes, 1982).

Pinch, T. and Bijker, W., 'The social construction of facts and artefacts: or how the sociology of science and the sociology of technology might benefit each other' in *Social Studies of Science*, 14, 1984: 399–441.

Porter, Gaby, 'Putting your house in order: representations of women and domestic life' in Lumley, R. (ed.), *The Museum Time Machine* (Commedia Press: London, 1988): 102–27.

Rees, A. and Borzello, F., (eds) *The New Art History* (Camden Press: London, 1986).

Reiser, S. J. and Anbar, M., *The Machine at the Bedside* (Cambridge University Press: Cambridge, 1984).

Ross, D., 'The documentary in television' in *BBC Quarterly*, V, 1, 1950: 19–23.

Scannell, Paddy, 'The social eye of television, 1946–1955' in *Media, Culture and Society*, 1, 1979: 97–106.

Schudson, M., 'Criticizing the critics of advertising: towards a socio-logical view of marketing' in *Media, Culture and Society*, 3, 1981: 3–12.

Silverstone, Roger, 'Narrative strategies in television science: a case study' in *Media, Culture and Society*, 6, 1984: 377–410.

Silverstone, Roger, *Framing science: the making of a BBC documentary* (BFI Publishing: London, 1985).

Silverstone, Roger, 'Museums and the media: a theoretical and methodological exploration' in *The International Journal of Museum Management and Curatorship*, 7, 1988: 231–42.

Skinner, Ghislaine, M., 'Sir Henry Wellcome's museum for the science of history' in *Medical History*, 30, 1986: 383–418.

Smithas, D. W., Letter in *British Medical Journal*, II, 1958: 1473.

Stocking, B. and Morrison, S. L., *The image and the reality: a case study of the impacts of medical technology* (Oxford University Press (Nuffield Trust): Oxford, 1978).

Sussex, Elizabeth (ed.), *The Rise and Fall of the British Documentary* (University of California Press: Berkeley, 1975).

Susskind, Charles, 'The invention of computed tomography' in Hall, A. R. and Smith, N., *History of Technology* (Mansell: London, 1981).

Swallow, N., *Factual Television* (Focal Press: London, 1966).

Tagg, John, *The Burden of Representation* (Macmillan: Basingstoke, 1988).

Thompson, J. (ed.), *Manual of Curatorship* (Butterwick: London, 1986).

Underwood, E. Ashworth, *Guide to an Exhibition Illustrating the Story of Pharmacy* (Oxford University Press: Oxford, 1955).

Velarde, Giles, 'Exhibition design' in Thompson, J. (ed.) *Manual of Curatorship* (Butterworth: London, 1986): 394–402.

Warwick, Roger, Letter in *British Medical Journal*, II, 1958: 1354–5.

Watson, D., 1981. 'Busmen: Documentary and British political theatre in the 1930s' in *Media, Culture and Society*, 4, 1981: 339–50.

Watson, Claud, Letter in *British Medical Journal*, II, 1958: 1633.

Weiner, George, 'Why Johnny can't read labels' in *Curator*, VI, 1963: 143–56.

Objects as me...
S...

In the collections of the ... is an infantry officer's ..., ... which was worn by Lieutenant Henry Anderson at the battle of Waterloo, in what is now Belgium, on Sunday 18 June 1815.[1] The coatee is on exhibition in the National Army Museum, where if forms a part of the permanent displays. The jacket has been lovingly preserved from that June day to the present, and so we must suppose that it carries a genuine significance for the generations who have lived and died since the battle, up to and including our own. It is the nature and the implications of this significance which this paper sets out to explore.

As a first step, it is necessary to establish the specific context of the jacket in time and space, and to describe the historical moment of which it was a part. Anderson served in the Waterloo campaign as a lieutenant in the light company, 2nd battalion, 69th Regiment of Foot (later the Welch Regiment). On 16 June 1815, his regiment had fought at Quatre Bras, the action between the British Army and its allies and the French, which preceded the decisive encounter at Waterloo two days later. Due to a confusion of orders, the 69th were caught in extended line by the charge of Kellermann's brigade of cavalry. They were badly cut up, suffering some hundred and fifty casualties, and their colours were captured by the enemy. At Waterloo, the 2/69th took its place in the line of infantry regiments which held the ridge at Mont St Jean, and in the final phase of the battle, about seven o'clock in the evening, formed square with the 33rd Regiment as the British and Allied line prepared to receive the assault of the Imperial Guard (Whitehorn, 1932).

The precise events of this, the most celebrated passage of

arms in the entire Napoleonic Wars, has been a matter of dispute ever since. The square next to that of the 33rd and 69th seems to have been driven back in confusion, and that in which Anderson and the 69th stood began to give way until their commanding officer, General Halkett, himself took the 33rd's standard and encouraged them to stand their ground. At this moment, in the crisis of the battle, Anderson fell, wounded severely 'by a musket ball which broke his left shoulder, passed through the lungs, and made its exit at the back, breaking the scapula' (Army List, 1860). The coatee shows the tears and stains which would have resulted from such a wound. Anderson remained unconscious while the Imperial Guard was halted and turned, first by the attack of the 52nd Regiment and the 1st Foot Guards, and then by the mass of the Allied line: the battle was won and the French formations destroyed (Naylor, 1968: 78–80, 159–65; Howarth 1968: 203–7).

Anderson's own, very brief, account of these final events survives in a letter which he contributed to Capt. Siborne's collection as a result of Siborne's requests for information from officers who had served in the battle; the collected letters were ultimately edited and published by his son in 1891 (Siborne, 1891: 338). Anderson's slow promotion after 1815, and the considerable time he spent in 'desk jobs', suggest that his injuries at Waterloo left him something of an invalid for the rest of his life.

A number of points about this should be noticed, because they are of importance in the discussion which follows. The historical circumstances of time, place and action in which Anderson wore the surviving coatee, and in which he was wounded and the jacket damaged, are 'facts' as 'real' as any we shall ever have. The defeat of the Imperial Guard was recognized as decisive militarily and politically, and as glorious emotionally, within a few moments of its happening and, in at least some quarters, has been so seen ever since. The part played by the 69th, however, throughout the two battles, was much less prestigious and does not, therefore, form part of the extensive public mythology of the campaign. Anderson himself had his health affected, and we can only guess at the, probably complicated, mixture of feelings which led him to preserve his damaged jacket.

The jacket shows characteristics common to a great many pieces in museum collections, especially those within the broad social history, applied art, and ethnographic fields. Its connotations and historical context are extremely personal, giving it the value and emotional tone of a souvenir: nostalgic, backward-looking and bitter sweet. It is intensely romantic, in that, for its owner in later life, who was the first person to cherish it, it probably represented a time when life seemed more exciting and more meaningful than the dull present of middle age. It serves, also, to sum up, or make coherent in personal and small-scale terms, an important event which seemed confused, spasmodic and incoherent to most of the individuals who took part in it. Finally, it acts as the validation of a personal narrative: when the original owner told his story of the great battle, he referred to his souvenirs to bear out the truth of what he was saying, and to help him make his personal selection of the moments which he wished to recall (Stewart, 1984).

These intensely individual experiences are often of very limited interest to anybody else, and it is this which makes so much of this kind of museum material very intractable to deal with, either in terms of research or for the purposes of a display (or at any rate, of a modern display which aspires to make the past meaningful) because both research and display strive to operate within a broad and generalizing intellectual tradition, to which our jacket, of itself, seems to bear little relationship. But we know that many people *do* find the jacket worth looking at, because it has a quality which moves and excites us. In museums we are accustomed to call this the 'power of the real thing' and to regard it as the greatest strength which a collection-holding institution commands.

There is a problem here, upon which the concepts of semiotics may enable us to shed some light. We shall hope to show how the jacket works as a message-bearing entity, acting in relationship to Waterloo both as an intrinsic sign and as a metaphorical symbol, which is capable of a very large range of interpretations; and to explore how this relates to the way in which the present is created from the past. The nature of interpretation is then examined in terms of viewer-response, and this leads to a discussion of the relationship between individual responses and the social consensus of meaning, and so of the role of the

curator. Finally, objects are seen as one of several ways of narrating the past.

We may start by viewing the jacket in terms of the fundamental insights achieved by Ferdinand de Saussure, adapting what he offers for an understanding of language to the analysis of other communication systems, in this case material culture (1973). Figure 1, Section A (p. 129) shows the three conceptual elements and their relationships. Each society 'chooses' from the large (but not infinite) range of possibilities what its individual nature is going to be. This 'choice' is not forever fixed, but will alter as cicumstances change, a point to which we shall return. The choice gives each society at any particular moment a large range of communication possibilities, including a body of material culture among which, in the Britain of 1815, was our jacket. To be of social use, this range must be structured according to socially understood rules which command a sufficiently broadly based range of social support. This support is part of the local system of domination and subservience and therefore forms part of the local ideology. The rules, which can be called categories and which are the material equivalent to the grammar of language, and the range of possibilities equivalent to the vocabulary, together make up the deep structure of the society under analysis, and Saussure calls this structured whole the *langue*.

Later writers, like Barthes (1977), identify the *langue*, broadly, as the *signified*, that is to say, the body of social understanding which must operate through a social action of some kind. From the *langue* of society issues *parole*, that is the actual action, spoken sentence or performed deed, by means of which each society creates itself and continues its daily life. For Barthes, these concrete performances or embodiments, which he calls *signifiers*, have no necessary connection with the signified meaning which they carry (although this is debatable). Together, the union of signified and signifier gives us a *signe*, that is the social construct which members of the group can recognize and understand (Fig. 1, Section A).

The position of the jacket in all this seems quite clear. The *langue* of Western European society in 1815 held a mass of material and human 'vocabulary', which included the production of coloured cloths and brass fittings, gun powder, horse

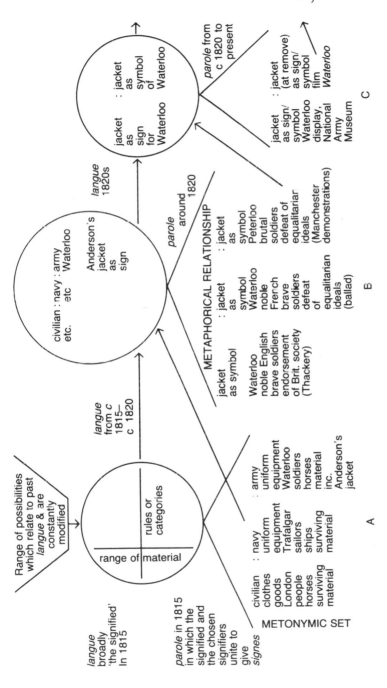

Fig. 1 Analysis of communication in material culture terms, using Saussure's system

wagons and so on. Its categories included a desire to define armies, and within these armies different ranks and different regiments. The jacket, with its special cut, its red colour, its regimental insignia and its elements indicating rank, shows material structuring at work in classic form. There was, however, no obvious reason why this particular choice should have been made, for there are other ways in which the same social categories could have been expressed. The jacket is then a *signe* in Barthes' sense, uniting the message (the signified) and the physical embodiment (the signifier).

Saussure shows that the structuring process means that *parole* works not in discrete pieces but in sets, in which meaning depends upon relationships, and categories are created by the distinction which divides one set from another. The rank which the jacket expresses would be meaningless if there were not other, higher and lower, ranks with which it forms a set. Equally, the category 'army' acquires clearer meaning in relationship to the different category 'navy', where everyone wears blue jackets, and both are distinguished from the category 'civilian'. So, to the lower part of Figure 1, Section A, we can add some of the sets which this society's *langue* produces as *parole*.

We may take the discussion an important stage further by employing the analysis of communication devised by Leach (1976: 12). The message-bearing entity (jacket as signifier) stands for the message (the signified categories) as a result of human choice. At this point, Leach makes a crucial distinction between his sign and his symbol, which is very helpful in enabling us to understand better how the jacket works (confusingly, Leach and Barthes use the same word to describe different things; here the French spelling will be used when Barthes' meaning is intended, and the English when Leach's is). Objects (and other messages) operate as a *sign* when they stand for the whole of which they are an intrinsic part, as the jacket does for the actual events of Waterloo; and in this case the relationship between the different parts of the whole is said to be metonymic. They operate as a *symbol* when they are brought into an arbitrary association with elements to which they bear no intrinsic relationship, and in this case the association is said to be metaphoric. This association is a human device which bears no logical investigation, but apparently we

130

instinctively behave as if it were true, particularly when objects or actions are connected with our deepest hopes and fears. We are inclined, for example, to invest considerable spiritual capital in religious ritual, which works precisely in this symbolic way, even though both rational thought and accumulated empirical experience suggest that this is misplaced.

This analysis of distinctions gives us a framework for expressing how Waterloo, both in immediate retrospect and ever since, has been experienced and interpreted in a large number of ways, or, to put it in post-structuralist terms, a number of discourses or narratives have been constructed around the event. Some of the broadly contemporary interpretations can be distinguished very readily. The socially approved norm, ideologically endorsed, saw the battle as embodying bravery, loyalty, worthy self-sacrifice, and national pride, so that its events became proverbial and all contact with it, like Anderson's jacket, was lovingly cherished. In *Vanity Fair*, published in 1847, but dealing chiefly with events around 1815, Thackeray, after a paragraph musing on the brave folly of war, described the battle in one of the most famous passages in English letters (Chap. 32):

All our friends took their share and fought like men in the great field. All day long, whilst the women were praying ten miles away, the lines of the dauntless English infantry were receiving and repelling the furious charges of the French horsemen. Guns which were heard at Brussels were ploughing up their ranks, and comrades falling, and the resolute survivors closing in. Towards evening, the attack of the French, repeated and resisted so bravely, slackened in its fury. They had other foes beside the British to engage, or were preparing for a final onset. It came at last: the columns of the Imperial Guard marched up the hill of Saint Jean, at length and at once to sweep the English from the height which they had maintained all day, and spite of all: unscared by the thunder of the artillery, which hurled death from the English line – the dark rolling column pressed on and up the hill. It seemed almost to crest the eminence, when it began to wave and falter. Then it stopped, still facing the shot. Then at last the English troops rushed from the post from which no enemy had been able to dislodge them, and the Guard turned and fled.

No more firing was heard at Brussels – the pursuit rolled miles away. Darkness came down on the field and city; and Amelia was praying for George, who was laying on his face, dead, with a bullet through his heart.

The view of the contemporary British labouring poor was rather different. A ballad in the BBC Sound Archive, recorded from the singing of Robert Cinnamond in Belfast, which seems to have originated soon after 1815, and which shows a detailed knowledge of Waterloo, gives one expression of the widespread sympathy which the underclass felt for the ideals of the French Revolution and for Napoleon as their glorious embodiment (*Folk Songs of Great Britain*, Vol. 8, 'A soldier's life for me', Topic Records, 1961):

> 1 Attention pay, both young and old,
> To these few lines that I unfold.
> It is the deeds of great Napoleon
> I'm going to relate.
> He was a gallant Corsican,
> As ever stood on Europe's land,
> I'm inclined to sing his praises,
> So noble was his heart,
> For in every battle manfully
> He strove to gain that victorie,
> And to the world a terror
> Was Napoleon Bonyparte.
>
> 2 On that fatal June at Waterloo
> It caused Napoleon for to rue,
> When he saw the tricks of Grouchy.[2]
> It struck terror to his heart,
> For there upon that fatal day;
> He was forced to yield or run away,
> Like a bullock sold in Smithfield
> Was Napoleon Bonyparte.

Egalitarian ideals and a hatred of the British soldiers at the command of the class oppressors are explicitly linked in the period of abortive revolutionary action following 1815. The men who attempted revolution in the Derbyshire Peak in the early days of June 1819, sang:

Everyman his skill must try,
He must turn out and not deny;
No bloody soldier must he dread,
He must turn out and fight for bread.
The time is come you plainly see
The government opposed must be (Thompson, 1968: 723–5).

As the marching men approached Nottingham, they were faced by a small force of Hussars, and their attempt collapsed: three men were ultimately executed and fourteen were transported.

The Derbyshire failure emphasized the dangers of armed conspiracy and, in Thompson's words (1968: 736–7), Peterloo, on 16 August 1819, followed directly as 'the outcome of an extraordinarily powerful and determined "consitutionalist" agitation, largely working class in character, within a potentially revolutionary context'. On that day about sixty thousand peaceful demonstrators in St Peter's Fields, Manchester, were deliberately ridden down by the Manchester Yeomanry (local men serving part time) and the regular 15th Hussars, on the orders of the local magistrates. The number of killed and wounded is uncertain, but there seems to have been about eleven dead and over five hundred injured. To quote Thompson again, 'The epithet itself – Peter-Loo – with its savagely sardonic confidence, indicates better than any other evidence, the tone of feeling' (1968: 755). We can still hear the contempt for the soldiery and the disparagement of military glory which brought the name to birth, and, perhaps too, echoes of wistful sympathy for the ideals, if not the realities, of the French armies which we hear in the ballad already quoted, and many others of its kind. To the survivors of Peterloo, Anderson's coatee would have been experienced in a way quite different from that felt by Thackeray and most of his readers. These examples show the range of interpretations in which the battle and its elements were directly involved. A finer mesh would ultimately bring us down to the feelings of each single individual who was alive at the time with his or her perceptions of loss, gain or indifference; and all these perceptions share an equal validity.

It is clear that, in the terms which we have already described, each of these perceptions forms its own metonymic 'Waterloo set', and that these sets have a metaphorical relationship to that

of Waterloo itself, and to each other (Fig. 1, Section B). The jacket as part of the set to which it has an intrinsic relationship – Waterloo – exists as a sign, but when it is part of the other sets it is acting as a symbol, although, as has been said, it is its metonymic sign nature which enables it to do this. The range of possible metaphorically-related sets is very large, because each contemporary was capable of seeing the battle in a very large number of ways. The jacket is correspondingly rich in symbolic possibilities. It is capable of acting as a signifier for much signification, with each one of which the meaning of the *signe* changes; or, to put it another way, it is polysemantic.

All these shifting perceptions of the battle and the jacket went in to the imaginations (*langue*) of those who continued to live after the battle was over, forming part of an ever-shifting flux of experience which was passed on as an inheritance to their successors (Fig. 1, Section C). The perceptions which matched the aspirations of the class in power naturally tended to suppress or dislodge those which were officially regarded as more subversive, and it is these perceptions which ultimately brought the jacket into its museum collection. In semiotic terms, what happens is that those objects which were once signifiers become themselves the signified, as they become a chosen part of the society's *langue*, in which they play a role in modifying both the existing categories and the rules of their use. Put in historical terms, the experience of Waterloo, in all its guises and including its physical souvenirs, becomes part of the collective consciousness, in which it will play its role in bringing about social change. It may be added here that society is an agglomeration of individuals, and although in some senses the whole may be greater than the sum of its parts, it is also true that each individual's experience follows much the same patterning which has been discussed throughout this paper in social terms.

The jacket and the battle, now part of the signified held in the *langue*, give rise to a fresh range of signifiers which will find their own appropriate *signes*, among which, again, may well be the jacket itself. The crucial aspect of the jacket, which differentiates it from most other kinds of message-bearers (or elements in *parole*) is that while it survives physically it retains its metonymic relationship to the battle itself; of Waterloo, whatever meaning may be attached to it, the jacket remains *not*

in Leach's terms a 'symbol' (however much it may be so described in ordinary speech) but, in his terms, a 'sign', an intrinsic part. So we have a sign available for constant symbolic re-use in the strict sense, in the creation of fresh sets of signifiers. The cycle of signified – signifier – signe (= sign : symbol) is constantly repeating itself throughout the span of an individual's consciousness, and in the course of social action, and it is the sum of these perpetually shifting meanings which makes up our perception of social change. In the example chosen here, the sign which carries meaning is able to do so because, unlike we ourselves who must die, it bears an 'eternal' relationship to the receding past, and it is this that we experience as the power of 'the actual object'.

This analysis helps us to understand the working of the emotional potency which undoubtedly resides in many sup-posedly 'dead' objects in our collections. It gives a framework for understanding better how our relationship with the material culture of the past operates, and shows that this is part of the way in which we construct our ever-passing present. This rests on the assumption that our reaction to the coatee is as important as the object itself, and the nature of this interaction hears further investigation. We have, as it were, the text created by the coat and its contexts, both originally and as a result of the signification chains already described; and we have the act of realization accomplished by the reader or viewer, the process which Roman Ingarden called *Konkretisation* (Iser, 1974: 274). The meaning of the object lies not wholly in the piece itself, nor wholly in its realization, but somewhere between the two. The object only takes on life or significance when the viewer carries out his realization, and this is dependent partly upon his disposition and experience, and partly upon the content of the object which works upon him. It is this interplay which creates meaning; however, the precise convergence can never be exactly pinpointed but, 'must always remain virtual, as it is not to be identified either with the reality of the text or with the individual disposition of the reader' (Iser, 1974: 274).

It is this 'virtuality', to use Wolfgang Iser's word, which gives rise to the dynamic nature of objects, as it does of texts. As the viewer stands in front of the show case, he makes use of the various perspectives which the object offers him, some of which

have already been suggested; his creative urges are set in motion, his imagination is engaged, and the dynamic process of interpretation and re-interpretation begins, which extends far beyond the mere perception of what the object is. The object activates our own faculties, and the product of this creative activity is the virtual dimension of the object, which endows it with present reality. The message or meaning which the object offers is always incomplete and each viewer fills in the gaps in his own way, thereby excluding other possibilities: as he looks he makes his own decisions about how the story is to be told of, for example, Lieutenant Anderson's feelings on that day.

In this act, the dynamics of viewing are revealed. The object is inexhaustible, but it is this inexhaustibility which forces the viewer to his decisions. The viewing process is selective, and the potential object is richer than any of its realizations. When the same person sees the same coat ten years later, it may appear in a new light, which seems to him more 'correct', richer, and more perceptive, so that artefact is transformed into experience. In one sense, it is reflecting the developing personality of the viewer and so acting as a kind of mirror; but at the same time the effect of the object is to modify or change the viewer, so that he is a slightly different person from the one he was before. So we have the apparently paradoxical situation in which the viewer is forced to reveal aspects of himself in order to experience a reality which is different from his own, because it is only by leaving behind the familiar world of his own experience that he can take part in the excitement which objects offer; and many of us would feel that this lies at the heart of the museum experience.

The viewer's process may be taken a stage further. He will endeavour to bring all his imaginative impressions together into the kind of consistency for which we are always searching, since, it seems, that the creation of satisfactorily complete sets, which have a parallel or metaphorical relationship to other perceived sets, is the way in which our minds work to provide distinctions and explanations. This brings us to the final problem to be considered here. The object as it survives has a fixed form and a definite factual history, without which it could not exist and we could not begin to understand it; but if viewing and interpreting it were to consist only of uninhibited specula-tion, uninterrupted by any 'realistic' constraints, the result

would be a series of purely individual sequences with little relationship to each other, and meaningful only in terms of the individual personality, no matter how bizarre, idiosyncratic or simply ill-informed this may be.

If the viewer cannot conjure up the kind of consistency just mentioned, which may be described as an act of interpretation, with all the claims to validity which this implies, he will lose interest in the object. But if his interpretation departs too far from contemporary norms, his community will lose interest in him, at least as far as this subject is concerned. This can certainly happen, but more usually it does not and the reason seems to rest in the relationship between object and viewer. The object provokes certain reactions and expectations which we project back on to it in such a way that the polysemantic possibilities are greatly reduced in order to be in keeping with the expectations that have been aroused. To paraphrase Iser, the polysemantic nature of the object and the interpretation-making of the viewer are opposed factors. If the interpretation-making were limited, the polysemantic nature would vanish, but if the polysemantic nature were all-powerful, the interpretation would be destroyed (Iser, 1974). Much the same point may be made by saying that the object only exists if it is 'made meaningful' through somebody reacting with it; but, at the same time, that somebody only exists, as a social being, as he is in the process of interaction (as, of course, he is most of the time). The balance is held by the object itself, with its tangible and factual content. About the nature of these, there is a consensus within each individual's community, and so the act of interpretation will bear a relationship to this consensus. Herein lies the dialectical structure of viewing. The need to decipher gives us the chance both to bring out what is in the object and what is in ourselves; it is a dynamic, complex movement which unfolds as time passes, and in the act of interpretative imangination we give form to ourselves.

The nature of this consensus is complex. Among other things, it embraces the body of traditional knowledge and expertise which we may call scholarship or curatorship, and the ability to apply this to a particular object or collection in order to extend the boundary of understanding. But the curator faces both ways. He possesses traditional knowledge, which in the case of

the Waterloo jacket means the ability to appreciate its specific nature and history, precisely the qualities which give it its unique value. However, he is also part of the dialectical process, so that each presentation of an object is a selective narrative, and the curator is engaging in a rhetorical act of persuasion, which has an uncertain outcome. The whole process assists each of us to make some kind of sense of our relationship to our past and so to our present, the perpetual re-creation in which meaning is always just through the next door.

Two further points remain to be made. The constant use, in this paper and others like it, of words like 'cypher', 'code', and, above all, 'text', gives us a broad clue to the first: objects and our relationship to them are analysed as if they were written narratives, and this approach needs a little more elaboration. The material to which we react, combining as it does both external events like the coatee and internal events like our own imaginative response, always lies in the past, although this past may be as distant as Waterloo or as recent as a moment ago. The past survives in three ways: as objects or material culture; as physical landscape (the difference between which and artefacts is conventional rather than essential); and as narratives (which may, of course, take the form of film or tape as well as of written text). To these should be added a further dimension, that of individual memory, but it seems likely that this memory forms itself as images of objects and places, linked with physical remembrances like heat and cold and with remembered emotions, to construct narratives similar to those which have external form.

The distinction between narrative as 'historical' writing, which claims to 'tell the truth about the past', and narrative which is 'fiction', like a novel or a poem, becomes increasingly flimsier the harder it is looked at. Both will have to bear a relationship to 'external' fact and to a generally received view of the human condition which they illumine, if they are to hold our interest and stimulate our imaginations (and are generally held to be the greater, the more they achieve this), and both are equally 'true' in the sense that they set out a view of the human social past as conceived by the writer in his day. Both require their present meaning to be constructed in the ways already described, and both, therefore, are subject to Barthes' famous

'death of the author' (1977). But narratives of these various kinds all require a degree of explication to help in the creation of most of their meaning, which is another way of sayng that the cultivation of curatorship and scholarship, in the traditional sense, is fundamental to our enhanced understanding of them, in spite of the fact that, as we have seen, scholarship is itself a dialectical process. Precisely the same applies to the objects and the landscapes which survive from the past. These also tell their story, like a verbal or pictorial narrative, and they do this more meaningfully the more they have been studied. Hence the fact that both technical history (the events of Waterloo and Peterloo), and technical fiction (*Vanity Fair*), together with that shifting, moody, quicksilver construction which is each individual, have all been drawn into this attempt to unravel the nature of our relationship with the coatee on display; and hence, also, the title of this paper.

Secondly, it is important to remember that we ourselves – I who write this paper and you who find yourself reading it – are actors in the story. It is our better understanding, as we live our lives, of the processes of making meaning which enables us to analyse the nature of our relationship to the objects which come from the past, and to perceive how they affect us, both individually in the dialectical creation of meaning and self, and socially in the ideological creation of unequal relationships. Better understanding in both these modes brings discontent, since it is seldom comfortable to know more either about one's self or about one's position in the world, but equally, understanding is a liberating project, even though forever bound in self-related subjectivity. So tension is generated, and it is precisely for these reasons that authors write narratives, museums collect objects and display them, people visit galleries, and we all construct our explaining stories from what we see, read, and remember; and all these meanings, as we have seen, are the continuous re-creation of significance through the perpetual play of metaphor and metonymy, of signification and signifier. So the jacket which was once part of Lieutenant Anderson's past and present now becomes part of our own, carrying the objective reality of its red cloth and its bullet hole along the chain of meanings.

Notes

1. I am very grateful to Michael Ball and Simon Davies, both of the National Army Museum, London, who supplied me with details about Lt. Henry Anderson and his coatee.
2. On 15 June Napoleon divided his army into three groups, and command of the right wing was given to Marshal Grouchy. On the 17th Grouchy was ordered to pursue the Prussian army, presumed (wrongly) to be in disarray after the action at Ligny on the 16th, and prevent a junction between the Prussians and Wellington. Grouchy's force spent the crucial hours of the 18th partly in delay and partly in useless pursuit of part of the Prussian army. If Grouchy had interpreted his orders differently, or ignored them, or received more sensible orders much earlier, he might have turned towards Waterloo sooner and prevented the arrival of the Prussians on the field and so, perhaps, the French defeat. This muddle was used in some quarters to make Grouchy the scapegoat for Napoleon's failure, in many ways unfairly because the responsibility for the orders which Grouchy was given rests with Napoleon himself. The pro-Bonapartist ballad quoted here takes an extreme view of Grouchy's actions, and even hints that Napoleon was 'betrayed'.

Bibliography

Army List, 1860.

Barthes, R., (trans Heath, S.) *Image–Music–Text* (Fontana: London, 1977).

Howarth, D., *Waterloo* (Fontana: London, 1968).

Iser, W., (trans Macksey, C. and Macksey, R.), *The Implied Reader: Patterns of Communication in Prose Fiction from Bunyan to Beckett* (Johns Hopkins: Baltimore, 1974).

Leach, E., *Culture and Communication* (Cambridge University Press: Cambridge, 1976).

Naylor, John, *Waterloo* (Pan Books: British Battles Series: London, 1968).

Saussure, F. de (trans Baskin Wade), *Course in General Linguistics* (New York, 1973).

Siborne, H. T., *Waterloo Letters* (London, 1891).

Stewart, S. *On Longing: Narratives of the Minature, the Gigantic, the Souvenir, the Collection* (Johns Hopkins: Baltimore, 1984).

Thompson, E. P., *The Making of the English Working Class* (Pelican Books: London, 1968).

Whitehorne, A. C., *The History of the Welch Regiment* (The Welch Regiment: Cardiff, 1932).

6

Methodological museology; or, towards a theory of museum practice
PETER VAN MENSCH

Introduction

This paper is written in the belief that one of the contributions which museology can make to the actual operation of museums in practice is the development of theories about the nature and potential scope of museum collections, and of the ways in which these can be regarded; the implications of this for museum work are, of course, very considerable. This, however, is still an underdeveloped aspect of museology. Museological theory, or methodology, should enable us to describe and understand museological phenomena. It should also provide the basis for (re-)integrating the different specialisms within the profession. As far as conservation and exhibition design are concerned, separate methodologies have already been developed, and the application of methodologies within research derived from subject-matter specialisms is well established. Equally, there is the tradition of applying sociological approaches within

ıl approaches, however,
ıg starting point for the
ork as such.

ıl approaches have been
oretical basis for museum
ın the conception of the
recently a good deal of
for example, writes 'The
ıseal working procedures,
the complete character of
tly it has also determined
ıd to the museal working

141

object context

procedure (Sola, 1982). Finley (1985), Maroevic (1983, 1986a, 1986b), Pearce (1986a, 1986b, 1986c) and Rüdiger (1983) are among those museologists who have attempted to develop a consistent object-based theory which can work in museum practice. Their approaches, though developed independently, are fairly similar, and they are partly based on, or at least connected with, methodological thinking in the field of material culture studies. Rather than analysing their contribution to museological theory (see van Mensch, in prep), this present paper will summarize an approach to museology which has been developed in a series of articles from 1983 onwards (van Mensch 1984, 1986; van Mensch, Pohw and Schouten 1982).

This paper will return to museum fundamentals, and set out possible parameters within which the definition of museum objects, activities and institutions may operate. It then explores the range of objects (in the broad sense) which may be regarded as the museum's proper concern, that is as *musealia* or *museological objects*. These are all understood as possessing as a data structure, and this, with its levels of data, will be discussed in terms of a possible model. This model will then be applied to one museum activity – conservation – which will demonstrate how it operates, and some of its implications. This leads to the broader, and final, question of the problematic nature of any special character which may reside in the authentic object, and suggests that some contemporary developments in museum thinking are producing new approaches in which the importance of the preserved authentic object dwindles away.

Object-oriented theory in relation to three fundamental parameters

A possible object-based approach to museum theory may be developed from the following assumptions. There is a special relationship between mankind and his physical environment based on cultural rather than economic values. This special relationship manifests itself in a characteristic set of activities. These are: *preservation* (including collection, conservation, restoration, registration, documentation), and *research* and

communication (including exhibition and education). These activities create and use that selected part of our material environment which we usually call 'heritage'.

Despite the apparent diversity of theoretical approaches to museology, there seems to be a high degree of consensus among museologists concerning the basic parameters. The first parameter concerns the object, seen as the fundamental element in our cultural and natural heritage. A general frame of reference is provided by Deetz's definition of material culture (Deetz, 1977: 24–5). Deetz defines material culture as 'that sector of our physical environment that we modify through culturally determined behavior'. This interpretation of material culture does not limit itself to tangible, movable artefacts, but includes:

all artifacts, from the simplest, such as a common pin, to the most complex, such as an interplanetary space vehicle. But the physical environment includes more than what most definitions of material culture recognize. We can also consider cuts of meat as material culture, since there are many ways to dress an animal: plowed fields; even the horse that pulls the plow, since scientific breeding of livestock involves the conscious modification of an animal's form according to culturally derived ideals. Our body itself is a part of our physical environment, so that such things as parades, dancing, and all aspects of kinesics – human motion – fit within our definition. Nor is the definition limited only to matter in the solid state. Fountains are liquid examples, as are lily ponds, and material that is partly gas includes hot-air balloons and neon-signs. . . . Even language is a part of material culture. . . . Words after all, are air masses shaped by the speech apparatus according to culturally acquired rules (Deetz, 1977: 24–5).

The second parameter refers to the complete range of activities surrounding the preservation and use of our cultural and natural heritage. Little difference of opinion appears as to their content, but opinions differ as to their grouping. In this paper, all these activities are brought together into the three groups: preservation, research and communication.

The third parameter concerns the institutional form in which these activities are implemented. The traditional museum is, by definition, the institution in which all the activities are carried

out but only in relation to tangible, movable objects, usually excluding books and other written and printed documents. However, if we follow Deetz's definition of material culture, other kinds of institution come within our scope. Finally, the fourth parameter is society as a whole, usually conceived in terms of target groups. It is always the object in relation to the other basic parameters that forms the content of museological thinking. Museological theory and practice aim at 'the systematic combination of the values of objects and human beings' (Tsuruta, 1980: 48). Museums and museological practice are but mediators, not ends in themselves.

Musealia and *museological object*

Museologists vary in their views on the categories of objects which museological theory should embrace, and the diversity of their views is related to their opinions about the subject matter of museology as a whole. Different traditions have been established concerning the maintenance and use of different categories of objects. The categories concerned are: (1) artefacts *sensu stricto*; (2) documents; (3) books; (4) buildings; and (5) living organisms. The terms are, on the whole, used in a rather intuitive way, without clear definitions. The different approach towards each category is reflected in different specialized institutions: artefacts – museums; documents – archives; books – libraries; buildings – historic preservation (German: *Denkmalpflege*); living organisms – zoological and botanical gardens. The relation between object category and institution is not, however, exclusive. A museum may contain artefacts, documents, books and even monuments (open air museums), while an archive may contain some books and artefacts, and a building may contain artefacts.

The essential element across this diversity, as far as musem theory is concerned, is the documentary character of the objects. The object is selected and isolated from its original environment, and preserved. By this act or rather process it becomes a document (using this word in a theoretical, rather than a specific sense) and, as such, a source of knowledge (German: *Primärquelle*). This special character of the museological object is reflected in

Stransky's definition of *musealium* as 'object separated from its actual reality and transferred to a new, museum reality in order to document the reality from which it was separated' (Stransky, 1974: 32).

Schreiner gives a similar definition in which he also includes the conditions under which the object as document is preserved:

Musealia are part of the movable (cultural property and the cultural) heritage. They are materialized results of work in which human characteristic forces manifest themselves. These objects are selected, acquired from the social as well as natural environment by museum work, and then preserved, decoded and purposefully utilized. Musealia are such objects of the movable cultural property that show the following specific features: (1) They verify, as means of demonstration and evidence in their authentic references, ... the historical development of nature in relation to society; (2) They are brought into fixed state by means of conservation, or preparation, or they own it; (3) They are selected and acquired for the collection and are preserved and decoded there; (4) They are purposefully utilized, or made usable for social and intellectual-cultural and scientific work in public, namely by means of exhibition and other forms of communication for education and aesthetic pleasure, and by means of research aiming at the increase of new cognition for the whole society (English version in Schreiner, 1988: 5).

Maroevic (1986b: 2) refers to the definition given by Stransky, but includes 'real and potential museum objects'. He advocates a broader approach than Schreiner, although he also uses the term *musealia*. But more emphatically than Schreiner, Maroevic sees a broadening of the scope of museums, including more sectors of our cultural and natural heritage, and coming close to Deetz's definition of material culture. One step further is to abandon the concept of a specific 'museum' institution. In this view, museology should include the whole field of cultural and natural heritage (see, for example, Sola, 1982), and in this connection the term *museological object* has been introduced (van Mensch, 1984).

Data structure of objects

The concept of 'museological object' is based on the distinction of four 'levels' of data: (1) structural properties; (2) functional properties; (3) context; and (4) significance. *Structural properties* imply the physical characteristics of the object. Some common usage of the term 'object' refers to this level of information. *Functional properties* refer to the use (potential or realized) of the object. *Context* refers to the physical and conceptual environment of the object. Finally, *significance* stands for the meaning and value of the object.

On the basis of a similar approach to the object as data carrier, Maroevic (1983, etc.) developed a model of the object as three-fold sign. The first level is *the object as document*. This level concerns the sum total of data as we have defined them. These data are the 'vehicles' of the communication process. This is the level of *the object as message*. This message only can be actualized under certain conditions. Since the message arises from the interaction of the object as document and the subject as transmitter, the object may be the carrier of many different messages. The third level is the level of *the object as information*. This level concerns the impact and the meaning of the message.

The first level relates to the sum total of data embodied in the object. This sum total is the result of an historical process. Reconstructing the object's 'biography' by means of the information categories we have used does overlap the aims of subject-matter specialisms, but such interpretation is necessary in order to develop adequate approaches to preservation and communication practices. So, the 'synchronic' listing of data categories is completed by a 'diachronic' series of identities. In the biography of artefacts, three stages can be distinguished: (1) conceptual stage, (2) factual stage, (3) actual stage.

The first stage is the idea of the maker. This idea is related to the conceptual context of the maker (i.e. his or her culture). This is, in fact, the potential object. The other stages refer to the realized object. The factual stage refers to the object as it was intended by the maker, just after the production process had been completed. The set of data emerging as the sum total of

these three levels constitutes the *factual identity* of the object. During its life history, the object changes. In general it could be said that its information content will grow, although quite often an erosion of information occurs too. The result of the accumulation of information on all levels constitutes the *actual identity*: the object as it appears to us now.

The information structure of the artefact *sensu stricto* (in Maroevic's terms 'the document') may be set out as in Figure 2.

idea matter conceptual identity

genesis

structural identity functional identity factual identity

primary data primary function

...................... use
.. re-use ..
.. ..
...................... decay
... ...
............ conservation
.... restoration
....
....
secondary data secondary function actual identity
....
....

Fig. 2 Information structure of the artefact

Brandi (1977: 2) distinguishes between *structure* (materials) and *appearance* (image). Structure is the carrier of the image. In restoration the image may be retained while the structure is substituted. Similarly, the structure may be preserved while the image is lost. In a marble statue, for example, the marble is the structure, while the image is that what makes the piece of marble a statue. Apart from this distinction, it seems useful to distinguish between *structural identity* (including both structure and appearance) and *functional identity*. There is a close relationship between structural identify (form) and functional identity (function). Both aspects are the expressions of the *conceptual identity*, since the maker aimed at a certain use-value, or function.

The distinction between conceptual identity and structural identity is also made by Swiecimski (1982: 40), who speaks about *conceptual object* (conceptual identity here) and *authentic object* (actual identity here). The factual identity is described by him as 'the original shape of the authentic object' (1982: 43).

Application of this model in conservation

The classical dilemma which surrounds the preservation of the information embodied in objects may be summarized as 'conservation or restoration'. *Conservation* might be defined as the 'attempt to retain an object in a stable condition, prevent further deterioration and retain the integrity of the object' (Monger, 1988: 376). *Restoration* might be defined as 'the attempt to reconstruct the original state in conformity with the intention of the maker' (Kirby Talley, 1982: 105). Conservation could have been seen as the safeguarding of the actual identity, while restoration, as defined, refers to the revealing and preserving of the factual identity. Nevertheless, the distinction between conservation and restoration is rather academic. There are times when conservation also involves an element of restoration: for example, cleaning involves the removal of accumulated dirt, rust, and so on. This is part of the conservation process, since it helps to prevent further deterioration. But dirt is part of the object's actual identity and is, as such, of documentary value, since it is a part of the object's biography. At the same time, cleaning may reveal the factual identity, and is as such part of the restoration process. But where is the borderline between factual identity and actual identity? Sometimes what has been considered as *secondary information* proves to be *primary information* and the removal is an irretrievable loss. This is called 'totalitarian cleaning' by Brandi (1977) or 'over-restoration' by others.

Securing the factual identity means the denial of the historical process. The secondary information has to be removed in order to reveal the primary information. This means a loss of data. Moreover, since frequently part of the primary information is lost during the historical process, the search for the factual identity usually means interpretation and reconstruction. This is

reflected in the words of Philipott: 'It is an illusion that an object can be brought back to its original state by stripping it of all later additions. The original state is a mythical, unhistorical idea, apt to sacrifice works of art to an abstract concept and present them in a state that has never existed anyway' (Philipott, 1976: 372). Restorations, like copies, are always interpretations. These interpretations are biased by our own time and culture, and are, as such, anachronistic. That is why Murtagh (1976: 387) speaks of the 'inescapable freedom and cultural responsibility of the restorer in making history'. In this connection, Brachert (1983: 83) speaks of 'uninterpretation', that is, the subjective vision of the original in which later generations are only really seeking confirmation of their own aesthetics. He distinguishes between two conflicting schools of thought (1983: 85–6). One school adheres to the Platonic concept of the completeness of a work of art and regards missing parts and the patina of age as intolerable invasions into the 'wholeness, truth, and fullness' of the object, whose right to preservation is intrinsic and, therefore, demands a visionary intuitive recreation by the restorer. This school of thought thus emphasizes the factual identity. The other school emphasizes the contingent nature of reconstructions, which renders them interpretative and, therefore, inadmissible. This school, considered by Brachert to be 'the protestant-materialistic line of development' advocates the conservation of fragments and patina (i.e. the actual identity).

This approach is strongly opposed by, among others, Kirby Talley, who says:

In their frenzied obsession not to disturb anything original . . . proponents of the documentary approach to restoration have made monumental advances in creating what might almost be a new art. It might even be called 'Resto Art'. . . . The master's original work is the only thing that matters, and yet we should never forget the original intent behind a work of art [conceptual identity]. . . . What is of primary importance is a picture's aesthetic value, all other considerations are secondary, including any documentary value it may have for historians or other academics. The restorer's task is to tread a fine line between what is still original and the original intent (1983: 352).

Patina dilemma

Patina is the result of an historical process of interaction between the object and its environment. As such it stands between us and the original object (patina as secondary information), but at the same time it may have a positive importance of its own. In conservation/restoration practice the problem of actual identity versus factual identity is sometimes known as the 'patina dilemma' (van de Wetering, 1982). Respect for the patina, that is, for the actual appearance of objects, creates an atmosphere of authenticity and historicity, but also contributes to their beauty by 'a chromatic strengthening' (Brandi, 1977: 18). This finds its corrupted counterpart in 'Patina Kitsch' (van de Wetering, 1982: 25), where an artificial patina is added to the object in order to give it the status of authentic and historical dignity. True patina, however, 'is precious because it can only be acquired by time' (Fitch, 1982: 250).

The inclination to remove the traces of age and wear, that is 'cosmetic intervention' (Fitch, 1976: 315), creates a surface that may have existed a few hours or days after manufacture, but that never actually occurs. Such painstaking restoration results in alienation. Ripley (1968, quoted in Burcaw 1975: 162–3) speaks of 'the preservation trap' in which 'everything becomes pretty and nice, and history itself becomes a story book experience'. Fitch, however, makes clear that different categories of objects might be approached differently. Speaking of architecture, he showed how the surfaces of monumental upper-class buildings were usually cleaned regularly, demonstrating that the cosmetic criteria of restoration can be that of the creators. The reverse applies to most vernacular or peasant buildings: although all these buildings were at one time new and bright, it is doubtful if any attempts were made to keep them that way (Fitch 1976: 316, see also Fitch, 1982).

The patina of works of art has influenced our perception of these objects to such extent that the cleaning of, for example, paintings often causes a shock. Paintings had (or still have) usually a brownish-yellow coloured varnish (*'Galerieton'*). After the impressionists had dramatically changed our perception of colour, the restoration of older paintings was influenced by this new aesthetic, as Brachert makes clear: '. . . at present cleaning

of paintings has been taken up with post-expressionist diligence, in which we want to find our aesthetics of the colourful painting confirmed by the Old Masters' (Brachert, 1983: 86). It is, however, almost certain that earlier artists applied coloured varnishes or, at least, reckoned with the darkening of varnish (Brachert, 1983: 87–8; see also Brandi 1977). It appears that cleaning does not reveal the factual identity; on the contrary, it takes us further away from it.

Preserving functional identity

A further analysis of the literature on the theory and practice of conservation and restoration shows that the basic problems go beyond the question of which stage of the structural identity of the object should be preserved. In conservation and restoration the functional and conceptual identity of an object must also to be taken into consideration. The emphasis on the material integrity of an object, that is its structural identity, was challenged by a viewpoint in which emphasis was put on the functional identity. In the field of science and technology, especially, it was felt that securing the functional identity brings us closer to the original idea of the maker, that is, the *conceptual identity* of the object, than securing the structural identity.

Choosing for preservation of the structural identity – whether the actual identity or the factual identity – means *static preservation*. Changes in the physical information is not accepted or at least kept at a minimum. Interventions should be reversible. Choosing for preservation of the functional identity means *dynamic preservation*. This implies gradual change in the information content due to wear and possible repairs or adaptations. In other words: the *historical quality* is allowed to 'grow'.

As far as structural identity is concerned, a distinction has been made between *structure* and *appearance*. Appearance may have a dynamic aspect, that is, it may involve moving parts. Well-known examples in the field of art are the objects made by Jean Tinguely, but in the field of science and technology many more examples can be found. Indeed, all machines have a dynamic aspect, so that when they are preserved as static objects, there is a chance that their moving parts may rust and,

eventually, may not be able to function at all. In a similar way, musical instruments will lose their tone if they are not regularly played. The continuation of their use, or function, implies repairs and adaptation. To what extent are adaptations necessary and/or allowable in order to make the continuation of the original function possible? Sometimes these adaptations are nothing but repairs, such as the substitution of missing parts, but sometimes adaptations are necessary to comply with the law, as with steam-engines, vehicles, and so on. The modern alterations or additions interfere with the physical integrity of the object as historical document.

In architecture, there is a further step that causes a dilemma. Sometimes, adaptations are necessary to make a building suitable for a new function within the museological context. This arises when the building is still considered to be a valuable monument, but a new function is given to it in order to secure its 'survival'. As Feilden says:

The best way of preserving buildings as opposed to objects is to keep them in use – a practice which may involve what the French call 'mise en valeur', or modernization with or without adaptive alteration. The original use is generally the best for conservation of the fabric, as it means fewer changes. Adaptive use of buildings ... is often the only way that historic and aesthetic values can be saved economically and historic buildings brought up to contemporary standards (Feilden, 1982: 10–11).

When a building looses its function it will no longer be maintained, so it is destined to fall into decay. The dilemma is caused by the fact that, while this new function interferes with both the physical integrity and the functional integrity of the building, without this new function the building is doomed to disappear. The most obvious examples are churches that are given new purposes, such as housing, shops, or even dance halls and swimming pools. On the conceptual level, there is a tension between the former sacral function and the present profane function. In Dutch, this is indicated by a newly coined phrase: 'piety-tension' (*pieteits-spanning*). Because of this piety-tension, for example, the Roman Catholic Bishop of Roermond (the Netherlands) has forbidden the rehabilitation of an obsolete

church building for housing purposes, saying that he would rather see the church demolished. Similar examples can be given for former prisons, concentration camps, and so on. Giving a monument a museum function is usually considered to be the best solution. It is the solution with the least possible piety-tension.

The transformation to a *museological context* is less radical for monuments than for movable artefacts. For movable artefacts, this transformation means a radical change of function and meaning, but this change does not usually imply a piety-tension, except for human remains and religious objects. As far as this last category of objects is a concerned, new development in anthropology museums is worth mentioning. In Australia, the United States, and Canada some museums with collections that are still relevant to descendants of the original native people are beginning to consider their objects, especially religious ones, as loans. The traditional owners are allowed to use these objects for their religious festivals and so on, and afterwards the objects are returned into the custody of the museum.

Preserving conceptual identity

The attempts to reveal the factual identity, and to preserve the functional identity, are connected with the aim of coming close to the conceptual identity of the object. But is it necessary to preserve the realized object when our main aim is to preserve the idea behind it? This question is raised by Washburn (1984) in an article entitled 'Collecting information, not objects'. He points to the inability of museums to fulfil what is seen their main commitment to preserve in perpetuity:

There is a great deal of cynicism among museum observers as to what 'perpetual' means in a museum context. Although outsiders assume that once an object has gotten into a museum, it stays there, in fact there is a continuing erosion of objects in the care of museums. Sometimes nature takes its toll, whether through fire, flood or deterioration; sometimes man is responsible, either officially through formal deaccessioning or unofficially through theft, negligence or other forms of loss. . . . Space is

153

running out and ... money for additional space for future collecting activities is going to be harder to get (1984: 5).

In short, Washburn suggests a solution similar to what is common practice in libraries and archives: to make copies.

In the world of books the microfilm revolution has been a new guarantee that the precious content of certain objects – books – will never be completely lost so long as the planet and solar system survive. As the original books disintegrate or are lost or stolen, their surrogates – the copies in microfilm, microfiche or microform – provide an inexpensive record of the content of those objects and a compact way of recording the output of one generation for generations in perpetuity however long that may be (1984: 6).

Revolutionary as this may seem, there is already a long-standing tradition in scientific museum work to transfer information from objects to other media:

the communication of a museum item and the transfer of information that item can emit to a potential user is right from the moment of entry into the museum, slowly directed towards other carriers of information. ... Thus, there exist in museums lists of items, inventories, catalogues, card files, books and a number of other information aids which are used and developed (Maroevic, 1983: 242).

Communication between museum professionals, and between museums and their public, is to a great extent based on such transfers of information to other media. In this process something of the quality is lost. To quote Maroevic again:

Not just the quality, but also a quantity of information is lost so that, finally, information of this type often reaches the final user merely as a reminder of the knowledge that should be obtained from the object. The channels of flow are either too narrow or often they are blocked and only passable with difficulty (1983: 245).

Taborsky (1982) and Cannon-Brookes (1984) have both drawn attention to the fact that the vast majority of societies, past and

154

present, are concept-centred. For these societies, the process of collecting and preserving objects is limited to very special objects only, because the transmission of cultural traditions is overwhelmingly oral. As Mead says,

Preserving the past meticulously is a western preoccupation and a particular concern of several branches of study. If conservation were no longer a prime function of museums, these institutions would be less like a hospital for art objects. ... The task of maintaining an art tradition is the primary concern of a community. Display and conservation are of secondary importance (1985).

Contemporary developments in museum work show a new tendency to concepts and practices in which the preserved authentic object gradually disappears (van Mensch, in preparation). This development challenges an object-centred museology, such as those outlined earlier. However, it must be said that in museum thinking, the preservation of objects should not be the sole concern. Models like that presented here are intended to map out decisions that have to be taken, decisions about preservation as well as about communicative use. This paper has concentrated on the application of the proposed model to preservation, but it is clear that decisions in this field are not to be separated from the communicative function of the museum, nor its research function. It is hoped that a museological theory in which the proposed model will stand as one of the cornerstones, will provide a usable basis for the further development of the integrated museum.

Bibliography

Brachert, T., 'Restauriering als interpretation' in *Maltechnik-Restauro*, 89, 2, 1983: 83–95.

Brandi, C., *Principles for a Theory of Restoration* (Rome, 1977).

Burcaw, G. E., *Introduction to Museum Work* (American Association for State and Local History: Nashville, 1975).

Cannon-Brookes, P., 'The nature of museum collections' in Thompson, J. M. A. (ed.), *Manual of Curatorship* (Butterworth: London, 1984): 115–26.

Deetz, J., *In Small Things Forgotten* (University of California Press: California, 1977).

Peter van Mensch

Feilden, B. M., *An Introduction to Conservation of Cultural Property* (Butterworth: London, 1979).

Feilden, B. M., *Conservation of Historic Buildings* (Butterworth: London, 1982).

Finley, G., 'Material history and curatorship', *Muse*, 3, 3, 1985: 34–9.

Fitch, J. M., 'On formulating new parameters for preservation policy' in Timmons, S. (ed.) *Preservation and Conservation: Principles and Practices* (Washington, 1976): 311–25.

Fitch, J. M., *Historic Preservation: Curatorial Management of the Built World* (McGraw-Hill: New York, 1982).

Jaro, M. (ed.), *Problems of Completion, Ethics and Scientific Investigation in the Restoration* (Institute of Conservation and Methodology: Budapest, 1982).

Kirby Talley, M., 'Bemerkungen zu zeitgenossischen Tendenzen in der Kunstgeschichte und in der Restaurierungspraxis' in *Maltechnik-Restauro*, 88, 2, 1982: 103–11.

Kirby Talley, M., 'Humanism, restoration and sympathetic attention to works of art' in *International Journal of Museum Management and Curatorship*, 2, 4, 1983: 347–53.

Maroevic, I., 'The museum item – source and carrier of information' in *Informatologia Yugoslavica*, 151–3, 1983: 237–48.

Maroevic, I., 'Museum object as a link between museology and fundamental scientific disciplines' in *Informatologia Yugoslavica*, 181–2, 1986a: 27–33.

Maroevic, I., 'The subject of museology within the theoretical core of information sciences' in *Informatica Museologica*, 1–3, 1986b: 3–5.

Mead, S. M., 'Indigenous models of museums in Oceania' *Museum*, 35, 2, 1985: 98–101.

Monger, G., 'Conservation or Restoration?' in *International Journal of Museum Management and Curatorship*, 7, 1988: 375–80.

Murtagh, W. J., 'Commentary' in Timmons, S. (ed.) *Preservation and Conservation: Principles and Practices* (Washington, 1976): 383–90.

Pearce, S. 'Thinking about things' in *Museums Journal*, 85, 4, 1986a: 198–201.

Pearce, S., 'Objects high and low' in *Museums Journal*, 86, 1, 1986b: 79–82.

Pearce, S. 'Objects as signs and symbols' in *Museums Journal*, 86, 3, 1986c: 131–5.

Philippot, P., 'Restoration: philosophy, critic, guidelines' in Timmons, S. (ed.), *Preservation and Conservation: Principles and Practices* (Washington, 1976): 367–82.

Rüdiger, B., *Quellenkundlicher Leitfaden für die Arbeit mit historischen Sachzeugen*; Schriftenreihe Institut für Museumswesen, 18; 1983.

Schreiner, K., *Terminological Dictionary of Museology* (Berlin, 1988).

Sola, T., 'Towards a possible definition of museology' (paper presented at the ICOFOM Annual Conference, Paris, 1982).

Stransky, Z. Z., 'Metologické otázky dokumentace soucasnosti' in *Muzeologicke Sesity*, 5, 1974: 13–43.

Stransky, Z. Z., 'Museology as a science' in *Museologia*, 15, 1980: 33–40.

Swiecimski, J., 'On some ethical problems connected with the display, conservation and restoration of material cultural objects in museum exhibitions' in Jaro, M. (ed.) *Problems of Completion, Ethics and Scientific Investigation in the Restoration* (Budapest, 1982): 36–49.

Taborsky, E., 'The sociostructural role of the museum' in *International Journal of Museum Management and Curatorship*, 1, 4, 1982: 339–45.

Timmons, S. (ed.), *Preservation and Conservation: Principles and Practices* (Preservation Press: Washington, 1976).

Tsuruta, S., 'Museology – science or just practical work?' in *Museological Working Papers*, 1, 1980: 47–9.

van Mensch, P., 'Museologie en het object als informatiedrager' in *Museumvisie*, 8, 3, 1984: 76–8.

van Mensch, P., 'Museology and the object as data carrier' in *Informatologia Yugoslavica*, 18, 1986, 1–2: 35–43.

van Mensch, P., *On the Theory and Methodology of Museology* (in preparation).

van Mensch, P., Pohw, P., and Schouten, F., 'Methodology of museology and professional training' in Sofka, V. (ed.), *Methodology of Museology and Professional Training* (ICOFOM: Stockholm, 1982).

van de Wetering, E. 'Die Overfläche historischer Gegenstande im Licht der Zeit' in Jaro, M. (ed.), *Problems of Completion, Ethics and Scientific Investigation in the Restoration* (Budapest, 1982a): 21–6.

van de Wetering, E., 'Die Overfläche der Dinge und der museale Stil' in *Maltechnik-Restauro*, 88, 2, 1982b: 98–102.

Washburn W. E., 'Collecting information, not objects' in *Museum News* 62, 3: 5–6, 9–10, 11–15.

7

Cultural empowerment and museums: opening up anthropology through collaboration[1]

MICHAEL M. AMES

A paper first presented in abbreviated form to the Annual Meeting of the Society for Applied Anthropology, Santa Fe, New Mexico, 8 April 1989

The movement towards self-determination among North American First Nations[2] continues unabated and with some degree of success. They are asking that society recognize their interests in their own heritage, spiritual as well as material. The call for the repatriation of burial remains and sacred objects is part of this much larger claim to exercise more control over their own history and present conditions and over how they are represented or misrepresented in museums, universities and the media. In this paper I want to consider some ways in which museums might respond to these issues.

There are a number of conceptual distinctions or boundaries museums and the academic world take for granted and express in their activities that may appear alien to the Native American experience. The use of these distinctions to classify and describe First Nations heritage is thus frequently seen as a vestige of colonial domination. First Nations people offer a more holistic perspective in opposition to this differentiated one. Prominent examples are the institutional distinctions between art and artefact, past and present, and culture and politics.

(1) *Art/artefact.* This distinction is enshrined in museums of art and anthropology, separating other peoples' objects according

to a Western European/North American theory of aesthetics. From the First Nations point of view, objects may be seen as beautiful, practical and spiritual all at the same time, and the academic tendency to focus on only some of these values to the exclusion of others diminishes the original holistic or multiplex meaning.

(2) *Past versus the present.* Non-native Americans tend to separate the past from the present, relegating the former to museums. The contemporary activities and interests of First Nations are as a result frequently ignored or limited to displays of arts and crafts. Galleries showing contemporary art usually exclude First Nations works unless they are in the modernist European style. First Nations, on the other hand, give more importance to continuities between past and present and to their continuing presence in contemporary society. Non-native people are still struggling to come to terms with the fact that the past can be continuous with the present, that the 'traditional' may be part of the 'modern' – as in 'living traditions' – and that Indians who wear Adidas running shoes, drive pick-up trucks, and carve with the aid of power tools, are still no less Indian for all that.

(3) *Politics and culture.* While First Nations may understand a museum's interest in keeping out of politics, they note as well the political implications of what museums do and refrain from doing. Whether a work by a contemporary First Nations artist is displayed in a museum of art or of anthropology is, from the perspective of those included and excluded, as much about status as it is about aesthetics. As a First Nations educator said during a talk he gave recently at the Museum of Anthropology, 'the *concept* of a museum of anthropology is the creation of the dominant White society, but the *content* of the museum is the creation of the dominated Native peoples'. A number of problems flow from this political disjunction.

It is helpful to understand where Native Americans are coming from as well as where they are going. Where they *want* to go is towards greater degrees of self-determination. High on their agendas are land claims, economic self-sufficiency, control over their own education and welfare, and then issues relating

to museums. Where they are coming from is a history of colonial domination. A paradigm for this history that is still prominent in First Nations discourse, at least in Canada, is the Indian Residential School. Generations of First Nations children in Canada were taken away from their families and communities and lodged in distant residential schools staffed by missionaries and other Europeans who set about in organized ways to control their young charges, to convert them to various Christian denominations, and to foster their assimilation to European languages and customs. The teachers probably had good intentions and First Nations express more than just negative feelings about residential schools. When speaking about those experiences, however, they frequently sound like refugees from a colonial situation which they believe *continues* to exist. They see many of the same systems of White domination continuing to govern their lives today – paternalistic government regulations, expensive legal systems, schools foreign to their traditions, other people occupying their lands, White-operated museums that hold custody of their heritage, and so on. It is not difficult to understand how this colonial ideology might influence their attitudes toward museums and other educational institutions. To make it even more interesting for museums, Native Americans over the past twenty years have formed a number of national and international political alliances, are speaking out more often, are using the media more effectively, and are obtaining more public sympathy for at least some of their claims. If they are not directing even more attention to museums at the present time, it is possibly because the other issues, such as land claims, employment and education, are more pressing. Museums nevertheless are still on the list. The question is how are museums responding to these developments?

Museums are responding in various ways, some more enthusiastically and creatively than others, but probably none as promptly or positively as Native Americans would wish. And there is not much time left for museums to take the initiative. Rather than attempt to catalogue these responses, however, which would be a lengthy task,[3] I want to outline a few things I think museums, in an ideal world, *could* do. I will then describe three modest examples of what museums, in a real world, actually can do.

First, there are at least three ways museums could relax, bridge or mediate between the conceptual and institutional separations they have created:

(1) *Cultural empowerment*: transferring skills to others and providing opportunities for them to present their own points of view within the institutional context. This would mean such things as granting originating peoples (that is, those from whose communities the collections originated) certain moral and exhibition rights over museum collections (for example, consulting with First Nation representatives regarding the collection, storage, display and interpretation of their heritage); and allowing people to speak for themselves, through exhibitions and programmes, about issues that are important to them (perhaps, for example, contemporary issues instead of, or in addition to, such traditional museum topics as pre-industrial technology and exotic ceremonial patterns).

(2) *Multi-vocal interpretations*: creating opportunities for several voices to be heard on a more equal basis, combining outsider academic perspectives with the insider academic and cultural perspectives of First Nations. This involves making more public the differences between these perspectives and articulating the separate epistemological grounds upon which they are based, plus respect for those differences. Historian Thomas Woods draws a useful distinction in this regard between the 'experiential perspectives' of people studied, grounded in their own histories – for example, the cultural expertise of First Nations elders and the scholarly knowledge younger generations have acquired in the academic system, and the 'interpretative perspectives' of the non-native observers, grounded in the academic tradition of research on others (Woods, 1989).

(3) *Critical theories*: applying more critical perspectives to both the management of museums and their curatorial and interpretative enterprises. Critical theory has its roots in Marxism and the critique of public culture (Duncan and Wallach, 1978; Fay, 1975; Hall, 1981; Hoepfner, 1987; Horne, 1986), and advocates the use of academic expertise to identify those features of social situations which can be altered in order to eliminate certain injustices, frustrations and mystifications people experience. Museums could critically examine those systems of power,

161

authority and ideology that hold dominance in a society and which thereby perpetuate particular social formations. To those systems one can then put the question: is justice as unequally distributed as power and status? Some may think it unreasonable to expect museums – given their position in society as wards of the establishment – to serve as the vanguard of critical theory and practice. They nevertheless still could provide some leadership, however, by working towards a more democratic or liberated museology (Ames, 1988: 19) and by dealing more directly with the political and economic issues of the day.

What museums can do, for example, is to facilitate the cultural empowerment of the less powerful, many of whom are, typically, the peoples which anthropology museums have traditionally studied, collected from and represented (the 'originating populations'). I will describe three experiments in empowerment within the normal museum context of public programming tried out recently at the Museum of Anthropology in Vancouver, each intended to cross over conceptual, institutional and cultural boundaries. The first two examples were temporary exhibitions, one a survey and the second a more personal statement by two curators about their own community. The third, involving two First Nations actors representing trickster figures, was a theatrical performance introduced into the museum's school programme.

The exhibition 'Robes of Power: Totem Poles on Cloth', 1986

This exhibition of North-west Coast Indian 'button blankets' was curated by Gitksan Indian artist and writer Doreen Jensen (Jensen and Sargent, 1986). It was the first exhibition at the Museum of Anthropology solely curated by a First Nations person, demonstrating that someone culturally knowledgeable but without professional museum training could still meet the normal curatorial and scholarly standards by working in collaboration with museum staff.

North-west Coast ceremonial robes display in two-dimensional

form the same images carried on the rounded sculptural forms of the more widely known totem poles, hence the sub-title 'Totem Poles on Cloth.' These robes have long served as insignia of family and clan histories, duties, rights and privileges, and they are beginning to mark as well a deter-mined presence in contemporary Canadian society as social and political statements. They continue to be made and used. People still wish to display their historic rights and privi-leges, and they want increasingly to demonstrate a shared identity that is socially modern though remaining culturally Indian. Before the coming of the Europeans, robes were made from animal skins and furs, cedar bark and other vegetable fibres. Designs may have been painted on the skins. When cloth was introduced it was adapted to traditional uses. The fastening of buttons – the origin of the term, 'button blankets' – succeeded the older style of attaching amulets, puffin bills, dentalium shells, and prized pieces of abalone shell. The cloth blankets are typically made from dark-blue wool with red-flannel applique and pearl-white buttons, though styles vary from culture to culture. This was the story Doreen Jensen wanted to tell.

The display and interpretation of the robes were designed to cross a number of institutional boundaries or differentiations. Jensen's intention was to represent in one exhibition the different cultural styles; demonstrate both the antiquity and continuity of Indian traditions (the past linked to and continuous with the present); record how Indian women and men work together in the creative act of designing and making a robe; show how they serve as both ceremonial and political instruments of power; demonstrate how, with their bold patterns and bright colours, they may be viewed as works of art as well as artifacts; and draw attention to the continuing presence of separate Indian communities ceremonially and politically linked together within the framework of the modern nation-state called Canada. The opening of the exhibition was celebrated by the robe makers and their families as a further statement of their solidarity and their willingness to collaborate as equal partners with a museum. Doreen Jensen travelled an earlier version of the exhibition to six Australian cities, and a selection of the robes are continuing on an exhibit circuit.

Michael M. Ames

The training exhibition 'Proud to be Musqueam', May–October, 1988

This is an example of skill transfer. Two young First Nations women, Verna Kenoras and Leila Stogan, came to the Museum of Anthropology from the nearby Musqueam Indian Reserve for a four-month work placement, as part of their training under a Job Re-Entry Programme managed by the Musqueam Band (Fisher and Johnson, 1988). As their special project they decided to research the history of their band by studying the photographs held by families on the reserve and interviewing elders about them. The end product of their work was to be an exhibit which they entitled 'Proud to be Musqueam'. Lizanne Fisher, a cultural educator and former MOA student, was hired to coordinate the project and to provide curatorial guidance. Other museum staff provided training as needed.

The two Musqueam curators chose fifty-four photographs from the hundreds offered by members of their band, deciding to cover the period from 1890 – the earliest date photographs could be located – to 1960. They worked to represent every family in the band and to cover the typical community activities. Everyone depicted was identified by name and connections to the present generations at Musqueam. Upon the advice of their elders, which they sought early on in the project, they did not include photographs of ceremonies and masks that were considered private.

The exhibit labels were drafted by Lizanne Fisher taping the two Musqueam women as they discussed each photograph in turn, reporting the information they had learned from elders. Statements were extracted from the tapes, given minor editing, and, with the approval of the two women, became the labels for the exhibit. The introductory label (stated in the first person) explained the intention of the two Musqueam curators:

We're from Musqueam and we're proud to be Musqueam. We were at the Museum of Anthropology on a Job Re-entry Programme. It started out from the first two weeks we were there: that's when I first got the feeling about doing an exhibit on Musqueam. Because it seems to me that when you give people the address of Musqueam, they'll say, 'What? Where's

164

that? I didn't know there was a reserve out there by the University.' We just wanted to show where Musqueam is.

I'd love them to think . . . that we're civilized. Because a lot of people, kids, come up to me and say, 'You're Indian?' and then they'll ask us if we still live in teepees. I want to show that we don't still live in teepees or long houses and we're just like them. It's just that we have brown skin. I'd like them to really appreciate the pictures, because I really have a good feeling for the pictures.

Kenoras and Stogan noted how proud they were to include photographs of three thousand-year-old basketry fragments archaeologists recently excavated from their area:

Our ancestors made them and I think it's important for people to know, because it shows that we have been here for years and years and years. I'm proud that we've been here for so long. I'm proud because we're still here and we will be here forever.

The two Musqueam women also learned about their own community while they were acquiring research and interpretation skills:

The exhibit taught me a lot about the people, who the families were, the family trees, who belonged to what family. Just a lot of history, a lot of Musqueam history. That's something I'll always remember.

The response has been really good from the elders, and from everybody. When we first started out, a lot of elders would say, 'No, I don't have any pictures.' Then we'd show them what we already had gathered, and then pretty soon they would say, 'Yeah, I've got some,' and then they would go and get their little tin boxes, or tin cans, or photo albums and start bringing them out and showing us all the pictures they'd have.

The hardest part of doing the whole exhibit was having to choose the pictures because we had a lot of good pictures that we had to take out. That really broke my heart.

The exhibit was popular with museum visitors because both photographs and text were informal, personal and direct, 'from the heart' as it were. It represented Musqueam people as ordinary parents and children at work and at play: 'we're

just like them'. It also demonstrated continuity between past, present and the future: 'I'm proud because we're still here and we will be here forever'. Following its run at the Museum the exhibit was presented to Musqueam for permanent display in its Elder's Centre, and the Museum is seeking funds to produce a second copy as a travelling exhibition.

The trickster programme 'A Rattling Under Glass,' Autumn, 1988

Two First Nations performing artists, Archer Mayling and Monique Mojica, were recruited to develop an interpretative programme for school groups scheduled to visit the museum during the Autumn of 1988. It was to be based on Indian trickster figures, those 'outrageous heroes' (Abrahams, 1968) who at various times serve as clown, fool, jokester and culture hero. A recurring feature of the trickster is his or her tendency to cross the boundaries of social and natural conventions, thus simultaneously challenging and highlighting them.

We began the experimental trickster programme with a number of questions: how would tricksters enliven museum interpretation? Would the programme be understood by young school children (in British Columbia grade four is the designated year for studying First Nations), or even by the general public? Would the satirical role of tricksters be appreciated? Would the fact that both performers came from Eastern Canada and were not familiar with North-west Coast Indian culture create problems of interpretation? Finally – given that the two actors are politically conscious and outspoken First Nations people – could an overt critique of museums be successful in a museum context?

The performers probably raised more questions than they answered (Hull, 1988). Both performers, referring to themselves as 'half-breed clowns', were trained in the techniques of masque clowning – a convention in which a performer creates a character who subsequently develops through its experiences and evolves separately from its creator. Archer Mayling, of Cree origin, has worked as a circus and street performer as well as in theatre, and is based in Vancouver. He called his trickster character

'Itch', representing a hybrid of the tricksters Wesakechak and Coyote. He derives both from his own Plains heritage, including Cree mythology and the traditions of the Metis buffalo hunter and the Contrary Warrior figure. Monique Mojica, a Cuna/ Rappahannock and 'citizen' of Six Nations Reserve (she carries a passport issued by Six Nations), is a Toronto-based actress trained in theatre and dance. Mojica's trickster character is Coyote, which she derives in part from the Mayan-Aztec figure Hue Hue Coyote (Old Man Coyote). She sees her character as a powerful and vital contemporary force which appears in many guises.

The trickster programme began in the Great Hall of the museum, with forty to eighty school children seated in a semi-circle on the carpeted floor. Itch and Coyote tell the story of the Canadian government's suppression of the potlatch, the harm it did to North-west Coast cultures – including seizure of regalia – and the subsequent Indian reassertion of their rights. Itch enters the Hall first and introduces himself to the assembly, clowning and teasing. He then discovers Coyote, frozen inside a glass diplay case. He transforms himself into an anthropologist (whom he refers to as an 'anthro-clown') by putting on a white lab coat and Groucho Marx false nose-and-glasses, and pontificates on the 'functions of the Indian trickster figure'. Coyote slowly awakens to the sound of her name, finds her way out of the display case, mocks the anthropologist, and through the power of her drumming puts him to sleep and eventually entices him into the glass case. As Susan Hull reports (1988: 6):

This scene is designed to establish the symbolic representation explored throughout the performance. Coyote is to be seen as representing all native culture and, more specifically, artifacts which have been removed from native culture, lying captive and dormant in museum collections. The performers are attempting to communicate that the trickster, like much of native culture in general, is alive and well in contemporary society. Many of the restrictions that have confined native culture have been over-come, and tricksters not only are being liberated but are themselves liberators; they are modern-day personas capable of teaching both natives and non-natives 'how to laugh again.' The scene also illustrates an important aspect of a trickster, the

167

ability to transform his or her appearance to meet the demands of any given situation.

Itch leaves the lab coat and false nose-and-glasses in the display case, with an exhibit label containing a photograph of the museum's director, and joins Coyote as she tells the story of the potlatch. Itch then dons a gown and transforms himself into a magistrate, ordering Coyote to cease potlatching. 'Stop!' he shouts at her:

The law of the Dominion of Canada forbids the winter ceremonies or potlatching. From this day forward there will be no feasts, no singing, no dancing. From this day forward the winter ceremony or potlatch is against the law!

Hearing this, Coyote shrieks in despair and slowly sinks to the floor, dying. Discarding his magistrate's gown, Itch reverts to his trickster role and wails in lament. Dismayed, Susan Hull continues in her report (1988: 8), to find his best friend dead:

He continues the potlatch story, imploring Coyote to get up since the potlatch is now permitted, and many of the things that were taken have been returned. Most of the students at this point have suspended reality and are prepared to accept Coyote's death, joining Itch in his grief. The 'spirit' of Coyote appears and joins in this moving grieving scene, switching from sincere crying to mocking snickers.

Here the performance is operating at two levels simultaneously. At one level we are to accept and participate in a very real loss, a loss of Coyote and of a cultural lifeway. And yet, through Coyote's behaviour, it has become apparent that at another level what we are witnessing is yet another trickster ruse, with Coyote setting Itch up to believe she has died. This is a magical and powerful moment in the performance, and it is evident from the audience's reactions – mixed feelings of grief and mirth – that the essential duality of the trickster's character is being experienced.

Following Coyote's advice, Itch invites the audience to help revive Coyote. He asks them to place in his leather pouch their most precious possessions, or to whisper them in words. All

offerings are gratefully and graciously received by Itch, Hull continues (1988: 9), and are offered to the spirits:

Although some children take advantage of this opportunity to break away from the tension created by the grieving and offer ridiculous things such as smelly running shoes and chewed erasers, many take the request to heart and give valuable rings, watches or whisper such precious things as their parents or a prized poster.

Coyote jumps up and grabs Itch's pouch, 'howls with delight at tricking everyone, and runs off.'

The involvement of the students in reviving Coyote not only serves to 'sucker' them into falling for a trickster prank, but also is meant to allow them to experience the communal power in giving valued property, the cornerstone of North-west Coast Indian potlatching (Hull, 1988: 10).

Itch leads a search for Coyote, finding her hiding near 'Raven and the First Men', a large sculpture by contemporary Haida artist Bill Reid depicting Raven discovering mankind in a clam-shell. Itch and Coyote conclude their programme here, by introducing their cousin Raven as a North-west Coast trickster.

The trickster programme received mixed reviews. Those who were critical of the programme – some members of the museum's volunteer education committee, some museum staff, some teachers, and some First Nations people – said the content was offensive; it showed a reckless and disrespectful attitude towards the museum environment and the artefacts (at one point Itch and Coyote climbed on top of a large contemporary Haida Sea Wolf wood sculpture and made believe it was a motorcycle); it was more theatrical than didactic and got children too excited ('as educators', as one Vice-Principal wrote in his evaluation, 'We cannot justify school time on entertain-ment; there must be a strong education component'); it made Native People seem crude and neglected the serious and spiritual sides of First Nations life; it used (after the fashion of true tricksters) too much 'raucous dialogue with sexual over-tones', as a member of the Volunteer Education Committee reported, 'resulting [in] over stimulation of children' (one of the

first things Coyote did after finding her way out of the glass box was to pretend, dog or coyote-like, to urinate on the anthro-clown); it attempted to portray ideas that were too abstract or complicated (such as transformation, cultural suppression and appropriation, repatriation, and self-determination – issues which, teachers pointed out, were not included in their curriculum – even the banning of the potlatch is not usually mentioned in schools); and it was too improvized and the messages too confusing, rather than tightly scripted. As the chairwoman of the museum's Volunteer Education Committee summed up in her annual report, the tricksters 'presented us with very real difficulties in managing the children at the performances and attempting to give our usual quiet programmes concurrently'.

Some of the criticisms were justified. The programme was indeed improvized, and it changed ('evolved') from perform-ance to performance. That was because we did not have sufficient funds to provide Mayling and Mojica with adequate rehearsal time, script writers, or director. They were invited to develop a trickster programme on the fast track, with a fair degree of freedom to explore their own characters. And there were indeed frenetic moments, especially during early perform-ances, when some of the children became as raucous as the tricksters.

In response to the criticisms, the two actors said they wanted to express their own feelings and interpretations as two contemporary First Nations activists, and to maintain the integrity of their trickster characters while also trying to attend to the needs of their audience; to avoid the traditional stereotype of the wise old Indian storyteller; to demonstrate that First Nations are living peoples not just museum pieces; to test the physical and ideological limits of the museum environment; to be unlimited by the historical simplifications of school curricula; to demon-strate how humour can be used as a critical force (and it was time Natives began to laugh at themselves, Mayling and Mojica stated); and to confront directly the major political issues of cultural suppression and self-determination. Although inter-views with teachers and grade four students confirmed that indeed the messages were mixed, sometimes unclear, and occasionally confusing, contrary to the expectations of the critics, they also revealed that children picked up on a number

of those issues and were able to respond to most of them when they were raised in discussions. (Although the teachers were sent information packages prior to their visits, apparently none of the groups received advance preparation.)

As an experimental programme 'A Rattling Under Glass' was a considerable success. It did not please everyone, nor was it intended to. It was presented as a 'work in progress,' therefore rough edges were to be expected. It did not meet the expectations of all of the teachers, which was partly the fault of our information packages, the evolving nature of the programme, and teachers' desire for more heavily didactic content. Nor did it fit neatly into the grade four curriculum, which is perhaps more the fault of the school system for ignoring the historical injustices done to First Nations. It stretched the capacities of the two performers and they expressed appreciation for the challenge. It also stretched the museum's capacity and the sensibilities of its staff and volunteers, by demonstrating that controversial topics, with some management, can be presented in novel ways in a museum context and be understood and appreciated by school children. The tricksters upset people, but they also caused them to think about important issues.

The time has come, to conclude this paper, for museums to work more closely *with* Native Americans, rather than simply study and exhibit their histories. All these issues are also pursued in papers by Ames (forthcoming) and Ames, Harrison and Nicks (1988). Relations of trust must be built up over time. Providing opportunities for cultural empowerment is one way to begin, and three examples are cited here. Like the trickster, a museum can also animate, facilitate, provoke and cross traditional (institutional) boundaries, helping to open up anthropology to everyone as an act of empowerment. It was also suggested that such museum projects could be linked to a broader programme of critical theory and practice. Empowering others to speak for themselves does not mean losing one's own voice, but finding it.

Notes

1. I am indebted to Rosa Ho, Elizabeth Johnson and Margaret Stott, curators at the Museum of Anthropology, for helpful comments on

that earlier draft; to Doreen Jensen, Gitksan artist and MOA consultant, for speaking so freely about her intentions for 'Robes of Power'; to Lizanne Fisher, Intercultural Consultant, Elizabeth Johnson, and Verna Kenoras and Leila Stogan of Musqueam, for information on 'Proud to be Musqueam'; to Susan Hull, Programme Consultant, Museum of Anthropology, for information on the trickster programme; and to Archer Mayling and Monique Mojica for many discussions about the contemporary meaning of the trickster. I am also indebted to Nancy Marie Mitchell, Stanford University, for her widely ranging discussions of the relations and future possibilities between museums and First Nations. All interpretations, errors and omissions in this paper remain solely my own, however.

2. The term 'First Nations' appears to be emerging as a preferred self-designation by the indigenous peoples of Canada (Indians, Inuit and Metis), although 'Indian', 'Native', and 'Native Indian' continue to be used. 'Native American' appears to be the preferred usage in the United States, but 'American' is rarely used in Canada as a self-designation.

3. For a recent summary of relations between museums and First Nations in Canada, see the special issue of *Muse*, journal of the Canadian Museums Association, vol 6, no 3, Fall 1988. The United States Council of Museum Anthropology's newsletter, *Museum Anthropology*, provides an entry into the literature on the United States situation. The relations are dynamic and continuing to evolve, at different rates in different regions.

Bibliography

Abrahams, R. D., 'Trickster, the outrageous hero' in Coffin, T. P. (ed.) *Our Living Traditions: An Introduction to American Folklore* (Basic Books: New York, 1968): 170–8.

Ames, M. M., 'Prosposals for improving relations between museums and the indigenous peoples of Canada' in *Museum Anthropology* 12 (3), 1988: 15–19.

Ames, M. M., Harrison, J. and Nicks, T., 'Proposed museum policies for ethnological collections and the peoples they represent' in *Muse, Journal of the Canadian Museums Association* 6 (3), 1988: 47–57.

Ames, M. M., Forthcoming. 'Cannibal tours and glass boxes; a discussion of "The objects of culture" and the politics of interpretation'.

Duncan, C. and Wallach, A., 'The Museum of Modern Art as late capitalist ritual: an iconographic analysis' in *Marxist Perspectives*, Winter, 1978: 28–51.

Fay, B., *Social Theory and Social Practice* (Allen & Unwin: London, 1975).

Fisher, L. and Johnson, E. L., 'Bridging the gaps – a museum-based heritage awareness programme' in *Museum Anthropology*, 12 (4), 1988: 1–8.

Hall, S., 'Notes on deconstructing "the popular"' in Samuel R. (ed.) *People's History and Socialist Theory* (Routledge & Kegan Paul: London, 1981): 227–39.

Hoepfner, C., 'Local history and critical theories' in *History News*, 42 (3), 12, 1987: 27–9.

Horne, D., *The Public Culture: The Triumph of Industrialism*, (Pluto Press: London, 1986).

Hull, S., 'A Rattling Under Glass: the trickster programme', *Museum of Anthropology Report* (December 1988).

Jensen, D. and Sargent, P. (eds), *Robes of Power: Totem Poles on Cloth* (University of British Columbia Press: Vancouver, 1986).

Woods, T. A., 'Perspectivistic interpretation: a new direction for sites and exhibits' in *History News* 44, 14, 1989: 27–8.

8

Knowing objects through an alternative learning system: the philosophy, design and implementation of an interactive learning system for use in museums and heritage institutions

MARGRIET MATON-HOWARTH

Introduction

The parental *cri de coeur*, 'what did you learn in school today?' meets so often with the reply 'nothing much'. There is more truth in the response than most parents ever realize. While it would be expected that there should be a great deal of 'teaching' in evidence in the classroom environment, that is, the passing on of some kind of instruction, it tends to be forgotten that 'teaching' and 'learning', the assimilation of that information, are not necessarily mutually interdependent activities. Teaching is not synonymous with learning, nor is the occurrence of one a prerequisite for the existence of the other. As long as the classroom is perceived as the principal arena in which education occurs, society as a whole and parents in particular, will rarely consider the possibility that this is neither the only nor necessarily the best place for the realization of the learning experience. On the contrary, if one considers 'education' in the true sense of the word, that is to draw out of the child his full intellectual, creative, social and spiritual potential, the classroom is possibly the most unlikely place for learning to transpire. It is an environment more sympathetic to 'cramming in' than 'leading out'.

Ivan Illich, now famous for his notions of deschooling, states unequivocally that: 'the institutionalisation of values leads inevitably to physical pollution, social polarisation, and psychological impotence' (Illich, 1971: 3). Adopting the basic premiss, therefore, that true education is better realized outside the

174

confines of the classroom, this paper seeks to propose an alternative learning system, both in philosophical and empirical terms, and will address three main issues: (1) a brief considera- tion of the psychology of learning in an attempt to justify the afore-mentioned premiss, to establish a basic understanding of the learning process, and to outline the evolution of a personal philosophy; (2) an analysis of the educative potential of museums and heritage institutions in an attempt to assess whether, as learning environments, they could feasibly add to the learning experience of the young; and to what degree, if any, they already fulfil this role; and (3) the development of an alternative learning system for use outside the school environment and specifically in museums and heritage institutions.

Teaching and learning

The evolution of the British education system

The *raison d'etre* of the British public education system has always been one of meeting the needs of society, rather than those of the individual. During the Industrial Revolution it became evident that the cities could not cope with the vast numbers migrating from the impoverished country villages; squalor and social unrest grew rapidly. Education for the masses, which had hitherto been unnecessary, took on an unexpected importance. Moves to 'school' the poor, in terms of teaching them to read scripture, were aimed primarily at social constraint. Teaching them to read was some attempt to develop Christian morals and values which would temper the character, eliminate vice and bring the lower classes under social control.

As an industrial society continued to evolve, a modicum of education was required in order to facilitate a basic understand- ing and learning of skills. It is possibly this shift of emphasis that heralded a major change in society. An awareness of the basic dignity of humanity, and the potential of the human character, brought with it the ideal of equal rights and opportunities. It brought also a dichotomy of teaching ideologies, the effect of which remains evident to this day.

Children in those early days of public education were taught

the rudiments of reading, writing and number work regardless of the irrelevance of the subject matter to their frequently impoverished life styles. Observers of human nature, such as Froebel and Rousseau recognized that children learnt infinitely more about life in their free play activity than was ever gained in the classroom. However, it was not until many years later that this philosophy was given credence, when the education report of 1931 stated that:

in the earliest days of popular education children went to school to learn specific things which could not be taught at home: reading, writing, cyphering. The real business of life was picked up by the child in unregulated play, in casual intercourse with contemporaries and elders (Dept. of Education Report, 1931: 92).

This quotation serves to highlight the fundamental error which still persists: that is the confusion between 'schooling' and 'learning'. The changes within the classroom have not kept pace with those of society which demand far more sophisticated survival skills than schools are able to offer. And as the structure of society has evolved so too has the requirement that each and every individual develop some degree of fluency and creativity of language and idea. But while this holds true, a conflict of methodology endures.

'Behavioural' versus 'experiential' learning theories

In very simple terms, cognitive science can be split into two main schools of thought: that of 'behavioural' and that of 'experiential' learning. Borger and Seaborne define learning as, 'any more or less permanent change of behaviour which is the result of experience' (Borger and Seaborne, 1973: 14). But experience is endless, and an assessment of the learning process is complex as theories develop and grow into new but related concepts, and one school of thought begins to merge with another. In fact, it might be suggested that the issue in question is really one of semantics: what is 'experience', and how narrow or how wide is it? And what is meant by 'learning': process or substance?

Behavioural conditioning focuses on the belief that learning

takes place as a result of the action of the environment upon the individual. Behaviourist theory concerns itself very much with 'process'. The quality of the learning experience and, therefore, of the information imparted is diminished; and retention of that information is poor. This is exemplified in the secondary school, where the neatly copied out and memorized notes take precedence over the development of first-hand knowledge; potentially exciting learning material loses its quality and becomes simply more facts to take in. Learning is passive, involving an act outside and beyond the individual's control. The internalization of information, or 'a making of one's own', which is essential to any learning experience, also occurs through some kind of external reinforcement which can be either of a positive or negative nature; a grading system, for example, is most effective. Evidence shows that conditioning of this kind does bring results, but allows no room for interpretation, ingenuity or creative thought on the part of the individual.

Experiential learning takes as a basic premiss the concept that learning occurs as a consequence of interaction by the individual with the environment. In experiential learning a level of self-motivation is built up through a complex meaning-structure, which thus facilitates the ready assimilation of information. A layering of experience, seen and interpreted in the light of previous experiences allows learning to take place in context and facilitate meaning which is not only accumulative but also transferable. The added dimension of choice internalizes motivation in the sense that the individual maintains a greater interest while in control of the learning experience. Involvement of the individual in his or her education in the most concrete and active terms is essential to the building of a meaning-structure.

The Plowden Report in 1967 recognized and defined these two concepts. Of the behaviourist theory it says that it is 'concerned with simple and complex operant conditioning, the place of reinforcement in learning, habit formation and the measurement of various kinds of stimulus–response behaviour' (Plowden Report, 1967: 192). Of experiential learning, that is learning from concrete situations as lived or described, it continues: 'learning takes place through a continuous process of interaction between the learner and his environment which results in the building up of consistent and stable

patterns of behaviour, physical and mental' (Plowden Report, 1967: 192).

Jerome Bruner maintains that in modern-day society children *do* need to learn vast bodies of knowledge, a need well catered for in schools. But he goes on to say that the learning of facts needs to be balanced with problem solving. This philosophy goes some way towards 'education' in the true sense of the word, that is in terms of the development and fulfilment of the *whole* individual. Children, in striving to develop and assert their own individuality, need to learn from experience, as well as ikonically, through visual imagery, and symbolically, through language. A child's learning is a combination of selected, planned experiences, like, for example, those of the classroom, and of the unselected, chance experiences of each waking hour. In short, it is essential to the full development of the individual to learn through first-hand as well as second-hand experience. It follows, then, that a teacher's role should be primarily that of 'facilitator', one endowed with the ability to show children how to make meaning out of life's confusion. This role is secondary to the child's as 'learner'. One could define this as a 'gestalt' philosophy, whereby the whole is more important than the sum of the parts.

The social construction of reality

The concept of 'making meaning' of life is central to the learning experience and requires a comprehension of two elements. Primarily reality, being socially constructed, relies for that construction upon *the richness of the 'here and now' experience*. It is undoubtedly possible to teach and learn by methods of control based upon conditioning techniques; this may be seen daily in secondary education. But this type of learning experience is passive and sterile, and its worth is debatable because the 'reality' which is constructed is narrow, restrictive and non-creative, allowing little personal interaction beyond the set moves, and certainly no opportunity for independent choice or question.

The reality of everyday life is organised around the 'here' of my body and the 'now' of my present. This 'here' and 'now' is the focus of my attention to the reality of everyday life. What is

'here and now' presented to me is the *realissimum* of my consciousness (Berger and Luckmann, 1975: 36).

The second crucial element is that through *the building of bridges between the 'known' and the 'unknown'* individuals are able to enrich and enlarge upon already existing knowledge from the vantage point of understanding. Winnicott refers to this as a negotiation between two realities, and the bridge spanning these realities as 'play'. Play, which belongs to its own space, time, mood and feeling, transcends the world and the individual, and yet relates to the world and the individual. Because it is rich in experiences that relate to the world's 'whys', 'hows' and 'whats', it necessitates concentration and preoccupation, and involves the formation and crystallization of ideas. Thus 'play' facilitates the ability to integrate the 'problematic' into the 'non-problematic' via the medium of creative experience, that being any experience that engenders in the individual the elements of motivation, interaction and reinforcement. Although this is a doctrine inherited from our educational past, it is not one which is over-zealously utilized. The 'play' experience must be allowed its proper place in the teaching of the young.

Behavioural and experiential learning may have more immediate relevance and application when compared to 'teaching by authority' and 'creative teaching and learning', respectively. Authoritative teaching relies heavily upon the symbol of second-hand information in the form of text book and illustration, while creative learning involves first-hand experience. One is left with the problem that what should be seen as a *whole* is viewed instead in terms of opposing ideologies: 'teaching by authority' versus 'creative learning'. Because this is the current state of affairs it is worth some analysis.

Teaching by authority

It is now widely accepted that the primary role of 'education' should be to equip each individual with the life-skills necessary to meet his or her potential. Nevertheless, in the classroom teachers are still undeniably active in 'schooling' rather than in 'educating', imparting information by didactic and authoritative means, with the child acting as passive recipient. In brief, it has

to be said that it is efficient in terms of time, cost and manpower to 'teach by authority', but it remains a static, inward-looking model which seeks primarily to maintain the status quo, for although 'we have long known that it is natural for man to learn creatively . . . we have always thought that it was more economical to teach by authority' (Torrance, 1962: 4). In this situation factual 'knowledge' is all important, with less emphasis placed on the social, mental and moral development of the child – the child as a fully functioning individual (see Fig. 3).

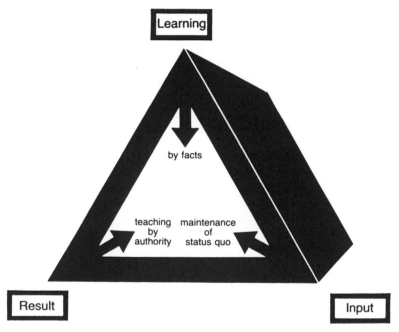

Fig. 3 The first paradigm. Authoritative teaching: a closed system

Creative teaching

Creativity has widespread connotations. It is a freely used item of jargon, and much to its detriment its meanings can range from anything vaguely 'good', to a supreme achievement within a particular field. The use to which the word will be put in this paper needs, therefore, to be clarified. In the context of education 'creative' is not, here, being used in relation to an outstanding

achievement in the arts or sciences, but quite simply to describe an individual's awareness of, and, therefore, ability to fulfil, his or her life potential.

Using the teacher as *resource* rather than *source* allows for a far more open-ended situation, one in which research and questioning are encouraged towards the development of independent and creative learning and ultimately life-skills, as a fundamental element of each individual's ability to deal with, and appreciate life (see Fig. 4).

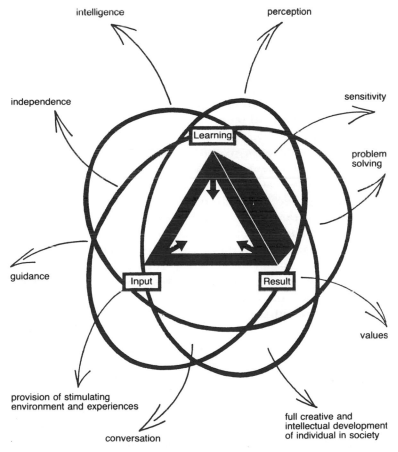

Fig. 4 The second paradigm. Creative learning: a flexible system

By drawing an analogy between present-day education and Plato's use of the cave simile, his writings can help to clarify, to some degree, the problems inherent within schools, and the struggle of 'authoritative teaching' versus 'creative learning':

In the cave are figures; Plato tells us that these figures have been prisoners since childhood, bound so that they can only face the back wall of the cave. Outside the cave entrance is a high wall, behind which people come and go talking. They are carrying objects and animals on their heads which are visible over the top of the wall. Behind these people a great fire blazes, so powerful that it casts the shadows of the objects being carried on to the back wall of the cave. The prisoners can see these shadows and believe them to be real things; they can also hear the voices and think that they belong to the shadows. One man is released from his bonds; the physical and mental act of entering into reality is difficult and painful. His confusion leads him to wish to return to the dark cave, but once accustomed to the light, and once he has come to terms with what is actually real, the whole of life begins to unfold before him (Plato, 1956: 278–86).

In relation to Plato's simile the secondary school environment begins to look remarkably like that of the cave, with the children taking in *symbols of reality* rather than dealing with reality itself; teaching becomes synonymous with symbol and process, learning with reality and substance. So while children are busy accumulating shadows of reality in the classroom, the real stuff of life, the colour of experiences and individuals, and the opportunity to observe and interact with them, passes them by. Consequently, on leaving school children are ill-equipped to enter into, and deal with, life, a fact which is becoming more and more apparent as schools suffer ever greater criticism from higher education and industry.

Literature upholds the fact that the most meaningful and life-orientated education is provided by interactive and experiential learning, and suggests that this truth is generally accepted by society. One needs, then, to consider why it is that schools continue to pursue a didactic approach, teaching by what would appear to be the most educationally ineffective means. Perhaps the key to the problem lies in the term 'effectiveness'. What is meant by effective education? Does it mean education that is

'effective' in imparting a body of fact; 'effective' in the development of creative or sensitive people; 'effective' in controlling large numbers of individuals; or 'effective' in getting the maximum number of students through the maximum number of examinations at the highest grades?

Clearly, secondary education is not primarily concerned with the development of individuality, creativity, sensitivity, perception or moral values. Its major aim is to 'play the system', to 'get children through their examinations', and the more the better. 'Effectiveness' in this sense is, therefore, synonymous with 'facts', 'control' and 'the maintenance of the social status quo'. This highlights the mistaken belief that schools are concerned with the opening up of children to education in the fullest and truest sense of the word, an education which allows them to deal with all the eventualities of life. Once the fundamental nature of this error is understood the solution begins to become transparent.

The logical answer would seem to be to allow the school environment to deal with 'schooling', with which it copes so well, and to look elsewhere for the realization of creative education. It is then possible to stop asking why it is that schools are not providing children with a good grounding for life, in the realization that *this is not their aim*.

For life-skills and values are still found, on the whole, *outside* and not *inside* the classroom; in Pestalozzi's words 'it is life that educates'. Once this state of affairs is accepted, then and only then can an alternative education, a 'real' education, be sought outside the classroom.

In the light of this revelation one can imagine the ensuing state of parental panic. If schools are not adequately fulfilling their roles as educators then where can one possibly turn? In the face of such alarm it is possible to find what might appear to be a rather perverse optimism. A summary of what has been said so far may clarify this:

— The most *effective* way to teach, and the most productive and exciting way to learn, is by interactive means, for 'learning will best take place when the teacher ensures that children have adequate experience of reality as a basis for the abstractions they form' (Stones, 1971: 392).

— The most *efficient* way to teach and to receive knowledge is by authoritarian or by didactic means.

— Schools on the whole teach by authority, adopting a behaviourist approach, and function therefore efficiently rather than effectively.

— It seems, then, that the need lies in allowing children (and adults, for that matter) the freedom to be partners in the formation of their own education. This will call on them to be fully involved in the most active and productive way in the development of their own learning.

— Failing the provision of such possibilities in school, one must, by necessity, look elsewhere to situations and environments that will not only provide experiences, but also allow each person to be able to interact with those experiences in whatever way, and on whatever level, he or she wishes, or is able.

The educative potential of museums and heritage centres

The nature of the museum experience

Britain has a large number and great wealth of heritage institutions. These are, on the whole, little used in what should be one of their major roles, that is as 'institutions of experience' and, therefore of 'real' learning. They are many, varied and rich in their naming: museums, stately homes, art galleries, botanical and zoological gardens, castles and archaeological sites, to name some of the more grand. But the smaller and more modest sites are often equally rich in the experiences they have to offer. They provide what has just been assessed as the ideal learning environment, first hand experience of life as it is, was, and possibly is to come. One can see and handle cooking implements in the Tudor kitchen at Hampton Court, trace the progress, results and implications of genetic engineering in plants at the Royal Botanical Gardens at Kew, learn the basic principles of physical phenomena at the 'hands-on' exhibition at the Science Museum, venture down a coal mine at the Beamish

Museum, observe the re-enactment of the Civil War at Boscobel House – the list is never ending, as are the experiences. Hitherto, none of these heritage institutions has been able to meet its potential simply because the education of the nation has, on the whole, always been seen as lying firmly, if somewhat erroneously, within the care of the schools; in this sense these other institutions which have so much to offer culturally and educationally, were neither recognized nor needed. The recognition of the true state of affairs within the education system at last pin-points not only where the need so obviously lies, but also where that need can be so richly fulfilled.

It has already been argued that the most productive way to learn is by contextual and experiential methods. Schools tend to teach through the provision of second-hand, abstracted information; heritage institutions, as a rich source of 'hands-on' experience of our own and other cultures can at least offer learning in context, and can thereby afford a potentially far more fertile educational environment. The degree to which that learning is experienced in play or interactive form is, however, yet to be considered. Therefore, although the fundamental importance of museums and heritage institutions is clear, it remains necessary to assess, firstly, to what degree there is an awareness within the museum system of that educational potential and, secondly, how far that potential is being met.

The evolution of educational policy in museums

In 1975, Luis Monreal, then Secretary General of the International Council of Museums, praised the advances made in the educational facilities provided by museums in general:

Museums have extended and diversified their activities, making room for a wide range of experiments, to such an extent that, apart from their cultural vocation, the only thing they have in common is that they are all permanent institutions open to the public (Monreal, 1975: GESM International Conference).

However, two years later the Museums Association scathingly reported that:

Museums exist as a largely untapped source of educational wealth. The essence of this statement was first expressed by the British Association in 1920 and has appeared in every official report to date. The effect has been nil (Museums Association 1977: 1).

These strangely disparate views on the state of education in museums are symptomatic of the vestiges of an earlier dichotomy of ideology within the museum system, similar to that found within the State education system, and are indicative of the confusion evident in museum education today. The earliest museums existed solely for the use of scholars and connoisseurs; but even at this stage it was sometimes recognized, in particular by rural institutions, that the masses could enjoy some enlightenment from the ethnological, botanical or zoological collections, and so museums would occasionally be opened to the 'lower classes' for their edification. In 1827 it was suggested by the Committee of the Castle Museum, Norwich 'that masters and mistresses of schools subscribing one guinea per annum be allowed to admit twenty of their scholars at the same time, provided that they attend with them themselves' (Frostick, 1985: 68). In the year 1847, when the Castle Museum opened its doors to the non-subscribing public for one day a week, 16,658 visits were recorded. Ultimately, the multiple role of museums as centres of research and education at all levels as well as depositories of cultural wealth and centres of preservation and conservation was finally acknowledged. Thus the idea of the museum as an educational institution was born, with the inevitable creation of supporting professional bodies for the promotion of education through museums.

The exploitation of educative potential

The dual role of museums and heritage institutions is today on the whole acknowledged by even the most conservative curator. Why then did the Museums Association publicly state in 1977 that it considered museums still to be a relatively untapped educational resource? The major problem lies in the definition, or lack of definition, of what exactly is 'education'. One curator may place emphasis upon the provision of interactive material

in an attempt to give a complete contextual and experiential picture for his visitors. Another may see the opening of his doors to academic research as meeting his educational obligation. In 1977 the development of an overall education policy in museums was neither firmly resolved, nor unanimously agreed upon. The situation remains largely unchanged to the present day.

The consequence of this is threefold. Firstly, the communication of ideas both within the museum service as a whole, and outside to educationalists and designers, is difficult because of the lack of a clearly specified ideology. Secondly, and as a result of this, much of what goes on in museums under the guise of 'education' widely misses the mark. Finally, and of equal concern, in an attempt to be 'educational' exhibitions begin to take on the ethos of the classroom. This being the case, the possibility of utilizing the full educative potential of any heritage institution is severely diminished, with the added disadvantage of developing in the minds of the public the same aversion for museums that many have previously felt for the classroom. As Terry Zeller makes clear, 'trying to make the museum experience an extension of the classroom ... over-shadows the unique learning opportunities of the museum ... and makes the museum into a school rather than emphasising the characteristics that makes it a different and unique learning environment' (Zeller, 1985: 7).

Museums should be offering, and should be aware that they are able to offer, a totally different educational experience. Perhaps the following quotation (Rosse Report, 1963: 3) gives some indication as to the extent of the problem:

It seems to us impossible to over-estimate the importance to future generations of teaching children the use and significance of museum objects, and we urge those local authorities who have not yet developed, or assisted museums in their areas to develop a school museum service to do so without delay; and especially to provide a loan service in all rural areas.

Here, there seems to be quite a remarkable misinterpretation of the educational purpose of the museums service. While still centred, many would say quite rightly, on the museum 'object'

it fails to appreciate that objects in isolation hold little meaning to anyone other than the academic, who is able to create his own meaning-structure. One needs to bear in mind that for the rest of the population, and children in particular, an object seen in a museum is little better than one seen in a book until that object is revealed as a tangible illustration of a complete contextual story. While an object made available through the museum's loans' service might well provide the missing link in a complete picture, it will not automatically create that whole picture.

This goes some way to explain the diversity of views as to the success of the educational service generally offered by museums. Once again, the problem lies in 'meaning', in the semantics of our language, and in the variety of interpretations of what, indeed, is 'educational'. And so, although there is considerable appreciation of the educative potential of museums, there is also a great lack of understanding as how best to utilize that educational wealth. This situation is further exacerbated by an additional problem: there is a very real fear, on the part of many curators, of relinquishing their professional jurisdiction and authority. The opportunity to open galleries to expert interpretation and use by other professional disciplines, in an attempt to meet the public's needs, is seen by many as a threat rather than an advantage.

The development of a museum educational ideology

The overwhelming impression of education in museums is one of confusion. Lacking an overall ideology each museum responds, educationally, to its collection in a different way. There are many extremes: the dusty and cluttered glass cases and almost illegible typed worksheets; the sparkling and expensive galleries where exhibits still remain firmly behind their glass walls; the rather worn and faded environment, where the experiences of dressing up, role-play and painting are paramount; the wonderland of the science playground. The list goes on. What exactly, then, is a valuable educational experience in the context of the heritage institution, and what should be the educational aim?

The Museums Association states quite correctly that 'visitors to museums today are looking for more than a passive experience

– they are looking for involvement' (Museums Association, 1977: 1). This statement upholds teaching philosophy which emphasizes the need for interactive experiences rather than purely passive observation or ingestion of text. But involvement by itself is not enough. It is fun to play in an experiential environment but if during the play experience nothing new is revealed, no problems are brought to light to be solved, and no additions are made to the meaning-structure, then the experience can only be of limited educational value. Supporting the enjoyment of the interactive experience there need to be clear educational aims with specific learning objectives, devised by educational experts.

In most other spheres of life it is accepted that each individual's expertize is limited, and that the way to solve a problem which lies outside that realm of knowledge is to employ an expert. It might be of considerable benefit to apply the same logic here. If it is agreed that clear educational aims, with specific learning objectives, must be established then clearly it is necessary to employ the skills of a professional educationalist. Unfortunately, educators are generally found only in the lower echelons of the museum service, as museum teachers, and only fifteen per cent of those working in education in museums have any kind of teaching qualification; the skills of an educationalist are rarely sought at all. It is, therefore, hardly surprising that the design of exhibitions usually ignores fundamental educational principles. The production of any kind of effective learning programme enters the realm of pure chance.

The development of design awareness in museums

An urgent need for carefully planned and stipulated educational principles has been brought to light, but it must not be forgotten that, for the public, the musum's work is made manifest through the media of display and design. In this way, the essential role of exhibition and graphic designers is brought into focus. Since the Second World War, museums have had an increasing awareness of the need for professional design assistance in the interpretation of the collections. In the early 1970s, spurred on by Hugh Casson's encouragement, the first conferences devoted exclusively to the discussion of the role of

design in museums were inaugurated, and in 1976 the Group of Designers/Interpreters in Museums was formed. With the accent placed firmly on interpretation, designers found a clarity of objective which eluded, and continues to elude, museum educationalists. As Frank Atkinson, director of the Beamish Museum sums up so clearly, 'we now need more than graphic designers on our staff; we need communicators' (Atkinson, 1975: 103).

This may have been the first insight into the 'complete' museum system with its trio of experts. The museums service took this ideology to heart and the 1970s saw the advent of a real change of emphasis. By the end of that decade, despite the economic depression, a hundred and seventy-five full-time designer posts had been created within British museums. The concept of the 'museum as communicator' was a major break-through, albeit one that educationalists had been advocating for some time. With this realization and the subsequent aim of public 'outreach' a new museum era began. It has finally been acknowledged that, 'only through the use of communications media utilising contemporary language and techniques for which the visitor audience has the appropriate facility to receive, decode and understand the messages, will the museum as a medium of communication be truly effective' (Belcher, 1983: 55).

It must not be forgotten, however, that any institution's ability to respond to demands will be to a large extent determined by whether or not funding is adequate to meet the need. Whereas it is generally accepted that many heritage institutions are grossly under-funded, consideration must be given to whether these limited funds are in fact being used to best advantage. Memorable experiences are to be had not necessarily in an expensive 'glitzy' designer environment, but, as we have already seen, by the provision of exciting, meaningful and carefully devised educational activity. Precious funds need to be used at two levels: in the employment of innovative staff in policy making, and then in the implementation of those policies.

The changing face of museum education

One can see that here lies the intention, the possibility and the catalyst. Designers are now an established part of the curatorial

scene, and professional educationalists hover in the wings; but somewhere along the line the rationale for their presence has been obscured. No one group of experts is able to function in isolation: neither curator nor designer is equipped, and should not be called upon, to make fundamental decisions concerning educational policy. But similarly, only the curator knows the richness and potential of his collection, and only the designer can visualize the devices which can best impart concepts and bodies of knowledge to the audience. Each has a very particular set of skills by which he is able to help to utilize fully the potential of the museum or heritage institution. Effective decisions can only be made by the joining of professional forces at the policy making level.

There have been some excellent responses to the ideology of the 'museum as communicator' from museums and heritage institutions all over the world. The result has been some very interesting interactive and didactic exhibitions. For example, 1970 saw the opening of the Beamish Museum in County Durham, Brussels' first children's museum opened its doors in 1976, and the San Francisco Exploratorium followed in 1977. To these major events should be added the development of the very popular 'living history' projects which are springing up at many historic sites. But the fact remains that these are the exceptions to a rule.

As yet museum policy makers have no clear directive to give to those within the service who are responsible for the development of the education system. As Eilean Hooper-Greenhill points out: 'the words education, communication and interpretation are a confused section of museum vocabulary, and the work of the educator may relate to many aspects of all three of these activities, however they are understood' (Hooper-Greenhill, 1985: 1). This passage serves to emphasize not only the magnitude of the problem, but also the ridiculous nature of the situation. The major issues requiring immediate attention remain. Firstly, that without terms of reference, employees will be unable to work efficiently. In consequence confusion, frustration, wasted time, effort and finances result. Secondly, the 'experts', in the form of educationalists and designers, are not being called upon to exercise their skills at the level of policy making, the area in which they are most needed.

The second phase of this discussion may, therefore, be summarized as follows:

— museums and heritage institutions offer an unprecedented realm of learning, but do not fulfil their potential

— this is largely because of the lack of clear educational philosophy, and the subsequent lack of specific policy

— and an unwillingness to relinquish professional jurisdiction and authority for a shared responsibility

— cognitive science reveals that children need to *experience* a museum, but beautifully designed and elegant exhibitions do not necessarily provide a worthwhile educational experience for children

— meaningful educational experiences are most likely to be encountered where interaction with the exhibit is available to the child

— however, to ensure maximum quality of experience a carefully structured and implemented learning programme needs to be brought into existence through the combined forces of a team of curatorial, educational and design experts

The courage must be found to bring to light the problem, to unwrap the educational rationale, and to join the expertise into a well-functioning, communicating whole with common ideals, so that museums can finally come of age with confident, assured and professional educational aims and objectives.

The development of a learning system for museums and heritage institutions

Addressing the problem

At present many museums show evidence of one of two extremes: the leaders in the field are on the one hand adopting an experiential approach, advocating either 'living history' and costumed role play, or the play-centred 'exploratorium' type of

experience. On the other hand can be found the consummate excellence of the mechanical 'interactive' experience, which nevertheless finds its origins in behavioural conditioning. Lagging behind are the many institutions, which, either through choice or ignorance, have no clear educational policy. Curators have been known to say, in their defence, that they have no specific educational aims because they tailor their response to the specific needs of individual groups of visitors. Such a 'response' is often in the form of the ubiquitous worksheet or gallery talk. Needless to say the logic of this philosophy does not withstand rigorous analysis. In smaller institutions with low levels of staffing there may be a genuine lack of awareness of exactly how much can be done even on a token budget with enthusiastic staff support. But many curators actively choose to retain firm and restrictive control of their academic environment and the public they aim to serve.

There is an obvious need to educate curators, particularly in the art of co-responsibility, but this is a long-term task. Ultimately it may be that only commercial pressures will force them to change; ironically the wrong motives may have the desired result. A more immediate step would seem to be to give tangible assistance to those willing to develop the potential of their museum or heritage institution. The framework of a coherent educational policy made clear and usable with a learning system structured enough to maintain sound educational objectives, but flexible enough to adapt to the specific bias and needs of the particular site and audience, would go some way towards meeting this need. Such an approach would place the emphasis upon challenging the individual in the development of practical, social, moral and academic skills through interaction with his or her environment.

The starting point for this kind of experiential learning already exists. A child's environment is remarkably small and a whole world of learning is to be found in the most modest experience. As educational facilitators the real problem is to open up the learning experience either by *utilizing* the available environment, or by *constructing* an appropriate environment, or both. This being the case, education has at its disposal an unparalleled and inexhaustible resource ready for use and inadequately exploited.

Interpretation of the learning environment, and initial aims in the production of a learning system need to be based on the following elements: (1) *motivation*: to stimulate initial interest; (2) *meaning*: to pose a problem to be solved, thus creating structure, relevance and context; (3) *interaction*: to provide by a variety of activities the solution to the problem while generating the discovery of other information; and (4) *reinforcement*: further interest and the desire for continued learning in and out of school.

A problem-solving situation offers high levels of satisfaction and motivation. Memory which in the classroom seems so unreliable functions most efficiently when there is something worth remembering, when the motivation is intrinsic and when there is a relation to information already known. To 'solve a problem' demands not only the use of a 'basic language' but also affords the opportunity for the individual to use his or her creative powers to the full. Creative adaptation is necessitated by an ever-changing society. Society is appropriate to the learning process because mankind is born into society and not into isolation. The interaction required by an individual's membership of society provides him with the substance of learning. While equipping its members with experiences, the building bricks of learning, it also passes on to them increasingly complex patterns of behaviour, shortcuts to learning through language and culture. This, in turn, is transmitted to other individuals, and subsequently to other societies, and facilitates, not only rapid learning and rapid adaptation to changed circumstances, but also gives rise to accelerated social change. The cycle continues laying emphasis on the essential nature of interaction.

Motivation and interaction based on experience, therefore, provide the intrinsic reinforcement of meaning through the probability of successful achievement. The importance of interactive/experiential learning undertaken ideally through a child's natural learning function, that is through some kind of play activity, cannot, then, be stressed too vigorously.

Clarification of objectives

Once it has established a firm structure for motivation, meaning, interaction and reinforcement, an institution then needs to

develop the relationship between these specified aims and its own particular circumstances. The following points may act as a framework for those decisions:

— the identification of teaching aims.

— the isolation and analysis of a body of knowledge that is to act as the basis for class or individual learning.

— the identification of means by which to 'build bridges' and extend knowledge.

— the involvement of the child in as much problem-solving activity, interactive play, role-play and logical information analysis, as possible.

— the structuring of the experience in order to make the finding of factual information essential only in as far as it is required in order to solve problems; in other words, in so far as it is necessary to the interactive activity and the subsequent development of the theme.

— the design of the mechanics of the exhibition in terms of room adaptation, floor plan, information design, graphic interpretation and design etc.

— the development of the 'exhibition area' merely as a base from which to explore the many possibilities of the site/museum.

— the consideration of follow-up activity.

— to construct, set up and evaluate the educational effectiveness of the exhibition.

The isolation of specific site-orientated objectives can now be put into practical effect in relation to the learning system devised by the author.

The learning system

The aim of the learning system is to provide a series of steps towards the development of a practical, effective and rich learning environment (see Fig. 5). It promotes highly specified aims in the form of 'action to be taken' – evident in the left-hand

boxes, and 'rationale' – in the right-hand boxes. While structurally specific, it maintains flexibility of interpretation which allows it to be adapted to any kind of museum gallery or heritage institution. In order to illustrate more clearly the dynamics of this system its structure will be briefly discussed in the light of a particular case study.

The first site-specific, interactive, learning environment to be devised and constructed based upon the principles of this learning system is to be opened this year at the Roman site of Viroconium at Wroxeter. Owned by English Heritage, this Roman fort is important archaeologically for its strategic military position on the borders of England and Wales. When its military importance waned, Viroconium was handed over to the civil authorities and subsequently flourished as a large and prosperous town. The baths and market area which have been excavated are among the most important remains to be found in Britain; this unfortunately does not make them any more visually appealing to children, for whom large areas of stone wall hold little immediate meaning. In this respect it presented a real test for a learning system which aims primarily to construct knowledge through meaningful interaction. Adopting the premiss that children need to be involved in some depth with their learning process in order that information be meaningful, emphasis was not placed upon the design of an 'exhibition', but rather on the development of a 'learning environment', in an attempt to bring the site to life. This meant initially devising an enclosed area into which the children would first enter and which would 'set the scene'.

The major and overriding difficulty in any educational experience is in initially gaining attention and interest. If one does not grasp the imagination immediately and firmly, all else may be lost in boredom. For this reason it is necessary to meet children on their own terms and in their own idiom. This was done in a number of ways, primarily, by using the senses in the conveying of information, so that instead of immediately requiring the use of reading skills (the basis for most learning), the 'period scene' sought to capture the imagination, the creative spirit, the sense of fun. In this section there is no written word; all information, and instructions, are conveyed by visual and auditory means. This approach, in itself, is by no means

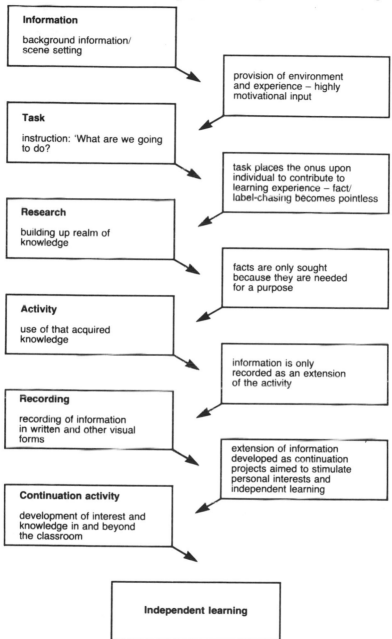

Fig. 5 The learning system

innovative; period settings and talking heads are capturing the imagination of museum audiences all over the country; their effectiveness is well proven.

However, from here the children move into the main body of the learning environment which is organized into a number of 'home bay' areas. Each of these bays relates to a different aspect of life at Viroconium, telling the story through life-size cartoon figures. The aim is to develop a graphic system without formality of image or typography, but one very much within the child's experience, using the medium of the cartoon strip. Through their narrative the cartoon figures not only suggest problems and activities with which the children become involved, but also pose queries or mention assumed knowledge which serves to act at an almost subliminal level and is intended to initiate a desire in the child to 'find out'.

Within each bay a small group of children work on their specific interactive, practical task which, it is aimed, will engage them for the duration of their visit. The aim is not, therefore, to 'get round the whole exhibition', but rather to promote in depth, and to a great extent, self-guided and motivated learning. It need also be said that in order to gather information to fulfil their task the children need to move out of the 'exhibition' area and into the rest of the learning environment. At this particular site they have access to the Roman remains, museum, church and local environs, which are safe because of their rural situation. Here the concept diverges from the norm, and requires a brief comparison to be made with the different kinds of interactive exhibitions already functioning in museums and heritage institutions.

Firstly, there are the 'high tech' interactive exhibitions, and here the comparison is quite simple to make. Both approaches are similar in that they appeal greatly to the senses, and are very much visual and tactile experiences. This means, inevitably, that emphasis is placed upon the role of play in learning, even if, as in the case of 'high tech' interaction it is a rather solitary 'play'. However, they differ markedly in ideology: push button exhibitions are essentially behaviourist in essence, in that a situation is set up, information is given, understanding is tested, and a correct or incorrect answer is reinforced positively or negatively. The 'exploratorium', on the other hand, offers a wonderfully

exciting, and truly interactive, play experience. However, the child functions in isolation of a meaning structure and, therefore, of any existing knowledge upon which to base his understanding or build further knowledge. Lastly there are the role-play situations, which are most rewarding in that they are truly experiential. But they are also highly structured and few allow deviation from the 'plot'. Nor is there the opportunity for the children to be involved in controlling the learning experience: to structure their own decisions about the learning path they will take, the bias they will adopt, the expertise and skills they will develop.

The aim of the kind of interactive system described here is to utilize children's natural learning facility of play, which requires the child to socialize and develop moral values, which allows them to question the 'who' and 'what' of themselves and the world, which encourages experimentation with materials and ideas, which engenders a sense of pride and achievement, and which will develop interests guaranteed to linger long after the school bell has gone.

The analysis of this learning system highlights various elements which are indicative of an innovative approach to museum education. It would seem, therefore, that this concept may not only help curators in their development of an effective education policy, but help to fill the current gap in interactive learning in museums and heritage institutions.

Conclusion

In accord with Gestalt psychology, the tenor of the argument in this paper has been that in the education of children, curators, exhibition designers and educationalists must hold as their prime concern the development of the *whole* child. Sir Thomas Percy Nunn says:

Educational efforts must, it would seem, be limited to securing for everyone the conditions under which individuality is most completely developed – that is to enable him to make his original contribution to the variegated whole of human life as full and as truly characteristic as his nature permits (1920: 5).

A recapitulation of the major stages and ideas of the project may be helpful. It has been argued that by and large, the school environment is not conducive to the 'true learning experience', this being defined as one which encourages the full development of the child, not only in academic terms, but also as a social, moral and spiritual being. Furthermore, that, contrary to public opinion, the school environment is unable to offer education in the richest sense, either by intent or action, because this is outside its brief and responsibility since its aims are essentially to impart factual knowledge. Life in its fullness exploits a child's total intellectual, creative, spiritual and moral being, and the medium through which this is best practised is play activity.

The nature of the learning experience has been discussed, and various conclusions have been drawn. Authoritative teaching stifles learning; it is more effective to teach creatively, but easier to teach by authority, for in order to motivate children to think creatively one needs to teach creatively, employing dynamic and interactive methods rather than relying on passive involvement. The highest order of learning occurs when the child is able to internalize an extrinsic motivation, and information must hold meaning in relation to the child's experience if it is to be internalized. In this way information needs to be objective not subjective. The most productive and permanent way for this to occur is when the child is actively involved in the learning experience, because such experience brings meaning to words. The greatest involvement is most likely to be manifest in interactive activity centred on the play experience, play being an element central to the creative development of the individual. The primary aim was, therefore, to devise a learning system which would be removed, and remove children, from the classroom to a potentially more fertile learning environment.

The objective of this paper has been to propose an innovative approach to learning, one which explores more fully the potential of heritage institutions and museums and their ability to offer exciting experiential learning environments. The awareness within these institutions of the need for greater educational involvement is growing, but there is a long way to go. It is wasteful of precious funds to upgrade an old-fashioned glass case museum, and serves merely to emphasize the misconception

that the educational policy of the institution *must* be effective if enough money is spent on refurbishment. Precious funds and resources need, instead, to be used primarily in the design of effective learning programmes, and subsequently in the development of those programmes in concrete terms.

Although the graphic presentation of any kind of exhibit is instrumental in the motivation to learn, by itself it does not presuppose effective learning. The graphic display can add a great deal to the quality of learning experience but cannot be equated with the quality of that experience. Equally, a valuable learning experience is quite possible without excellence of graphic display; an old-fashioned glass case museum can become an Aladdin's Cave in the hands of an imaginative teacher. Whereas teachers and designers are employed to implement the decisions made by musem staff there is, within museums, relatively little sharing of policy making. Professional barriers need to be removed in order to enable teams of experts to use their skills so that they may best serve the central issue: the child. Museums and heritage institutions have, on the whole, failed to clarify specific educational objectives, and consequently find the concept of 'learning programmes' within their curatorial system confusing.

Society is under the overwhelming obligation to make every possible provision for the full education of its children. In order to fulfil that obligation both personal and professional boundaries within museums and heritage institutions need to be transcended, and the wealth of expert knowledge and experience be pooled to provide for our children the richest possible learning environment.

At present society is slipping silently into mediocrity, with the full backing of the State education system as it churns out conformists and quashes original thinkers. Genuinely creative adaptation is not keeping pace with social change. It is now time to break with what is becoming a passive and culture-bound society if an attempt is to be made to deal with the growing multiplicity of social, cultural and environmental problems. This can only be done through education. In the words of Carl Rogers: 'unless individuals, groups and nations can imagine, construct and creatively revise new ways of relating to these complex changes, the lights will go out' (Rogers, 1954: 70).

Bibliography

Airey, V., 'The Past Twenty Years' in *Journal of Education in Museums*, 1, 1980: 10–15.

Atkinson, F., 'Presidential address' in *Museums Journal*, 75, 3, 1975: 103–5.

Belcher, M. G., 'A decade of museum design and interpretation: a personal view' in *Museums Journal*, 83, 1, 1983: 53–60.

Berger, P. and Luckmann T., *The Social Construction of Reality* (Penguin: Harmondsworth, 1975).

Borger, R. and Seaborne A. E. M., *The Psychology of Learning* (Penguin: Harmondsworth, 1973).

Bruner, J., 1974. *The Relevance of Education* (Penguin: Harmondsworth, 1974).

Danilov, V. J., 'Discovery. rooms and kidspace: museum exhibits for children' in *Science and Children*, 24, 4, 1986: 6–11.

Department of Education and Science, *Report of the Consultative Committee of the Board of Education on the Primary School* (HMSO: London, 1931).

Department of Education and Science, *Museums in Education*, Education Survey 12 (HMSO: London, 1973).

Froebel, F., *Froebel's Chief Writings on Education* (London, 1912).

Frostick, E., 'Museums in education: a neglected role?' in *Museums Journal*, 85, 21, 1985: 67–74.

Hodgson,J., 'A year of discovery' in *Education*, 149, 7, 1977: 11–14.

Hooper-Greenhill, E. H. G., 'Some basic principles and issues relating to museum education' in *Museums Journal*, 83, 2/3, 1983: 127–30.

Hooper-Greenhill, E. H. G., 'Museum training at the university of Leicester' in *Journal of Education in Museums*, 6, 1985: 1–6.

Hooper-Greenhill, E. H. G., 'Museums in education: towards the end of the century' in Ambrose, T. (ed.) *Education in Museums, Museums in Education* (HMSO: London, 1987).

Illich, I. D., *Deschooling society* (Calder Boyars: London, 1971): 39–52.

Kirk, G., 'Changing needs in schools' in Ambrose, T. (ed.) *Education in Museums, Museums in Education* (HMSO: London, 1987): 19–25.

Lawson, J. and Silver, H. A., *Social History of Education in England* (Methuen: London, 1976).

Moffat, H. A., 'Joint enterprise' in *Journal of Education in Museums*, 6, 1985: 20–3.

Museums Association, *Museums in Education* (HMSO: London, 1977).

Nunn, T. P., *Education: Its Data and First Principles* (Edward Arnold: Sevenoaks, 1920).

Plato, *The Republic* (Penguin Edn: Harmondsworth, 1956).

Plowden, B. H. (Lady), *Children and their Primary Schools: A Report of the*

Central Advisory Council for Education (England) (HMSO: London, 1967): Vols 1 and 2.

Reeve, J., 'Education in glass case museums' *Journal of Education in Museums*, 2, 1981: 1–6.

Ripley, D., *The Sacred Grove: Essays on Museums* (Washington, 1979).

Rogers, C., 'Towards a Theory of Creativity' in Vernon P. E., (ed.) *Creativity* (Penguin: Harmondsworth, 1980): 137–51.

Rosse, L. M. H. (Earl of), *Survey of Provincial Museums and Galleries* (HMSO: London, 1963).

Rousseau, J. J. (trans Payne, W.), *Rousseau's Emile or Treatise on Education* (Appleton: New York, 1892).

Schools Council, *Pterodactyls and Old Lace: Museums in Education* (Evans/Methuen: London, 1972).

Stansfield, G., *Effective Interpretive Exhibitions* (Countryside Commission: Cheltenham, 1981).

Stewart, W. and McCann, W., *The Educational Innovators 1750–1880* (Macmillan: London, 1967).

Stones, E., *An Introduction to Educational Psychology* (Methuen: London, 1971).

Torrance, E. P., 'Causes for concern' in Vernon P. E. (ed.), *Creativity* (Penguin: London, 1980): 355–70.

Vince, J., *An Investigation into the Processes of Education Observed in Selected Museums*, unpublished MA thesis (Royal College of Art, 1986).

Winnicott, D. W., *Playing and Reality* (Pelican Books: Harmondsworth, 1986).

Winstanley, B., *Children and Museums* (Basil Blackwell: Oxford, 1967).

Wittlin, A., *Museums: In Search of a Usable Future* (MIT Press: Cambridge, Mass, 1970).

Working Party, 'Museums in education' *Museums Journal*, 81, 4, 1982: 236–9.

Zeller, T., 'School and museum education: museum education and school art: Different ends and different means' in *Art Education*, 38, 3, 1985: 6–10.

PART TWO

Reviews

EDITED BY EILEAN HOOPER-GREENHILL

Can futurism find a place in the Museum of the River?

JOHN C. CARTER

Department of Culture and Communications, Government of Ontario, Canada

It was with feelings of hope and optimism for the future of good museum exhibits, that I first visited the new Museum of the River at the Ironbridge Gorge Museum. My interest in futuristic studies in museology had been whetted by reading various authors in the field. I agreed with the notion that: 'The legacy of the past and the shape of the future put museums today at the beginning of an era of considerable opportunity and challenge' (American Association of Museums, 1984: 27). This seemed particularly relevant to the new exhibition. Earlier studies stressed the need for such initiative. Alma Wittlin noted that museums, 'are specially in need of considering their viability in terms of their capability to enhance the overall potentialities of individuals and of society in years to come' (Wittlin, 1970: 205). This active role was reiterated by A. F. Chadwick. He suggested that museums should act as 'important forces in the lives of their communities' (Chadwick, 1980: 110) becoming 'leaders' instead of 'followers'. Museums, therefore, should move from their traditional passive stance of remaining reluctant participants, and take a much more pro-active role in our rapidly changing society. Instead of focusing only on the past, they should also look at the present and delve into the future. Would the Museum of the River be the source of such direction?

Since its official opening in 1973, the dominant message of the Ironbridge Gorge Museum has been the past. Promotional materials stress that 'the past is all pervasive', the musem is 'a place which is part of everyone's history', and that 'its importance derives from many things, all to do with the past' (Ironbridge Gorge, 1986: 2). While this approach initially proved to be successful, it was far from being complete. The necessity to provide a wider interpretative perspective was recognized. Management and curatorial staff began a three year planning process to address this need. As a result, the next phase of development at the museum was designed to tell a story of how the world has changed by industry and ingenuity in the Ironbridge area (Ironbridge Annual Report, 1988: 3). The Museum of the River project is the first component of this new direction. Its intent is to make connections between yesterday and today, and 'to present an ongoing story and examine some of the costs of industrialization' (de Haan, 1989: 8). Does this exhibition live up to its advance billing? Does it suggest choice and options to its visitors? Can it be regarded as a model for 'futuristic' exhibition development and interpretation to be utilized by other museums as they prepare for the quickly approaching post-industrial era of the twenty-first century?

The physical location of the Museum of the River is one of its greatest attributes. Housed in a magnificent *c.* 1840 Gothic style warehouse, originally constructed to serve storage needs of the Coalbrookdale Company, its position alongside the River Severn still contributes to the utility of the structure. It was built at the point where the tramway system met the river, facilitating the transhipping of goods manufactured by the local industries. Today, the warehouse continues to serve as a central marshalling point. Here visitors wishing to take in the various resources of the Ironbridge Gorge Museum can receive orientation before setting out on their excursions.

The entrance to the Museum of the River combines as admission kiosk and gift shop. The intended dramatic effect of cascading water has been lost by a waterfall that broke down shortly after the site's official opening in May. Another problem is traffic congestion, especially acute with the arrival of more than one coach load at a time.

The first exhibit is a small two dimensional wall display

dealing with the natural history of the Ironbridge Gorge. A case study of geology and raw materials provide some useful information about the earliest history of the area. Unfortunately, careful proof reading of the text has not been done as dates and commentary relating to the dissolution of the monasteries have been transposed. Not an auspicious way to introduce visitors to the rest of the displays!

The creation of wealth, looking at Ironbridge as the 'Silicon Valley' of the eighteenth century, is featured in the next display. New ventures, technologies, products, markets and money are portrayed through the effective use of a small number of artefacts and attractive reproductions of original graphics. What follows is the focal point of the Museum of the River. A thirty-nine foot scale model depicts Ironbridge Gorge as it was during the 1796 Royal Visit. It took eight months to make the 1,300 buildings; 9,000 trees; 400 boats and 11,000 figures that show how the River Severn was used as a 'motorway' to service the local industries. A breath-taking view of the Ironbridge through a window at the end of this model, provides a sense of realism to the 'Z' gauge scale figures. The lack of any labelling is problematic, especially for first-time visitors. Highlights such as the Hay Incline Plane, the Benthall Water Wheel, the Coalbrookdale and Bedlam Furnaces, the Tar Tunnel and the Coalport Bridge and Ironbridge should be noted. To avoid a preponderance of text, an informational brochure could be produced to augment the story meant to be told by this spectacular model.

A series of chronological displays is next which illustrates problems of low water levels, and the dangers of flooding to navigation, the effect of industrialization resulting in pollution, disease and decline, and the modern use of water with current problems associated with its everyday use. Most striking is the 'Teeming City' exhibit. It starkly portrays the sources of pollution in the Victorian era through a three-dimensional diorama. Panels showing a case study of pollution in the Ganges River miss the point, however. While the intent is supposedly to illustrate the ongoing problems associated with industrialization and pollution, there is an obvious lack of information about pollution in English waterways. This is a topic that the Severn Trent Water Authority (one of the exhibition's main corporate

sponsors), should be addressing head-on. Can museum exhibits remain impartial and objective when sponsorship can invite compromise in the theme, format and content of displays? (Schlereth, 1988: 31–2: Wallace, 1987: 43). Certainly a question to ask of this exhibit.

The remaining displays deal generally with contemporary issues related to the use of water, conservation, watershed management and responses to pollution. More is needed here about the *major* sources of pollution, environmental concerns and remedies. How many milk and fuel tankers overturn in rivers? An attempt is made to involve the visitor with exhibits, but six displays on personal water consumption with yes/no buttons are hardly interactive. A film loop on the water cycle, and other two-dimensional display boards are neither challenging nor thought-provoking. The continuous flow of water from a giant overhead tap seems the only prop to generate visitor response. It tends to make them thirsty or succumb to other bodily responses! An AV presentation in the Ernest Cook auditorium, while meant to 'pull together all the threads' of the exhibition, appears much like boosterism for the work of the Water Authority. If privatization occurs, this film and much of the second half of the exhibition will be relegated to serve as a 'memorial' to the Water Authorities in England.

With growing interest in ecology, the environment, conservation and the 'green agenda', the Museum of the River could have done more by taking a futuristic stance, and helping guide its visitors into the twenty-first century and beyond. The basis for such a message is in this exhibition. However, much like the non-functioning entrance waterfall, it requires some tinkering and modification to work. Once this is done, the Museum of the River could become a forerunner of futuristic museum exhibit design and interpretation in Britain.

Bibliography

American Association of Museums, *Museums for a New Century* (Washington DC, 1984).

Chadwick, A. F., *The Role of the Museum and the Art Gallery in Community Education* (University of Nottingham: Nottingham, 1980).

de Haan, D., 'Museum of the River' in *Ironbridge Quarterly*, 2, 1989: (8).

Ironbridge Gorge Museum Trust, *Ironbridge: A Pictorial Souvenir* (Telford, 1986).

Ironbridge Gorge Museum Trust, *The Ironbridge Gorge Museum Development Trust 17th Annual Report* (Telford, 1988).

Schlereth, T. J., 'We must review history museum exhibits' in *History News*, 43, May–June, 1988: 31–2.

Wallace, M., 'The politics of public history' in Blatti, J. (ed.), *Past Meets Present* (Smithsonian Institution Press: Washington DC, 1987).

Wittlin, A. S., *Museums: In Search of a Usable Future* (MIT Press: Cambridge, Mass, 1970).

The Spertus Museum of Judaica, Chicago

HELEN COXALL

Department of Humanities, Oxford Polytechnic

Situated in the middle of downtown Chicago, the Spertus Museum is the centre for Judaica in the mid-West of the United States. The permanent collection contains objects gathered from all over the world which represent the far-flung history of three-and-a-half thousand years of Jewish migration and settlement. The Spertus is unusual in that its policy is publicly stated in the museum guide and can be seen to be promoted by its exhibitions: its 'precious mission is to explore, examine and exhibit Jewish religious and cultural tradition and to make history come alive'. An issue-based museum, therefore, in so far as its presence is clearly a direct result of its stated purpose.

One such exhibit, the 'Bernard and Rochelle Zell Holocaust Memorial', draws attention to itself by virtue of its physical structure. Situated at the centre of the museum, the entrance is flanked by six tall, black stone pillars commemorating the six million who were slaughtered in Europe during the Second World War. Names engraved on the pillars are those of Chicago area family members killed in the Holocaust. The purpose of the exhibit is stated in the subtitle 'The Secret of Redemption resides in Remembrance'.

The Memorial exhibition starts with a large map of Europe showing the numbers of Jews living in each country before the outbreak of war in 1939. It is captioned:

The Holocaust centres around a basic paradox.
It imposes silence but demands speech.
It defies solutions but requires responses.

From the outset the exhibition sets out to defy detached silence, to articulate the details of the Holocaust and demand responses from its audience. The methods employed are clearly the result of much careful planning: design, layout, captions, and especially text, all work together to the same end. The exhibition itself is a very professional display of shocking photographs and artefacts from the war years. The text is silk-screened on to the display panels. There is a video available for those able to look at it.

The experience of being with the exhibition is one of isolation and confinement. This is achieved by the design. The space is small, low, dark and circular: in order to be released the visitor has to walk the full circle as if in an underground tunnel, or a tomb. At the exit is an identical map which identifies the numbers remaining after the war, captioned simply, 'In memory of the six million'. In that short walk the visitor has witnessed the destruction of six million innocent men, women and children.

The small exhibition is divided into six sections (a number that is repeated in the design several times) each dealing with a stage in the progress of the exterminations. The apparently objective, official language used enhances the museum's intended message which is conveyed by the ironic juxtaposition of the objects, photographs and captions and the explicit parody of the text. The section, called 'The Final Solution' is the most affecting of all. The impact of the historical reality coupled with a distress that the visitor cannot escape experiencing, is achieved by a very fine balance of information and implication. A row of six small photographs are placed above six objects in a glass case. Each photograph shows a mountain of objects in this order: spectacles, combs, dishes, shoes, Torah scrolls, and corpses. The caption is 'All that remained of them'. The immense numbers of these objects and the equation of bodies with inanimate objects is designedly appalling. In the case are examples of personal possessions captioned: 'Found in Auschwitz, remnants of the Shoah: rings, fused household objects, children's shoes, eye glasses, bowl and spoon, zyklon gas.'

Alongside this is a life-sized photograph of emaciated men

wearing concentration camp striped suits, lying on shelf-like tiered bunks. The intimate personal nature of the objects juxtaposed against the image of people awaiting death is extremely poignant. The caption reads 'Inmates in the "living quarters" of Buchenwald.' Placing the euphemism living quarters in inverted commas is a deliberate parody of official jargon. The self-conscious irony of this caption achieves an understatement that is more effective than a graphic description would have been.

The last text, which sums up the aim of the Holocaust Memorial is extremely effective and has obviously been very carefully constructed for maximum impact:

Nazi crimes had not been undertaken haphazardly. The ghettoization of millions, the deportation to Germany, the murder and ill treatment of prisoners of war, the mass executions of civilians, the shooting of hostages, and the fulfilment of the 'final solution' of the Jewish question – extermination camps – all of which were the result of systematic long-term planning.

The world was silent. The world knew what was going on – it could not help but know. And it was silent.

The language is formal, the area of discourse that of war crimes. The first sentence is an explicit accusation. Headed by the subject 'Nazi crimes', directly identifying the perpetrators: the negative focus forestalls a plea of ignorance. The second sentence substantiates this accusation with a thirty-seven word-long list, sounding very like a prosecutor's summing-up which enumerates the crimes and strategies. Only the events are mentioned, no comments are offered. It is perhaps this contrived, impersonal quality, more than any other that manipulates the meaning and therefore the reader's response. In the last clause – 'all were the result of systematic long term planning' – 'systematic', the only adjective, underlines the preferred meaning both semantically and linguistically. It not only qualifies the claim that crimes had not been undertaken haphazardly but foregrounds the fact that the list of atrocities is itself presented in a systematic, repetitive way that suggests an unfeeling, routine attitude to them. This attitude can be attributed both to the perpetrators and to a society for whom the familiar listed events have become statistics in the history books.

The language in the second paragraph is altogether different. It is non-technical and rhetorical. Four clauses form two repetitive, parallel pairs, both syntactically and lexically. The speechmaker's technique of foregrounding the content by introducing extra linguistic regularities is used effectively here to underline the world's common responsibility.

Coming immediately after the prosecutor's summing up, this last paragraph could be likened to a judge's address to a jury before retiring to consider the verdict. The suggestion for this line of linguistic analysis comes when examining the remaining large caption at the end:

THOSE WHO FORGET THE PAST ARE CONDEMNED TO REPEAT IT

Santayana

This line of quoted speech is quite obviously intended to be a spoken condemnation – it even uses this verb 'condemned'. But the remarkable thing is that it is not addressed to the Nazis in war-time Germany, but to all of humanity. And here lies the purpose of the Holocaust Memorial: to articulate the silence surrounding the Holocaust, to demand a response from society to *make* us remember. It is more comfortable to remember partial truths that acknowledge but marginalize events, allowing gaps and time to obscure the issues. The exhibition uncompromizingly speaks out against this process of marginalization. Exhibiting evidence of the possible extremities of human behaviour, it demands that we all remember in order that the events of the past cannot be repeated.

Marketing the arts: foundation for success

Nigel Wright

Manx Museum and National Trust
This is a 'do-it-yourself' learning programme consisting of a workbook and video. It certainly has a good pedigree, being financed by the Office of Arts and Libraries, commissioned by the Arts Council and designed by the Institute of Marketing. It is

intended to provide a foundation course in marketing and to complement other training courses, although we are not told what these might be. The package certainly sets its aims high; at the end of the course the 'user' should be able to understand marketing to the extent that they can devise a marketing strategy and prepare an action plan. All this after an estimated four hours of study!

The workbook, the centre-piece of the package, is split into eleven sections and at various points it refers the user to the video. This contains four case studies, one of which is 'Merseyside Museums'. Rather than defining marketing at the outset, the programme instead takes us through some commonly held misconceptions about marketing, such as 'marketing equals selling'. The closest we get to a definition here is that marketing means focusing on the customer. We move on to analyse the 'Foundations of Success' of the case studies. This is done through observation of the video and noting the key factors in the space provided in the book.

Leaving the video behind we discuss how to define a target audience and then what it is about our 'product' that appeals to this audience. Knowing what we are and who we are trying to reach we can now develop a strategy leading to a plan of action. This is divided into four segments, namely product, price, promotion and selling. Following a brief exhortation that marketing should be a team approach involving every manager (what about the workers?) the booklet is concluded by a reading list and glossary of marketing terms.

One of the major weaknesses of the package is that it tries to cover too much ground too quickly. Its claim to be a 'self standing package' is hard to justify. At one point we are actually told to 'take expert advice on how to go about finding out your organization's needs'. Many museums would need some assistance in market research, defining a target audience or even determining what their product is, before moving on to develop a strategy.

This leads on to another point, namely that of the relevance, or perceived relevance, of this package to museums. It covers the arts in general rather than museums in particular and the museum chosen as a case study is a national museum. Smaller museums in particular might be tempted to wonder whether this package is a suitable investment for them.

This is a pity because the workbook contains useful information. Language is generally good, with a minimum of jargon and only a few awkward phrases such as 'educating further customers'. The presentation of the package is good, as one would expect, but I found the video of limited use. Its main purpose seems to be to show 'real life' organizations and enable the package to be called a practical rather than an academic aid.

The film *Art of Darkness* by David Dabydean

M. D. KING

Museum and Art Gallery, Perth
In his film *Art of Darkness*, David Dabydean presents a challenge to modern British society in terms of the 'smug oblivion' commonly displayed towards its colonial past and in particular the exploitation of the enslaved ancestors of our present-day West Indian community in the Caribbean sugar plantations. He sets out to remedy our ignorance through a partly documentary and partly dramatized account of how Caribbean estates financed the 'high culture' and 'Black Masters' patronized by the commercial and aristocratic classes of eighteenth- and nineteenth-century Britain. He is especially eager to point out that not only did black manual labour contribute to such patronage, but that black slaves, particularly children, were also exploited in artistic, political and sexual terms in the artist's studio itself. It is his contention that the 'unseen' black work-force which today guards the National Gallery deserves to have the role of its ancestors recognized both in the financing of Angerstein's founding collection of 1824 and in the ideological artistic representations of blacks ministering to their colonial masters and mistresses.

Unfortunately, David Dabydean's treatment of the subject often leaves one in doubt as to where documentary fact ends and fictional dramatization begins. The potentially interesting exploration of the political symbolism of the white mistress and black slave-boy in eighteenth-century paintings is used as a touchstone for a persistent and unwarranted investigation of the 'social, cultural, racial and sexual space' between the black man

and white woman which dilutes the essential racial message throughout with sexual innuendo. Both the great Caribbean house where the mistress lives 'protected in a bubble of art from the naked truth of plantation economics' and the stately home in Berkshire are unnamed and replete with stereotypes rather than with documented historical figures. Just as anyone with taste can recognize caricatures of the British commercial and arist-ocratic classes in Hogarth's paintings, so one can spot them in *Art of Darkness*. Although Dabydean is astute in reading ideology into paintings, to use those paintings to reflect contemporary life rather than to read into them a statement on behalf of the painter or the patron would be a mistake. In taking the moral high ground surely the facts would have been enough, without manufacturing a personal 'Age of Degeneracy' from highly selective sources.

One wonders therefore if this is the whole story. Where, for instance, does the guilt of exploitation in history begin and end, and is it wise to perpetuate that burden rather than to under-stand the prejudices which allowed it to happen? Was Britain alone in exploiting the West Indies? What part did native Africans play in capturing their fellows and selling them to slave-traders? The issue of the slave-trade is clearly a sensitive subject which requires a conciliatory rather than a confronta-tional approach. Essentially, the answer to the problem outlined by David Dabydean lies in effective multi-cultural education, in particular the introduction of Black Studies in schools where this will promote understanding between racial communities. Where possible, museums must have a part to play in such programmes, providing special temporary exhibitions which bring useful educational materials together. Arguably, the place for didactic social history and multi-cultural exhibitions is not the National Gallery, but there is every reason for the Commonwealth Institute to take an interest in art and museum collections relevant to Britain's colonial past.

Things have changed since the bust of Sir Henry Tate of 'Tate and Lyle' was ironically set up amid the future West Indian community of Brixton. Insurrection may have been the only way for the slave-rebel Sam Sharpe to make a bid for freedom in Jamaica in 1831, but the way forward in the free Britain of today lis in mutual understanding and not in violence. The energy put

into David Dabydean's challenge to arms could be channelled to better advantage into tapping the rich seam which he has unearthed, namely collecting documentary, artistic and graphic material relating to black history from archives, art galleries and museums to make it accessible to teachers and students alike. Combined with this positive encouragement of a greater awareness in these institutions of the wealth of their multi-cultural resources, the sense of self-exclusion towards museums and art galleries which is generally felt by blacks may then be transformed rather into a voyage of self-discovery.

Museums 2000

MAHI GAZI

Department of Museum Studies, University of Leicester
A two day international seminar on the role and nature of museums and galleries in the twenty-first century was organized by the Museums Association on 10 and 11 May 1989 in London. Eight principal speakers, and a further twelve participants from the museum profession, politics, the media, and industry, discussed four major themes: politics, people, professionals, and profit in relation to museums.

Lorena San Roman, Director of the National Museum of Costa Rica, launched the first day by speaking on the political aspects of running a museum and the museum's role in the rescue of identity. Museums, as a means of presenting cultural history and evolution, are bound to receive increasing pressure from politicians, who wish to present their views as well. However, the use of museums as political instruments must be condemned. Museum presentations should be pluralistic, allowing for various views and opinions, and avoiding 'take away' solutions. An example was drawn from Costa Rica, where, in view of the centenary celebration of independence in 1989, discussion and collaboration among all interested parties has been established in order to mount a major new exhibition on the country's history.

Eric Moody, from the Department of Arts Policy and Management at the City University, London, examined the role of

government funding in the arts. In an era when museum sponsorship is increasingly important, governments should create conditions favouring sponsors by introducing financial benefits (e.g. tax concessions). Moreover, it is now time to 'exploit' the potential of museums as national resources (both cultural and economical).

Lord Montagu of Beaulieu chaired the discussion that followed. It was noted that while on one hand museums wish more independence from politicians, on the other hand they have increasing demands for funding by them. Thus, although most participants felt that private sponsorship could not be avoided today, the need for obtaining more government support was stressed. Lack of a clearly defined cultural policy was identified as the main reason why politicians do not know what to expect in return for their investment.

Talking on 'Museums and People', Donald Horne, Chairman of the Australia Council, concisely presented the evolution of museums, as well as the various approaches adopted by them with regard to their collections, ranging from the taxonomic, linear sequence of objects, through to the concept of museums as guardians of cultural heritage, to changed beliefs and the adoption of alternative types of museums under the influence of the Industrial Revolution. He emphasized the fact that there is no such thing as 'the public'. Instead, different types of people visit museums today, and our role is to help them in this encounter.

Saraj Ghose, Director of the National Council of Science Museums, India, spoke on the contribution of science museums in informal education. He stressed the need for close collaboration between museums and formal education. A programme developed by the Council of Science Museums in India consists of 'demonstration lectures' using simple game kits manufactured for schools, training programmes for teachers, and 'creative ability centres' for students; the final aim being the establishment of school science centres within the next few years.

The primary importance of museums in education was highlighted during the discussion. It became obvious, however, that not only do museum professionals need a much more specialized training, but, also, a more multi-disciplinary approach is required, if we are aiming at the 'edification' of the public. We

were, furthermore, reminded that people with special needs as well as cultural minorities should be taken into consideration in drafting a museum policy.

The second day, with Dr Patrick Boylan in the chair, opened with Tomislav Sola, Director of the Museums Documentation Centre, Zagreb, Yugoslavia, who spoke on the training of museum professionals. He pointed out that in an era of rapid museum development the profession still lacks its own theoretical framework, its 'theology'. In his view, museums should be seen as a part of a 'heritage galaxy', not in isolation. A 'cybernetic philosophy of heritage', a multi-disciplinary applied art of heritage communication, is what we should be aiming at. The key point Dr Sola made is that new museum professionals should emerge from undergraduate training.

Neil Cossons, Director of the Science Museum, London, pointed out the need to renew interest in museums' collections and make as much use of them as possible for the public's benefit. To this end, a clear acquisition policy is of utmost significance. Passion for the object is for Mr Cossons the root of scholarship. Thus, he stressed the importance of storytelling: creating stories about the objects and communicating them to the public.

The discussion on museum training centred upon the need for theoretical grounding alongside recognition that an increasing spectrum of skills and knowledge should be brought together in order to establish a new, sound museological theory and practice.

Paul Perrot, Director of the Virginia Museum of Fine Arts, United States, analysed forms of financial support for museums such as individual or corporate membership, and partnership with industry. He emphasized the importance of individual membership in creating a nucleus of interested people, which is beneficial for museums both from a cultural and a financial point of view. However, when looking for sponsorship, museums should bear in mind that clearly defined objectives are always of primary importance.

The last speaker, Frans Verbaas, Managing Director of the Museums Year Pass, Netherlands, emphasized that museums can no longer ignore present-day situations: a good sense of marketing, having in mind the consumers' needs, is required

today. Moreover, a communication policy should be adopted by museums if they are to be transformed from temple-like to market-oriented institutions.

The final discussion centred upon marketing issues and the different models adopted in America as compared to Europe. A combination of the American model of museum membership with the European model, which views museums as a social service, was suggested as a way forward to the future.

Concluding, it was generally agreed that we still have a long, though challenging and exciting, way to go in order to make museums lively places for the community.

Co-operation and curatorship: the Swedish– African Museums Programme

GAYNOR KAVANAGH

Department of Museum Studies, University of Leicester

In 1984, the Swedish National ICOM Committee broached the idea of an exchange programme between African and Swedish museums. Their aim was to fulfil article 7 of ICOM statutes, in particular 'to emphasize the importance of the role played by museums and the museums' profession within each community and in the promotion of greater knowledge and understanding among peoples'.

Further to initiatives taken in 1984, which included a major exhibition called 'Meeting Place Africa', a programme of meetings was held in Stockholm between Swedish and African curators in May 1989. This was organized by Elisabeth Olofsson and Gunilla Cedrenius for the Swedish National Committee of ICOM, with the aid of the Swedish International Development Authority and the Swedish Institute. The twelve day programme was designed to create opportunities for genuine dialogue and considerable advance in mutual understanding. It worked from the premiss that our future is global and that by working together Swedish and African curators could create something new. The underlying aim was to establish the kind of contacts that would be joyful, inspiring and long-term. The programme therefore was organized in ways that could promote feelings of

221

solidarity, not just through the common concerns of curatorship but also through a heightened awareness of our common humanity.

Delegates attended from Senegal, Zaire, Zimbabwe, Mali, Ethiopia, Zambia, Swaziland, Mozambique, Tanzania, Botswana, Madagascar, Sweden, Denmark, Italy and Britain. The programme for the twelve days had several different elements, including a two day conference on the concept of culture. As well as a number of museum visits, time was devoted to the formal process of twinning African museums with museums in Sweden. The aims of twinning are to promote the exchange of information, job swaps and exhibitions. African delegates visited their Swedish counterparts and took time to get to know them and their museums. As many as fifteen Swedish museums are involved with the twinning and their curators were keen to share with their African colleagues knowledge of their work and activities. In turn, Swedish curators will visit their twinned museum in Africa, so that they can learn more about its situation and policies.

A powerful ingredient in the success of the twinning must be the degree of understanding and mutual regard born out of the three day workshops that began the Swedish–African Programme's May meeting. Curators came together in a number of groups to explore the subject 'Death – a part of life'. Several curators had brought slides, music and objects associated with rites of passage observed within their own cultures. Others were able to use objects within the collections of the Museum of the Peoples in Stockholm. After three days of discussions and exploration, the groups, using objects, images, sound and music, created presentations, based on their discussions. These were shown to the assembled delegates and included an exhibition, a model of an exhibition, a portrait in song and speech and a video film of a funeral rite. Each confirmed not so much our cultural differences, but our shared experiences of life and death regardless of our country of origin. Each also confirmed the common bonds of curatorship as an activity which cares about and respects the people in whose name the museum operates.

There were moments of this I will not forget: a Swedish hymn of mourning sung in Swahili; a black African curator hand-in-hand with a white Swedish curator saying in unison 'as women,

what we fear most is the death of our children'; and the profound emotions which were experienced by the workshop which elected to merge and perform symbolically African and Swedish funeral rites. The presentations given by the workshops during the conference days were deeply moving. They were a reminder of how the skills of curatorship can enlarge our understanding and promote a sense of belonging to one world. They also provided a startling glimpse of the power and potential of curatorship which so often remains untapped.

The two day conference on the concept of culture allowed for the formal presentation of papers by delegates and further examination of the museum's relationship with the culture of which it is part. It included a key paper from Alpha Oumar Konare, Professor at *institut Supérieur de Formation et de Recherche Appliquée*, Mali, on the status of museums in Africa, which helped clarify and contextualize the position of African museums. Mrs Angeline Kamba, Director of the National Archives of Zimbabwe, lectured on the Oral tradition of East Africa and Dr Sverker Sörlin, University of Umeå, considered the sharing of our cultural heritage and the role of the museum in a diminishing world. The conference concluded with a dazzling evening of Swedish folk music and African singing and dancing.

Louis Auchincloss *The Golden Calves* (Weidenfeld and Nicholson, 1988)

EILEAN HOOPER-GREENHILL

Department of Museum Studies, University of Leicester
This is a delightful novel, written with a light and dryly humorous touch. The story is set in the Museum of North America and one of the joys of the novel is the unrelenting accurate observation of museum personalities and present-day museum dilemmas. If there is a tendency towards caricature, this is relieved by (and forgiven for) the dramatic use of these all too familiar aspects.

The main characters include Mark Addams, the self-confident bright new acting Director, who has come to the museum from a public relations firm. His claim to replace the sixty-five year-old,

about-to-retire Director, who suffers from emphysema, rests on his success in the post he has held for a short period of fundraiser for the museum. He is trim and tightly put together. His cause is supported by Sidney Claverack, Chairman of the Board, and a classic new interventionist trustee; he has left the running of his business to his younger colleagues in order to devote himself to the museum, with which he identifies strongly, mainly because of personal ambition for posthumous fame based on the final resting place of his own collection of rather second-rate Canadian paintings. 'Museums have become big business and should be run accordingly', he declares. In the new Director he is looking for a man (*sic*) who can sell a product as well as buy one.

On the female side we have Anita Vogel, who is quiet, lacking in self-esteem, and feels herself to be a bit of a blue-stocking. She is Assistant Curator in the Decorative Arts department, cares deeply for her collections, and for the rights of the public. After an unfortunate, affection-starved existence, she has been unofficially adopted by Miss Evelyn Spedding, the museum's main benefactor, who owns a vast eclectic collection of Americana. This collection is coming in dribs and drabs to the museum and the intention is that after her death the museum will inherit it all. The acting Director is concerned to secure an accompanying endowment, (as well, thereby, as his own position as Director). Miss Spedding has donated the collection on condition that it is permanently on display. Part of the will which leaves the collection to the museum also states that the museum should retain Anita Vogel to care for it. But Miss Spedding would like to secure her donation further by making sure that the shy but pretty Anita marries the dynamic acting Director.

The museum itself is at a point of change. It can no longer remain the quiet institution where the curators tended their own private gardens, resented the intrusion of the public, and regarded a strike by warders and maintenance men as a stroke of good luck that turned the building into a silent haven for scholars. The younger curators are keen to follow the lead of the acting Director and transform the museum into 'a kind of graduate school for all ages whose artifacts would offer instruction in the history and culture of a continent, whose shop would

be filled with enticing aids to learning and whose great central gallery would be available to display any of the popular 'mega-shows' so heavily covered by the press. By day the halls would be filled with students; by night they would glitter with benefit parties.'

The emotions and ambitions of the curators and their colleagues are played out against problems of display policy, building plans, curatorial jealousies and board politics. It is refreshing to see some of these sometimes painful features shaped into an affectionately observed narrative.

Daniel Miller *Material Culture and Mass Consumption* (Basil Blackwell, 1988)

SUSAN M. PEARCE

Department of Museum Studies, University of Leicester
Miller sets out his intention in the first sentence of the first part of his work. 'This book', he says, 'sets out to investigate the relationship between society and material culture, and to assess the consequences of the enormous increase of the industrial production over the last century'. We have, therefore, two main fields before us: the nature of material culture, understood generally through the book as 'goods' or 'artefacts' (although this is supremely an area where every word is loaded), and the relation it bears to the community which makes and uses it; and, as a specific problem within the general theme, the nature and significance of modern mass consumption, which is arguably so different in kind from what has ever been experienced before that it raises particular problems in material culture theory related to the nature of capitalism and the hope of human progress.

Miller has had experience of some 'traditional' ways of life and their associated material culture in his work in the Indian sub-continent and, as he shows in his preface, this left him ultimately with an awareness of the limitations and constraints of 'non-industrial societies such as the archetypal peasant community' (p. viii), and an awareness of how such communities can be falsely romanticized. We recognize from the outset

that this book, which deals with the other side of the coin, will take a broadly optimistic view of European consumerism: for Miller capitalism with all its works is not necessarily satanic.

Miller begins at the beginning and spends his first five chapters in a discussion of the subject–object relationship at the level of abstract philosophy, with 'object' here meaning the whole external world. Here, he draws particularly upon Hegel's *Phenomenology of Spirit* and abstracts from it the concept of 'objectification' which is at the core of the book. This term is used to describe a 'dual process by means of which a subject externalizes itself in a creative act of differentiation, and in return re-appropriates this externalization through an act (of) sublation' (p. 28). Put rather crudely, the human person as subject creates from within himself an entity of whatever kind – including material artefacts – which assumes an external existence as an object; but then takes back this creation to use it as part of the basis of the next burst of creative activity. The gulf between subject and object is, therefore, healed because both are aspects of a single relationship; that relationship is always process, and the process is always progressive, for better or for worse.

Following discussion of Marx ('Objectification as Rupture'), and Munn ('Objectification as Culture'), Miller discusses the work of Simmel, and especially his *Philosophy of Money*, which establishes the idea of 'Objectification as Modernity'. Simmel's work suggests that both the positive side of objectification, sublation or renewed identity, and the negative side, of externalization or rupture, together give the dynamic force to history which confers modern freedom, equality and prosperity, but also its opposites of exploitation and alienation. This, at any rate, allows the possibility that the process may be positive.

Chapters 6 and 7 then shift the discussion from the general nature of objectification as a process to the specific area of material culture objects and the way in which the concept can be applied to them. This takes us by way of psychological and linguistic discussion (Chapter 6), and discussion of artefacts in time, space and style (Chapter 7), to the position that artefacts are so deeply integrated in the constitution of culture and human relations that they are very difficult to discuss, and that they play a crucial role in the whole objectification cycle of

externalization and sublation because they are intrinsically specific and concrete.

In the final section of the book (Chapters 8–10) Miller returns to his second theme, and discusses mass consumption. Miller concludes that 'in consumption, quite as fully as in production, it is possible, through the use of self-alienation which created the cultural world, to emerge through a process of reappropriation towards the full project of objectification in which the subject becomes at home with itself in its otherness' (p. 192).

It will be obvious from this brief sketch that this is both an important and a brave book. Miller refers several times to the paucity of the academic tradition of material culture interpretation. In the nineteenth century material culture loomed large in cultural studies because it could be interpreted in Darwinian evolutionary and diffusionist terms, and easily displayed in these modes. By the 1920s this approach was discredited in favour of integrated and specific community studies, and artefacts were displaced from their cultural position. Museums were viewed as correspondingly dowdy, and the intimate relationship between the history of material culture theory and of museum development would make an interesting study in itself. Both have been on the way up since the 1960s with the development of broadly structuralist and post-structuralist ways of thought across the field of human culture, but both are still in the pioneering phase and so workers in the field lack the sustaining thrust of a tradition against which to write.

Miller has succeeded in opening up the field in this, one of the first book-length studies of its kind, which develops the topic from a serious philosophical base. His idea of objectification has a good deal in common with much broadly post-structuralist writing, and in particular with Iser's reader–response theory, which is equally applicable to artefacts as viewer–response theory. Both do something towards balancing post-structuralist anarchy and received tradition, and both are progressive with grounds for optimism. Miller's careful dissection of the objectification concept and its relation to artefacts is stimulating and illuminating.

The ideas discussed are difficult, and the book is not an easy read. Miller has chosen to approach his subject by way of the analysis of a range of chosen texts, particularly in the earlier

chapters. This is certainly one way, but since artefacts are at the heart of the study it might have been varied by more discussion of actual objects in play, from which the philosophical problems could be teased out. Particular criticisms notwithstanding, this is a book which must be taken seriously by all workers in the area. Miller describes modern material culture as 'having consistently managed to evade the focus of academic gaze' (p. 217). Here, he has made a major advance in the sharpening of our vision.

Arnold Toynbee and Daisaker Ikeda (edited by Richard Gage) *Choose Life: A Dialogue* (Oxford University Press, 1989)

SUSAN M. PEARCE

Department of Museum Studies, University of Leicester

Also received for review was *Choose Life: A Dialogue* by Arnold Toynbee and Daisaker Ikeda, edited by Richard Gage and published (1989) by Oxford University Press. Toynbee is, of course, best known for his monumental work *A Study of History*, published in six volumes before the Second World War. This work has had its severe critics, but it left Toynbee, in the words of *Time* magazine, as an international sage like Albert Schweitzer or Bertrand Russell. Ikeda is President of Soka Gakkai International, a Buddhist lay organization with some ten million members, devoted to the promotion of education, culture and peace.

Between 1971 and 1974 Toynbee and Ikeda discussed a wide range of important contemporary issues. They exchanged written questions and answers, and held conversations which were recorded and subsequently edited for publication by Richard Gage. Hence the unusual organization of this book, which takes the form of a protracted conversation between the two men, expressed in dialogue form.

The book is divided into three sections: Personal and Social Life; Political and International Life; and Philosophical and Religious Life. Between them, they encompass issues ranging from the subconscious and organ transplant to Japan's contribution to

the future and the question of eternal life. Put thus crudely, the book sounds like a sort of glorified philosophical bran tub, but this is probably unfair. Certainly, however, the dialogue style does not make for easy reading; it is best dipped into rather than read through, but a leisurely browse will prove rewarding.

Call for papers for forthcoming volumes

The topic chosen for *New Research in Museum Studies* volume 2 is *Museum Economics and the Community*, and that chosen for volume 3 is *Europe 1992*. These volumes will concentrate upon the chosen topics, but may also include papers which deal with other aspects of museum studies. The editor would be pleased to hear from any worker in the field who may have a contribution. Any ideas for papers or completed papers for consideration should be sent to Dr Susan Pearce, Department of Museum Studies, 105 Princess Road East, Leicester LE1 7LG.

Contributions to the reviews section, including reviews of conferences and seminars, videos, exhibitions and books, or any other museum event, are similarly welcomed, and should be sent to Dr Eilean Hooper-Greenhill at the above address.

Editorial policy

New Research in Museum Studies is a referreed publication and all papers offered to it for inclusion are submitted to members of the editorial committee and/or to other people for comment. Papers sent for consideration should be between 3,000 and 10,000 words in length, and may be illustrated by half-tones or line drawings, or both. Prospective contributors are advised to acquire a copy of the *Notes for Contributors*, available from the editor, at an early stage.

New Research in Museum Studies has a policy of encouraging the use of non-sexist language, but the final decisions about the use of pronouns and so on will be left to individual authors. However, the abbreviation s/he is not to be used.

The editor wishes it to be understood that she is not responsible for any statements or opinions expressed in this volume.

Index